THE ART OF OMAR KHAYYAM
Illustrating FitzGerald's *Rubaiyat*

William H. Martin & Sandra Mason

Published in 2007 by I.B.Tauris & Co Ltd
6 Salem Road, London W2 4BU
175 Fifth Avenue, New York NY 10010

www.ibtauris.com

In the United States and Canada distributed by Palgrave Macmillan, a division of St. Martin's Press, 175 Fifth Avenue, New York NY 10010

Copyright © William H. Martin and Sandra Mason, 2007

The right of William H. Martin and Sandra Mason to be identified as the authors of this work has been asserted by them in accordance with the Copyright, Designs and Patents Act 1988.

All rights reserved. Except for brief quotations in a review, this book, or any part thereof, may not be reproduced, stored in or introduced into a retrieval system, or transmitted, in any form or by any means, electronic, mechanical, photocopying, recording or otherwise, without the prior written permission of the publisher.

ISBN: 978-1-84511-282-0

A full CIP record for this book is available from the British Library
A full CIP record for this book is available from the Library of Congress
Library of Congress catalog card: available

Designed by Paula Larsson
Typeset in Scala by Dexter Haven Associates Ltd, London
Printed and bound by MKT PRINT, Slovenia

CONTENTS

Preface .. vii

Acknowledgements .. viii

Part 1 – Illustrating FitzGerald's *Rubaiyat* ... 1
 A unique publishing phenomenon ... 3
 Illustrating *The Rubaiyat* ... 11
 A century of change in illustration .. 19
 Still popular – at home and abroad .. 29

Part 2 – Illustrating individual quatrains .. 31
 Presenting the quatrains .. 33
 Illustrations for FitzGerald's first edition – quatrains 1–75 36
 Illustrations for FitzGerald's other editions of *The Rubaiyat* 159
 Illustrations unrelated to specific quatrains 163

Appendix 1. Publishers and illustrators of FitzGerald's *Rubaiyat* 167
Appendix 2. Artists who have illustrated FitzGerald's *Rubaiyat* 169
Appendix 3. Published versions of *The Rubaiyat of Omar Khayyam* ... 172
Appendix 4. Omar Khayyam and his *Rubaiyat* 174
Appendix 5. Edward FitzGerald and his *Rubaiyat* 175

Notes .. 177
Select bibliography .. 179
Index .. 181

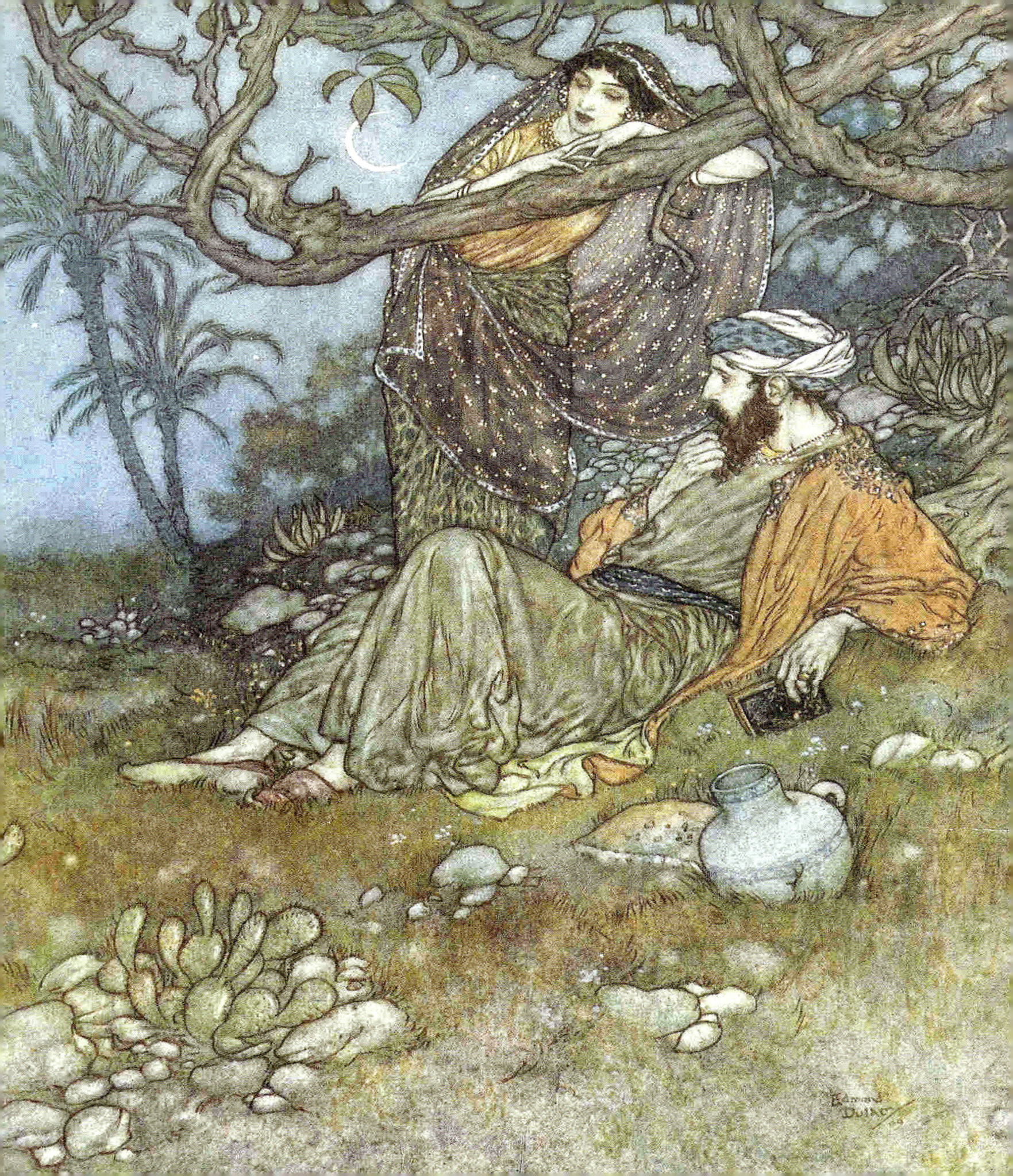

Here with a little Bread beneath the Bough,
A Flask of Wine, a Book of Verse – and Thou
Beside me singing in the Wilderness –
Oh, Wilderness were Paradise enow!

E. Dulac, 1909
(quatrain 12 in second edition)

PREFACE

This book has been both a labour of love and a voyage of exploration. The voyage stems from chance meetings with FitzGerald's *Rubaiyat* in our youth, and it has continued over many years, taking us to bookshops and libraries at home and abroad. Illustrated editions of *The Rubaiyat* drew us to them, and they became the focus of more searches. We gradually came to appreciate the extraordinary variety, quality and continuity of the 'Art of Omar Khayyam'.

Our own fascination with this subject became something to share with friends and family, and others with an interest in Khayyam and FitzGerald. From this sharing came the idea of a book, so that we could open up what we had discovered to others who might be interested. We have tried to convey our discoveries at three different levels. First, there is the approach of the historical detective, looking at the artistic and publishing history of FitzGerald's *Rubaiyat* since it first saw the light of day in 1859. In Part 1 of the book, we follow the story of the many editions, the publishing houses and the illustrators who have been involved with the art of *The Rubaiyat* over the past century and a half. The second approach, pursued in Part 2, is that of the illustrator, examining the individual quatrains and looking at what there might be in them that inspires the artist. Here we highlight the enormous range of artistic interpretation, style and content that exists for this one poem. Finally, in the appendices, the approach of the analytical researcher comes into its own, with detailed information on bibliography, illustrators, publishers and their work.

The story we present of FitzGerald's *Rubaiyat* is not just one of books and illustrations; it is also one of people. There are the two key players of Omar Khayyam and Edward FitzGerald, and the cast of FitzGerald's friends, especially Edward Cowell, who played a crucial role in the creation of *The Rubaiyat*. In addition, over the years since 1859, there have been many other players. They include major scholars and interpreters of Persian literature, like Heron-Allen, Batson, Arberry, Avery, Hedayat, Foroughi, and Dashti, and cataloguers of *The Rubaiyat* like Potter, as well as key people in publishing houses large and small, and the illustrators they commissioned. All have been caught up in different ways in the publishing phenomenon of FitzGerald's *Rubaiyat*. As we have followed the trail of this phenomenon, we have come to know such people well through their work. Our common interest has made them seem almost like friends, and we hope that others will also enjoy meeting them.

[opposite]

E. Dulac, 1909 *(quatrain 12 in second edition).*
Here with a little Bread beneath the Bough,
A Flask of Wine, a Book of Verse
 – and Thou
Beside me singing in the Wilderness –
Oh, Wilderness were Paradise enow!

ACKNOWLEDGEMENTS

We wish to thank many other people for their contribution to the production of the book. It is not possible to acknowledge individually all the librarians and booksellers who have helped us in our search for editions of *The Rubaiyat*, nor all our friends and fellow enthusiasts with whom we have shared our thinking over the years. But we have a special debt of gratitude to Jos Coomans, Secretary of the Nederlands Omar Khayyam Genootschap. Jos not only allowed us to browse his extensive collection of *Rubaiyats*, but also gave us details of many editions and patiently answered our questions as we tried to sort out the complexities of *Rubaiyat* publishing and illustration. We are also very appreciative of the help given to us by Garry Garrard, another British collector and researcher, not least for his persistence in locating additional illustrators and translators of *The Rubaiyat*. And we thank the librarians of Syracuse University and Cleveland Public Library in the USA who allowed us to view *Rubaiyats* and other material from their special collections.

Acknowledgements are also due to the illustrators, their publishers and copyright holders who have given us permission to use their work in this book. We have attempted as far as possible to trace the copyright holders of all the illustrations used, though our search has not always been successful. We shall be glad to hear from any copyright holders that we have not been able to find so far.

Specific acknowledgements are due as follows:

to the Master and Fellows, Magdalene College, Cambridge, for work by Norman Ault;

to the Bridgeman Art Library, for work by Sir Frank Brangwyn;

to Peter Pauper Press, Inc., for work by Jeff Hill, Paul McPharlin and Jeanyee Wong;

to HarperCollins Publishers, for work by Eugene Karlin;

to Penguin Group (USA) Inc., for work by Sarkis Katchadourian;

to Nicolas Parry for his own illustrations;

to Eric Dobby Publishing, for work by Willy Pogany, first published in 1909;

to Penguin Group (NZ), for work by two illustrators (names unknown) published by Whitcombe and Tombs.

The illustration by Jessie M. King is reproduced by permission of the copyright holders, Dumfries and Galloway Council and the National Trust for Scotland. The authors have paid DACS (the Design and Artists Copyright Society) for the use of artistic work by Lynette Hemmant.

We are also grateful to our publishers I.B.Tauris, and their team, for the help they have given us in turning our drafts into a final publication. In particular, Paula Larsson made a major contribution in interpreting our ideas for page design and the presentation of illustrations, and Robert Hastings was a great help as manager of the text editing and production of the final document. The responsibility for any errors remains, as always, with the authors.

PART 1

Illustrating FitzGerald's *Rubaiyat*

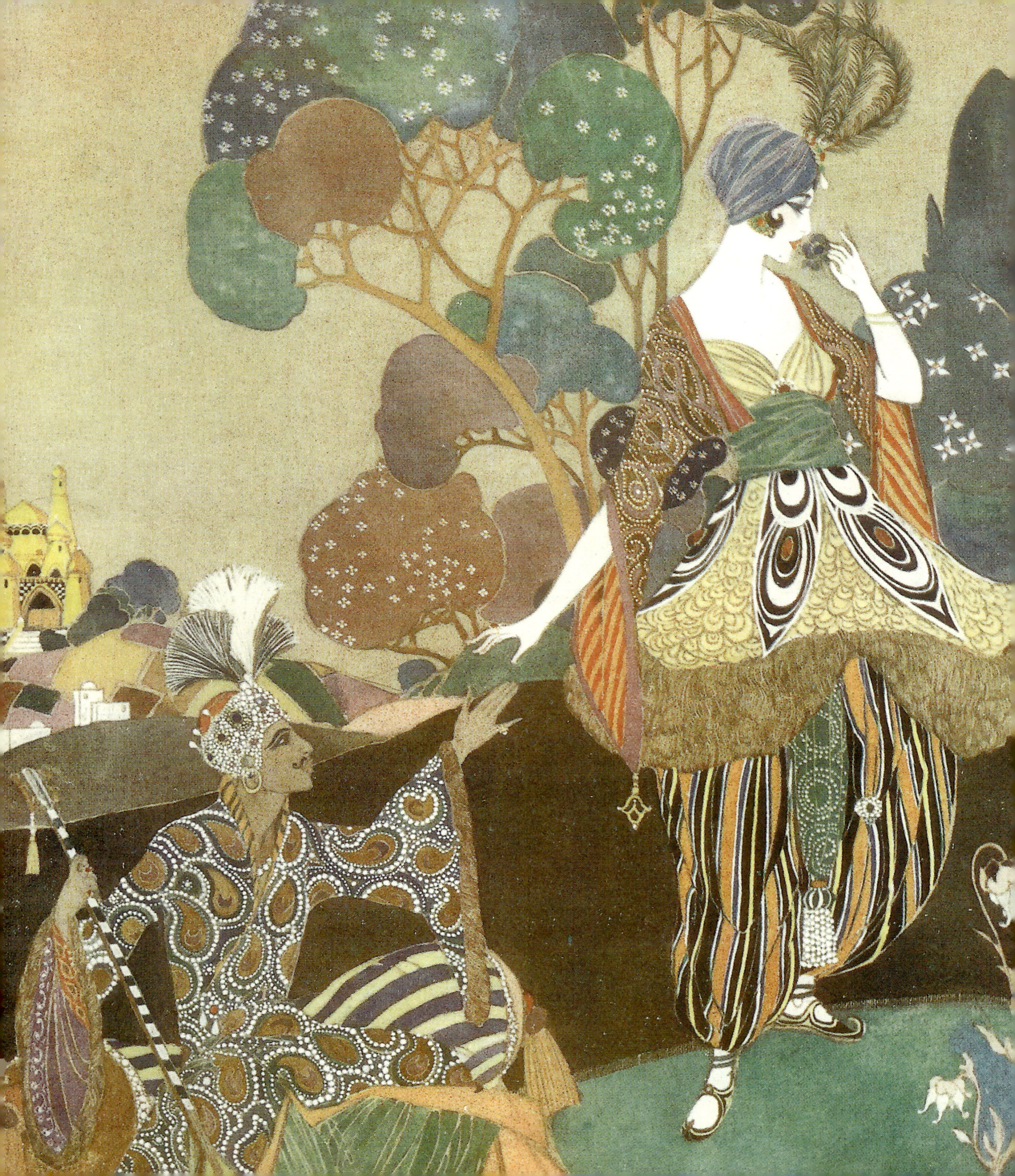

A UNIQUE PUBLISHING PHENOMENON

FitzGerald's *Rubaiyat*

When Edward FitzGerald published his version of *The Rubaiyat of Omar Khayyam* in 1859,[1] he could have had absolutely no idea of the 'Omar' publishing industry that would evolve from his action. In fact this was the start of a unique publishing phenomenon. Over the century and a half since that date, there has been a continual flow of subsequent publications of Omar Khayyam's *Rubaiyat*. A great many of these have been of FitzGerald's poem, despite translations of *The Rubaiyat* by other scholars. Additional publications have been in languages other than the original English of FitzGerald. It is thought that there have been as many as two thousand separate editions and reprints of *The Rubaiyat* published since 1859, in over seventy languages ranging from Latin to Swahili and involving at least eight hundred publishers.[2] This record is perhaps only exceeded, for English works, by the number of publications and translations of the Bible and Shakespeare.

Today, FitzGerald's *Rubaiyat* is one of the most universally known of all poems. It is also probably the most widely illustrated of all literary works. The first illustrated edition was published in the USA in 1884, by the Boston firm of Houghton Mifflin, with illustrations by Elihu Vedder.[3] Since that date, there have been some three hundred different illustrated editions (excluding reprints) with over a hundred and thirty known illustrators. To the best of our knowledge, no other written work has enjoyed so many artistic interpretations of its contents.

In this book, we focus primarily on illustrated editions of the various FitzGerald versions of *The Rubaiyat* that have been published in English. But we make some reference to the wider phenomenon of *Rubaiyat* publication and illustration in other languages, and by other translators.

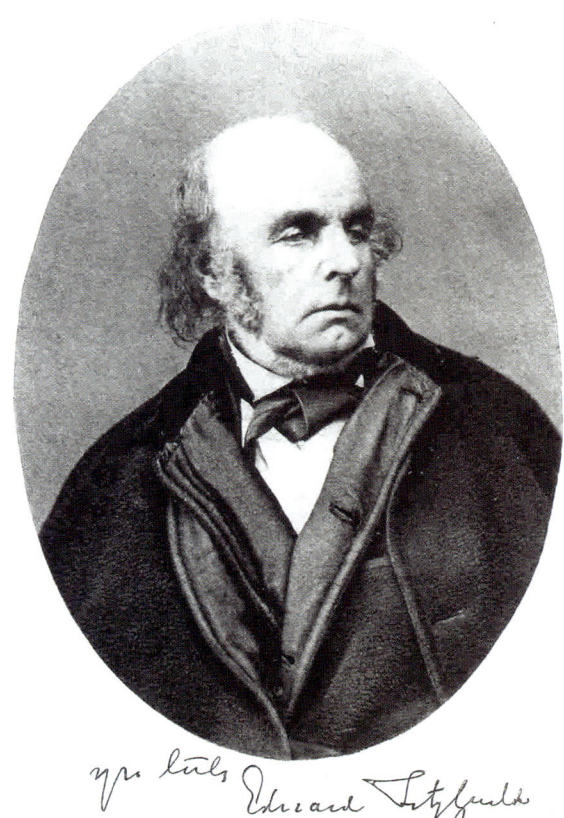

[opposite]

R. Balfour, 1920 *(unrelated to a specific quatrain)*.

1. *A portrait of Edward FitzGerald*.

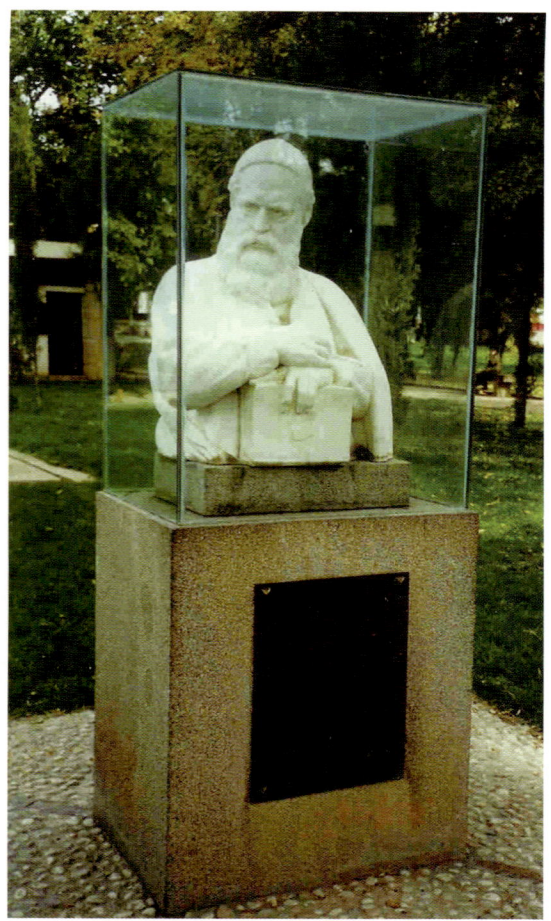

[left]
2. *An image of Omar Khayyam (bust of Khayyam in the garden of his tomb at Nishapur).*

[right]
3. *Title page of first edition (1859) of FitzGerald's* Rubaiyat.

The story of the creation of FitzGerald's *Rubaiyat* has been well documented elsewhere,[4] and we shall only summarise the most salient features. It was in 1856 that Edward FitzGerald was first introduced to the poetry attributed to Omar Khayyam. Khayyam was a Persian mathematician, astronomer and philosopher who lived from around 1048 to about 1126.[5] The acquaintance came through FitzGerald's friend Edward Cowell, who had introduced FitzGerald to the Persian language and its literature. Cowell had earlier worked with FitzGerald on the translation of other Persian poets, notably Attar and Hafiz. In July 1856, he sent FitzGerald a copy of the manuscript of *rubaiyat* attributed to Omar Khayyam, lodged in the Ouseley collection in the Bodleian library in Oxford.[6] This event marked the beginning of FitzGerald's work on Khayyam's verses.

After much hard work, FitzGerald published his first version of *The Rubaiyat of Omar Khayyam* in 1859. This first edition contained 75 quatrains (four-line verses known in Persian as *rubai*, plural *rubaiyat*) and it was published anonymously by FitzGerald himself, using the services of Bernard Quaritch.

More details of the publishing history are given below and in Appendices 1, 2 and 3.

The verses being illustrated

```
RUBÁIYÁT

OF

OMAR KHAYYÁM,

THE ASTRONOMER-POET OF PERSIA.

Translated into English Verse.

—————

LONDON:
BERNARD QUARITCH,
CASTLE STREET, LEICESTER SQUARE.
1859.
```

The poem was not a precise translation of Khayyam's Persian verses, but a personal interpretation by him, 'a paraphrase of a syllabus', as he called it on one occasion.[7]

FitzGerald was by no means the first scholar to study verses attributed to Omar Khayyam. The earliest known reference to Omar Khayyam in the Western world was by the chronologist Joseph Scaliger in his *De Emendatione Temporum* published in Switzerland in 1583.[8] The first known translation of Omar Khayyam from Persian into a Western language (Latin) was a verse included by the Reverend Thomas Hyde in his study of Persian religion published in 1700.[9] In the nineteenth century, there were others working and publishing in this field, including von Hammer, von Schack and von Bodenstedt in Austria and Germany,[10] de Tassy and Nicolas in France,[11] Zhukovsky in Russia,[12] Garner in the US,[13] and Whinfield and McCarthy in the UK.[14] Others followed in the twentieth century, including Christensen in Denmark,[15] Rosen in Germany,[16] and Arberry and Avery in the UK.[17]

However, none of these scholars was as responsible as FitzGerald, albeit innocently, for generating the worldwide interest in the poetry attributed to Omar Khayyam, or for the subsequent widespread publishing and illustrating of *The Rubaiyat*, which continues to the present day. For whatever reason, the other nineteenth-century scholars of Khayyam were notably less successful than FitzGerald in obtaining a large distribution for their versions of *The Rubaiyat*.

Different sets of quatrains

It may seem strange that the verses attributed to an eleventh-century Persian mathematician and astronomer should be of such continuing appeal, to so many people, worldwide. In fact, the situation is even stranger than it seems, since there is no direct evidence that Omar Khayyam was the author of any of the quatrains attributed to him. There are no original manuscripts of *The Rubaiyat* extant, and no evidence from his contemporaries, or in the years immediately following his death, of poetic activities by Khayyam. As mentioned above, Edward FitzGerald gleaned his words initially from one of the earliest known manuscripts, namely that in the Sir William Ouseley collection in the Bodleian library in Oxford. This contains 158 quatrains and is dated 1460/61; it was thus put together over three hundred years after the death of Omar Khayyam.

In preparing his first edition, FitzGerald also had access to another key manuscript, the Calcutta version, containing 516 quatrains. This manuscript, undated and now lost, was copied and sent to him from

4. Extract from the Ouseley manuscript of The Rubaiyat of Omar Khayyam, *with a transcription made by E. Heron-Allen (1898).*

India by Edward Cowell. Other manuscripts attributed to Omar Khayyam, some with an even larger number of verses, and others with only a few quatrains, have been discovered; nearly all are dated later than the Ouseley manuscript, and some have been used by other translators. A number are now known to have been collections of verses from a variety of poets, and, more recently, there have been forgeries purporting to be manuscripts of the work of Khayyam (see also Appendix 4).

At the present time, Khayyam scholars suggest that relatively few of the large numbers of quatrains attributed to Khayyam are likely to have been by him. Serious questioning of authenticity dates from the late nineteenth century, particularly from 1897, when Zhukovsky, the Russian scholar, revealed that 82 quatrains attributed to Khayyam were by other poets; he called these the 'wandering quatrains'.[18] Since then, there has been further research in Europe as well as in Iran on the authenticity of quatrains, and analyses by Ross and Christensen have raised the 'wandering' figure to 108.[19] It is now reckoned that the number of quatrains that can be fairly said to be by Khayyam may be under two hundred.[20] Dashti, a key Iranian authority, considers that only 36 quatrains have a real likelihood of authenticity.[21]

Apart from the uncertainties surrounding the Khayyam originals, FitzGerald also added to the variety of texts. Although FitzGerald's first edition of *The Rubaiyat* had an unpromising initial reception, it was gradually taken up by the English-speaking literary world. But FitzGerald remained dissatisfied with his first efforts. He began to have access to other versions of the Persian originals, notably the work by the Frenchman Nicolas published in Paris in 1867.[22] In 1868, FitzGerald finalised a second edition containing 110 quatrains and, in 1872, a third edition, which was cut back to 101 quatrains. In 1879, there came the fourth edition; this again contained 101 quatrains, and it was published together with FitzGerald's version of Jami's *Salaman and Absal*.[23] In 1889, the very minor changes that created a fifth edition of 101 quatrains were included in a collection of letters and literary remains, published after FitzGerald's death; this final edition was reprinted separately at least twice in 1890.[24]

The existence of five different editions of the FitzGerald *Rubaiyat* has given rise to extensive commentaries and analyses of the variations between them, as well as evaluations by scholars of the best versions of the Persian originals, and the way in which FitzGerald combined various parts of the original verses in creating his poem. Notable in this field is the work of Heron-Allen, Batson and, later, Rodwell, Arberry, Dashti and Saidi.[25] The variations also greatly

5. *The scholars dispute (O. McCannell, 1953, quatrain 27).*

6. Publication of FitzGerald's Rubaiyat, some summary statistics, based on a total of 873 new editions and reprints identified as being published between 1859 and 2004. Source: authors' research (see Appendix 3).

complicate the analysis of illustrations, since the numbering of quatrains beyond the seventh quatrain differs between editions one, two and three to five; for example the well-known quatrain number 51 ('the moving finger...') in the first version becomes number 76 in the second version and number 71 in the third and subsequent editions. More information on the key differences in quatrain numbering and wording is given in Part 2 and Appendix 5.

The publishing history

Despite all the changes made by FitzGerald, his *Rubaiyat* slowly gained an enormous reputation and worldwide popularity. This is shown by its subsequent history of publication (see charts below and Appendices 1 and 3). A disclaimer is needed here with regard to our statistics. There is no comprehensive catalogue of *Rubaiyat* editions, so our analysis must be seen in the nature of work in progress. We have trawled far and wide for information, in book shops, libraries and among other collectors. And we have drawn on the work of earlier cataloguers, notably Potter.[26] We know what we have been able to find in terms of illustrators and publishers of *The Rubaiyat* so far. But we are sure that there are other versions out there, so far hidden from us. This applies particularly to editions published outside the UK, and in languages other than English.

Since 1859, altogether over four hundred publishers worldwide are known to have been involved with publishing FitzGerald's *Rubaiyat* in English. Over one hundred and thirty artists have worked on the book as illustrators, and at least fifteen more as page decorators. Between them, the publishers and illustrators have produced

Publication of FitzGerald's *Rubaiyat*

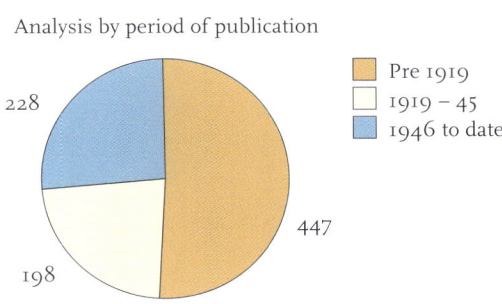

Analysis by period of publication

- Pre 1919
- 1919 – 45
- 1946 to date

228 / 198 / 447

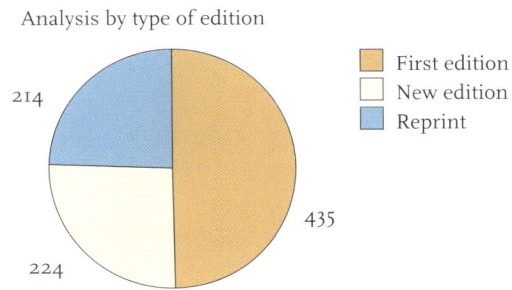

Analysis by type of edition

- First edition
- New edition
- Reprint

214 / 224 / 435

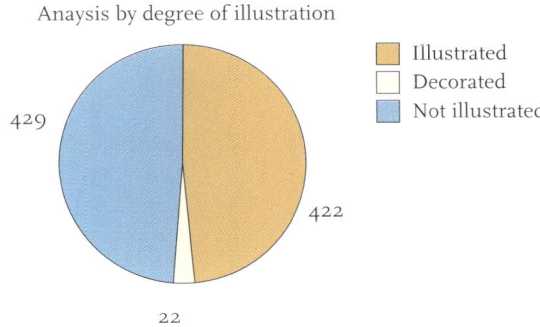

Anaysis by degree of illustration

- Illustrated
- Decorated
- Not illustrated

429 / 22 / 422

some six hundred and fifty different editions of this work, with many more reprints. By the end of the nineteenth century, some sixty different versions of *The Rubaiyat* in one of FitzGerald's interpretations had been published in the UK and the US; this excludes reprints. The first publication in the US was in 1870 in Columbus, Ohio, with a small private printing of FitzGerald's

second edition.[27] As the chart shows, the trickle of new *Rubaiyats* became a steady stream in the decades of the new century, peaking in 1909, the fiftieth anniversary of the first publication and the centenary of FitzGerald's birth, with almost forty new versions, including 11 identified reprints. From 1883 to date, there have been only a very few years, possibly none, when a new FitzGerald *Rubaiyat* did not appear.

New editions and reprints have formed an important part of *Rubaiyat* publishing. Examples are from Macmillan, who published no less than 50 different editions of FitzGerald's *Rubaiyat*, between 1899 and 1977, mostly in the same format, without illustration, and from George G. Harrap, who first published an edition illustrated by Willy Pogany in 1909, and subsequently reprinted it, in various formats, no less than 28 times between that date and 1979. In 1964, the American publisher Thomas Y. Crowell announced that they had published 80 editions since 1896.[28] Meanwhile, a version in Japanese, first published in 1949 by Otsuku Shinichi, had its fifty-seventh edition in 2000.

FitzGerald's *Rubaiyat* accounts for the majority of the editions of *The Rubaiyat* that have been published worldwide. Based on the editions and reprints that we have identified so far, we calculate that just about two thirds can be attributed to FitzGerald's versions of the work. But, since the end of the nineteenth century, a growing proportion of the *Rubaiyats* published have been by translators other than FitzGerald, in English as well as other languages. Whereas, in the period before 1919 FitzGerald accounted for over three quarters of all *Rubaiyats* published, in the period from 1945 this proportion has fallen to just over a half. A further three hundred and fifty publishers and nearly a hundred additional illustrators have been involved with this wider market.

Further evidence of the popularity of FitzGerald's *Rubaiyat* comes from the influence it has had on other creative artists. A particular feature of this is the large number of parodies that it provoked. Potter lists over two hundred of these in existence by 1928, ranging from *The Golfer's Rubaiyat* to *The Rubaiyat of a Persian Kitten*.[29] There has also been an extensive spin-off in various musical forms, including both the large-scale oratorio created by Granville Bantock early in the twentieth century and a set of songs by the famous Egyptian singer Oum Kalthoum.

What made for this success?

The widespread and continuing popularity of *The Rubaiyat* is due, in part, to FitzGerald's simple success in producing a well-written and enjoyable poem. The underlying philosophy of *The Rubaiyat* also appears to satisfy a continuing spiritual need. This was perhaps particularly true in the early years after the appearance of FitzGerald's work. By coincidence, Charles Darwin's provocative and disturbing book *The*

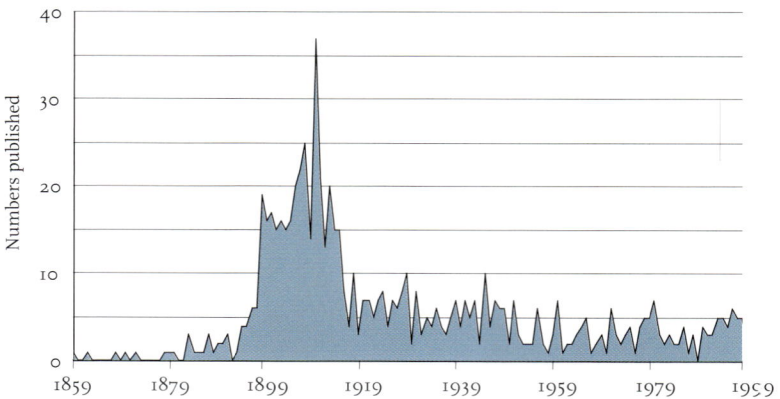

Publishing history of FitzGerald's *Rubaiyat*

7. Publishing history of FitzGerald's Rubaiyat: *number of new editions annually since 1859. Figures exclude editions for which date of publication is not known exactly. Source: authors' research (see Appendix 3).*

A UNIQUE PUBLISHING PHENOMENON | 9

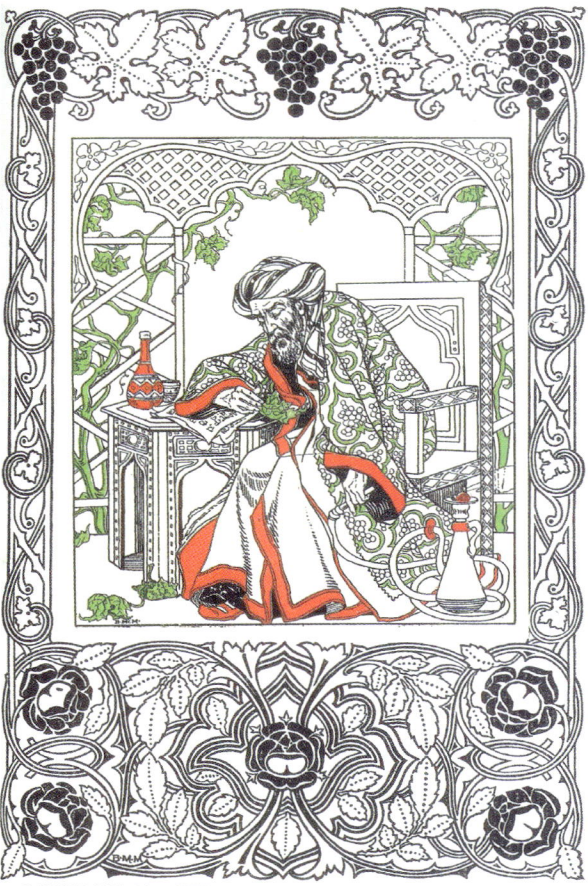

QUATRAIN No. XIV.

[left]
8. *The poet as philosopher*
(B. McManus, 1898, quatrain 14).

[right]
9. *The poet as illustrator (Edward Lear's* A Book of Nonsense, *1846).*

The extensive publication of illustrated versions of *The Rubaiyat* may also have contributed to its continuing popularity. Illustration is a unique feature of the work, which has no evident parallel. In the past, there had been novels, for example the various works of Dickens and children's books, as well as other classics, such as Lewis Carroll's Alice books, containing illustrations.[32] But for a book of poems any illustration was unusual and confined mainly to the work of poets who were also artists, for example William Blake or Edward Lear. It was especially unusual that a poem of the nature and length of FitzGerald's *Rubaiyat* should have attracted so many publishers so early on to bring illustration into their edition. In the case of *The Rubaiyat*, however, around two in five of all the editions and reprints identified have been illustrated. For FitzGerald versions, the figure is nearly half, while for other translators the proportion is around 30 per cent. This prompts a further question: why has *The Rubaiyat* uniquely been illustrated to this extent?

The prime explanation for the continuous publication of illustrated editions seems most likely to be the commercial instincts of publishers. They clearly recognised the opportunities created by the enduring

Origin of Species was published in 1859,[30] the same year as the first edition of FitzGerald's *Rubaiyat*. The publication, and widespread acceptance, of Darwin's book was a revolutionary challenge to aspects of the conventional Christian religious thought of the day. Edward FitzGerald's version of the quatrains of Omar Khayyam, with its somewhat fatalistic Epicurean philosophy and mysticism, may have provided some people with an alternative set of values or attitudes. John Stuart Mill's seminal work *On Liberty*, was also published in the same year, adding further to the debate about traditional values and thought.[31]

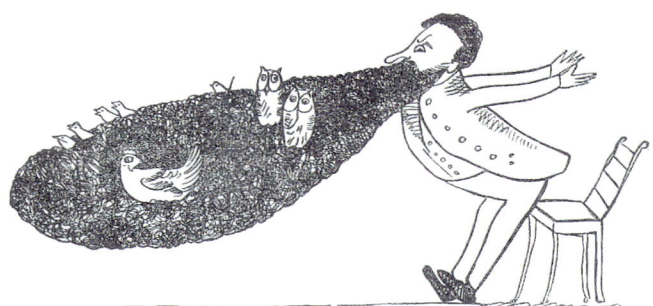

There was an Old Man with a beard,
Who said, 'It is just as I feared!—
Two Owls and a Hen, four Larks and a Wren,
Have all built their nests in my beard!'

popularity of the verses, both in their underlying sentiments and ideas, and in the way in which Edward FitzGerald, the poet, expressed them. Opportunities were also created by the developing interest that people in the West had in the Orient. At the same time, in the latter part of the nineteenth century, technical improvements in colour printing were encouraging publishers to make greater use of illustrations.

It is not surprising, therefore, that as the markets for books developed publishers started to look around for popular books to illustrate, print and distribute. Over the years, publishers and artists have continued to find new methods of presentation to interest buyers in the work and to 'illuminate' the underlying meanings of the various quatrains. Since the earliest editions, there has been a strong emphasis on producing high-quality gift and collectable editions of *The Rubaiyat*. The gift market for books had been developing at the end of the nineteenth century, as people became wealthier. Publishers were quick to see that books, suitably bound, illustrated or decorated, met a growing demand, either as occasional gifts, or for Christmas.[33] *The Rubaiyat*, along with other books of verse by popular poets,

10. A calendar for the year 1912 (published by Ernest Nister, London).

was seen as a typical subject for this market. Versions of *The Rubaiyat* were marketed either as parts of literary series or separately, for example as 'Flowers of Parnassus' or 'Miniatures Edition', or 'Xmas Greeting Edition', 'Christmas booklets' and 'Calendar Edition'. Such special editions were a particular feature of the first two decades of the twentieth century.

ILLUSTRATING *THE RUBAIYAT*

Trying to illuminate the text

Illustrating books is a subtle art form. On the one hand, there is a wish to match as closely as possible the illustration to the words. But, at the same time, the illustration should add to, illuminate, or 'light up' the words. For books of a descriptive nature, diagrams, maps and illustrations are an efficient way of highlighting facts and enhancing the text. But for books dealing with more ephemeral ideas, such as poetry or novels, illustrations have a much more ambiguous role.[34]

When the author and the illustrator are the same person, the illustrations can give a greater understanding of the author's intentions. But when the words and illustrations come from different people, the writer and the illustrator, there may be two interpretations, and where the illustrations and the words are put together by an editor or publisher, there is an even greater chance of a relatively loose connection between words and illustration. The gap in interpretations can become yet wider where there are differences of time and place between when and where the words were originally written, and when and where the illustrations were drawn. Illustrations for the Bible, Shakespeare or *The Rubaiyat*, in our time can only be the conjectures of the artist. Where words have been translated from other languages, but the illustrations have a different provenance, then even greater incongruities can appear. This book highlights many of these disparities.

11. A contrast between image and words (G. Ross, 1941, quatrain 3, which begins 'And, as the Cock crew, those who stood before/The Tavern shouted – "Open then the Door"').

History and changing techniques

Publication of FitzGerald's *Rubaiyat* came at a point of major evolution in the techniques of printing, and of creating illustrations. Illustration is not a modern phenomenon. Indeed, taking into account the cave drawings of early man, it can be argued that illustration long preceded the written word in the telling of tales. Both in the West and the East, books or manuscripts have been illustrated since their earliest production, sometimes primarily for decoration, at other times to show religious commitment.[35] In particular, in societies where illiteracy was fairly

general, illustration was a way of further communicating or illuminating the ideas contained in the written word, or perhaps for stimulating the imagination of someone who was telling the story to others. In earlier times, scribes, calligraphers and copyists would leave spaces in the texts for the illustrator to insert an appropriate painting or drawing.[36] In some societies, notably the Persian, this encouraged a great flourishing of the art of the miniaturist painter.[37]

The invention of the printing press, and the work of Gutenberg in Mainz and Caxton in England in the fifteenth century, meant that new ways of illustrating were available for multiple reproduction. In Europe, woodcuts were followed by the techniques of copper engraving and etching, and the use of stipple and mezzotint and wood engraving in later centuries. The nineteenth century saw the development of key new technologies for creating illustration, such as lithography and chromo-lithography and, by the end of that century, the earlier invention of photography had made its mark, with photogravure, as a primary form of book illustration, allowing a growing use of colour. At the same time, new technologies of printing, notably the use of linotype and monotype processes, massively enlarged the numbers of books being printed, meeting the growing appetite for books from a more affluent and better educated society.[38]

The growth of illustrated *Rubaiyats*

The early manuscript of *The Rubaiyat of Omar Khayyam* used by FitzGerald, the Ouseley manuscript mentioned earlier, contains only a modest amount of decoration. The claim to be the first illustrated version of Khayyam's verses lies with a manuscript in the original Persian, discovered in India,

12. Miniature by Bihzad, claimed as one of the first illustrations for The Rubaiyat of Omar Khayyam *(see text).*

dating from around 1500, and published in facsimile in Calcutta in 1939.[39] This includes a number of miniature paintings, including one attributed to the famous fifteenth-century Persian painter Bihzad. But it is not thought that these paintings were specifically made for Khayyam's work.

The first edition of FitzGerald's *Rubaiyat* had no illustration. This is also the case for the subsequent editions prepared by FitzGerald, though the fourth edition (1879)[40] did have a copy of a Persian drawing as a frontispiece. However, this edition of *The Rubaiyat* was published together with FitzGerald's translation of Jami's *Salaman and Absal*, and the illustration refers to the latter poem and not to *The Rubaiyat*, even though it fits, to some degree, quatrain 70 in this version ('The Ball no question makes of Ayes and Noes...').

Between 1859, the date of FitzGerald's first edition, and 1884, none of the *Rubaiyats*,

ILLUSTRATING *THE RUBAIYAT* | 13

[left]

13. Frontispiece from the fourth edition of FitzGerald's Rubaiyat *(see text).*

[right]

14. Cover of the first fully illustrated edition of FitzGerald's Rubaiyat *(E. Vedder 1884).*

Welcome, Prince of Horsemen, welcome
Ride a field, and strike the Ball.

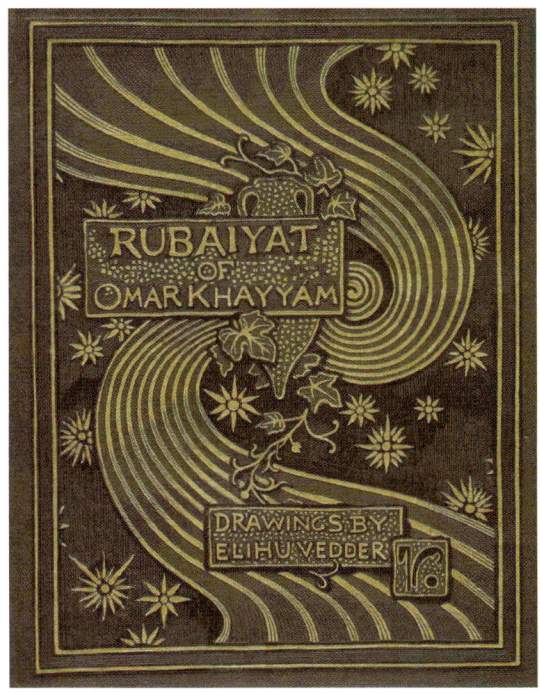

published by different translators, were illustrated. The first fully illustrated version of *The Rubaiyat* in the Western world was the one published by Houghton Mifflin in 1884 in Boston, with drawings by Elihu Vedder.[41] This edition, based on FitzGerald's third version, sold at $25 a copy, but also had a limited 'Edition de luxe' of 100 copies, at a price of $100 a copy; it is reported as having sold out six days after its debut in Boston. There were a number of reprints in following years.

It was the early part of the twentieth century that saw the flowering of illustrated editions of FitzGerald's *Rubaiyat*, reaching a peak of at least fifteen (including reprints) in the anniversary year of 1909 (see chart on p. 14). Illustrated editions of the verses continued to be issued in the next few years, and even during the First World War, often finding their way into soldiers' haversacks. There was a regular flow of new illustrated editions of *The Rubaiyat* in the twenties. With the depression of the thirties, there came a decline in the output of illustrated *Rubaiyats*, but publication continued through the Second World War, with an unexpected peak in 1940. In the period since 1945, there has been a steady year-on-year output of illustrated *Rubaiyats* worldwide, almost up to the present day. Over the whole of the twentieth century, there are only 12 individual years for which we have not identified any new issues of illustrated versions of FitzGerald's *Rubaiyat*. These include four years in the 1990s. At least four new editions have been issued in the twenty-first century.

Style and content of the illustrations

Over the hundred years or so since Vedder's first illustrations for FitzGerald's *Rubaiyat* appeared in 1884, there have been, not surprisingly, many changes in the style

and content of the illustrations. These have been due not only to changes in printing techniques already mentioned, particularly the introduction of mass colour printing, but also to the way in which publishers have sought to meet, and to exploit, changing public demand.

As will be seen in the next chapter, over the years the illustrations of *The Rubaiyat* have naturally reflected the innovations taking place in the world of art, as realism in painting gave way to the photograph, and led to the development of the more subjective schools of impressionism and expressionism, abstract art and postmodernism. However, these later influences have had a limited impact on book illustration, where the need for some realism in illustration seems to have remained paramount. More significant for the illustrators of *The Rubaiyat* were the developments with a strong design component, such as art nouveau and then art deco.

Another factor of growing importance to the content of the illustrations was the greater awareness, among illustrators and others, of what they saw as the 'real' Orient, distinct from the earlier myths and legends epitomised in the *Tales of the Arabian Nights* (or *The Thousand and One Nights*), first published in the West in the seventeenth century, and the fantasy world that these tales evoked. Greater knowledge came from the increasing amount of travel and research of academics and others, who, with their photographs, artefacts and pictures illustrating customs, dress and literature of the East, presented a seemingly more authentic point of view.[42] However, this approach has come to be heavily criticised as a form of 'orientalism', grounded in Western values and culture, rather than a true interpretation of the East.[43]

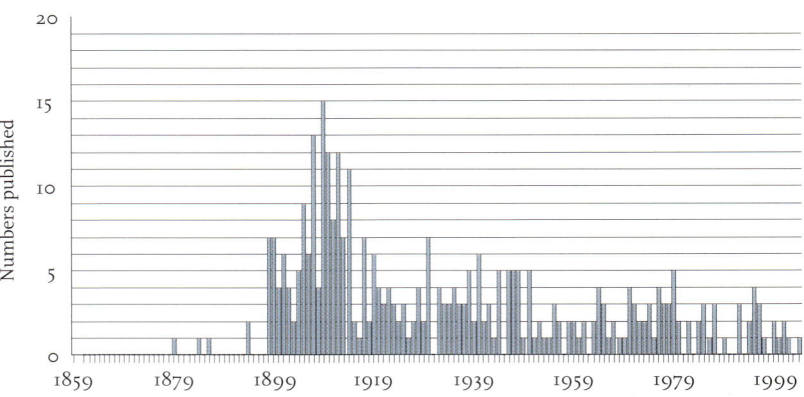

History of publication of illustrated editions of FitzGerald's *Rubaiyat*

Despite this interest in the Orient, many illustrations of *The Rubaiyat* remain resolutely Western in style. At the other end of the scale, some editions have used traditional Persian paintings as a basis for illustrations, while the more modern Iranian editions have used Iranian artists whose work shows the influence both of their Persian heritage and that of Western art. In our analysis, we have attempted to make a broad distinction in the style of illustrations of *The Rubaiyat* into three groupings, namely Western, orientalist, and Persian. Illustrations 16, 17 and 18 provide examples of this distinction, though we recognise that any such analysis has a strong element of value judgement in it.

Rubaiyat illustrations have been made from a wide variety of originals, including woodcuts and engravings, as well as paintings and drawings. Decoration has been a further feature of the editions of FitzGerald's *Rubaiyat*. In some cases, decoration is used to the exclusion of other forms of illustration. We have not included such work in the category of illustrated editions, but some details of the artists working as decorators of *The Rubaiyat* are given in Appendix 2. Equally, in fully

15. History of publication of illustrated editions of FitzGerald's Rubaiyat. *Figures exclude editions for which date of publication is not known exactly. Source: authors' research (see Appendix 3).*

ILLUSTRATING *THE RUBAIYAT* | 15

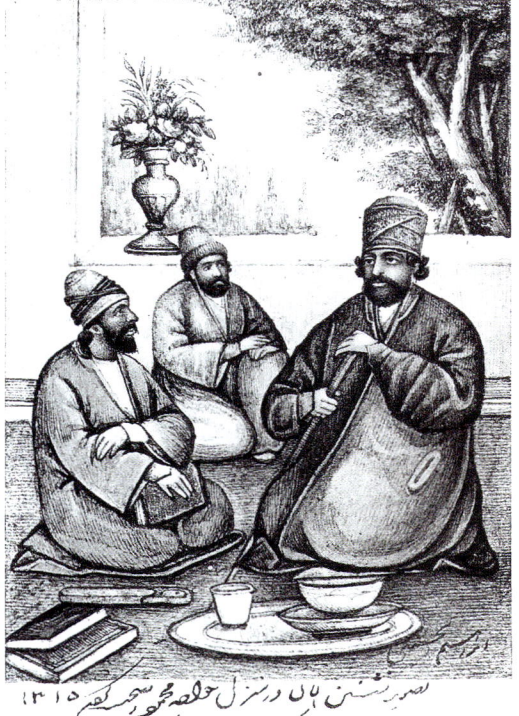

[top left]
16. A Western approach (A. Hanscom, 1905, quatrain 8 in the fourth edition).

[top right]
17. An orientalist approach (G. James, 1907 (second portfolio), quatrain 7).

[bottom left]
18. A Persian approach (Old Persian watercolour sketch in 1898 edition published by Henry T. Coates & Co, Philadelphia).

16 | ILLUSTRATING FITZGERALD'S *RUBAIYAT*

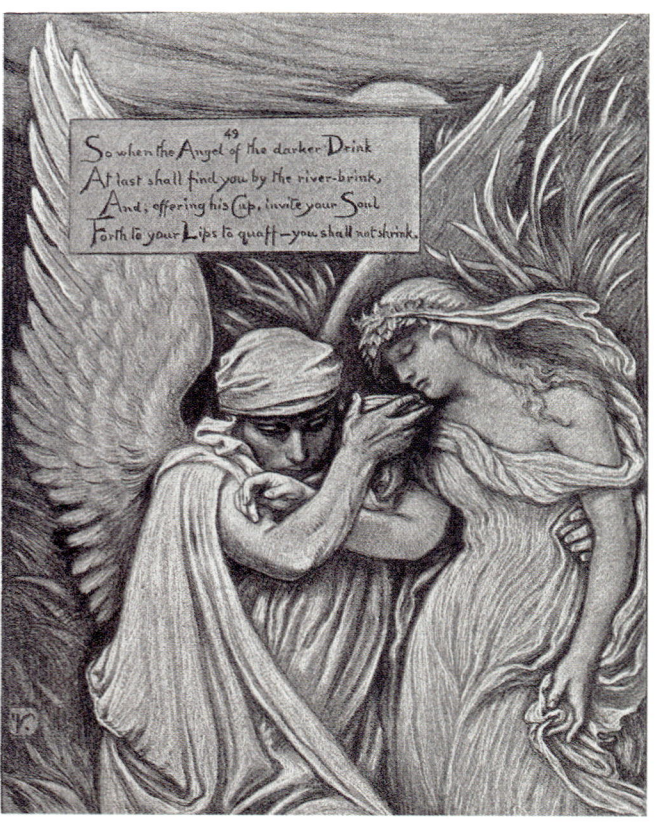
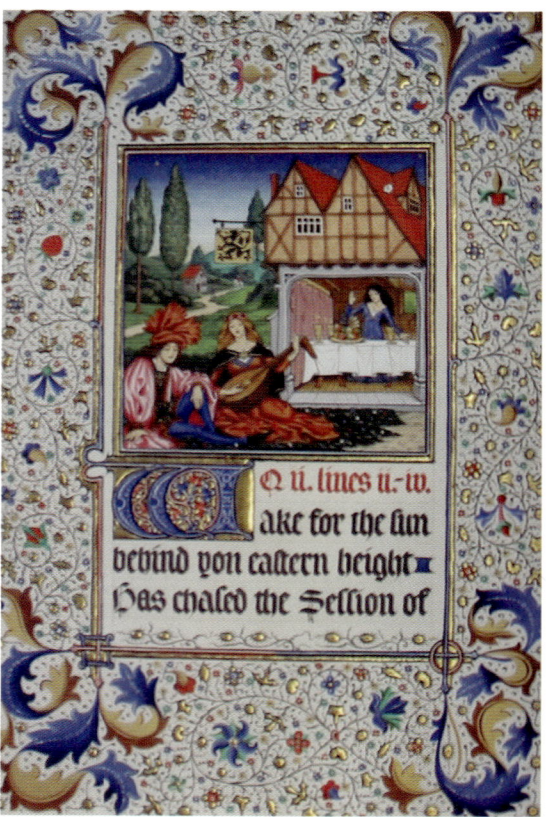

[left]
19. Incorporating the text in the illustration (E. Vedder, 1884, quatrain 43 in the third edition).

[right]
20. A modern illuminated manuscript (G.A. Pownall, 1919, quatrain 2).

illustrated editions, text and illustrations may both be incorporated within highly ornate borders. The work of E. Geddes and Helen Marie provides examples of this style from different periods. In some other versions, including the Vedder work, text and illustration are closely interwoven, somewhat in the manner of the mediaeval Persian miniaturists (illustration 19). Gilbert Pownall's unique work is a more modern example of this last approach, adapted to the style of the Western illuminated manuscript (illustration 20). But, the illustrations of many artists are shown entirely separately from the text, and it can be difficult to match some of them to any particular quatrain or line. We have called these 'unrelated' illustrations in our analysis

Illustration of the individual quatrains

This last point highlights some of the complexities involved in looking at the way in which *The Rubaiyat* has been illustrated. To clarify further, it helps to think about the actual process of creating illustrations for a poem like *The Rubaiyat*. After an artist has been commissioned for the task, one possible step is for the illustrator and/or editor to derive the subjects for an illustration by considering either quatrains as a whole, or one or more lines or words from a quatrain. In the verse, there might be a real subject, such as a scene or an action, or an abstract idea, like truth or death, to stimulate interest. From this may

21. Illustration of quatrain 1 text from the first edition (C. Robinson, 1910).

come the content of the illustration, while the skills and resources of the illustrator will provide the style. The illustrator's knowledge and understanding of the verses will affect the content of the image created, as well as the detail and authenticity of his interpretation, but in the end the visual imagination of the illustrator will be crucial. In some cases, the illustrator may produce only themed illustrations unrelated to specific quatrains, instead trying to give a pictorial sense of *The Rubaiyat* as a whole.

One problem faced by illustrators of *The Rubaiyat* is that, in Persian literature, a quatrain is generally accepted as being complete in itself, a form of epigram expressing a thought or idea. A quatrain should not normally have any relationship to other verses in the *rubaiyat*, and, in principle, individual lines, phrases or words in the quatrain are only components of the whole verse.[44] Thus, an illustration based on parts of the quatrain may only be partial in its attempts to 'illuminate' the meaning of a whole verse. In fact, FitzGerald himself seems to have ignored these principles, since he organised his version to provide something of 'a day in the life' of the poet;[45] his quatrains fall into sections with different themes, and there is a defined grouping of verses in the 'Kuza-Nama' ('Book of the Pots' – quatrains 59–66 in the first edition).

The difficulties involved in creating illustrations can be seen by looking, for example, at the first quatrain of FitzGerald's poem. In his first version of *The Rubaiyat*, this reads as follows:

*AWAKE! for Morning in the Bowl of Night
Has flung the Stone that puts the Stars to Flight
And Lo! the Hunter of the East has caught
The Sultan's Turret in a Noose of Light.*

What is the critical sentiment or idea here? Is it the first imperative word 'AWAKE', or is it the idea of dawn? What is the importance, if any, of the 'Sultan's Turret', or the idea behind 'flung the Stone' or the 'Noose of Light'? As is shown by illustrations 21–23, and others in Part 2 (pp.36–37), illustrators have chosen to interpret this key verse very differently.

For the analyst of the illustrations, further variation comes from FitzGerald's own changes to the verses. For example, in his second version, FitzGerald changed his first quatrain to read:

*Wake! For the Sun behind yon eastern height
Has chased the Session of the Stars from night;
And, to the field of Heav'n ascending, strikes
The Sultan's Turret with a shaft of Light.*

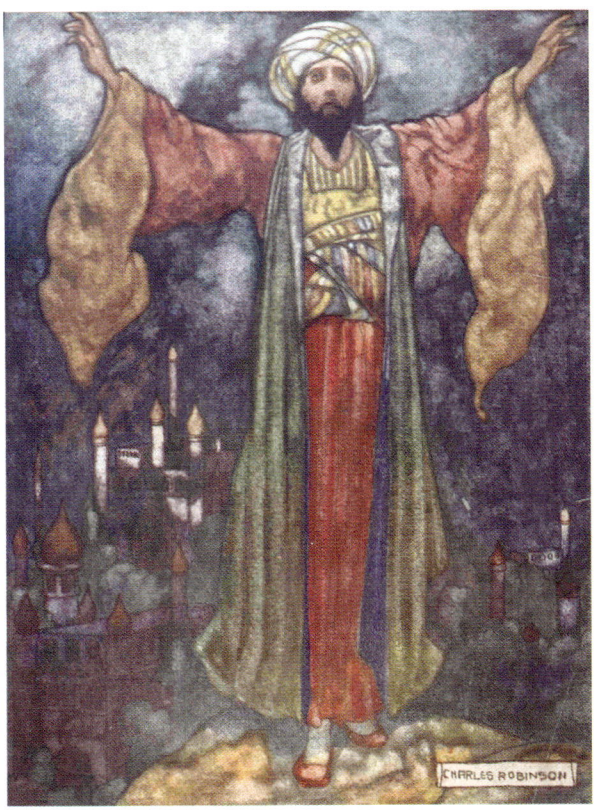

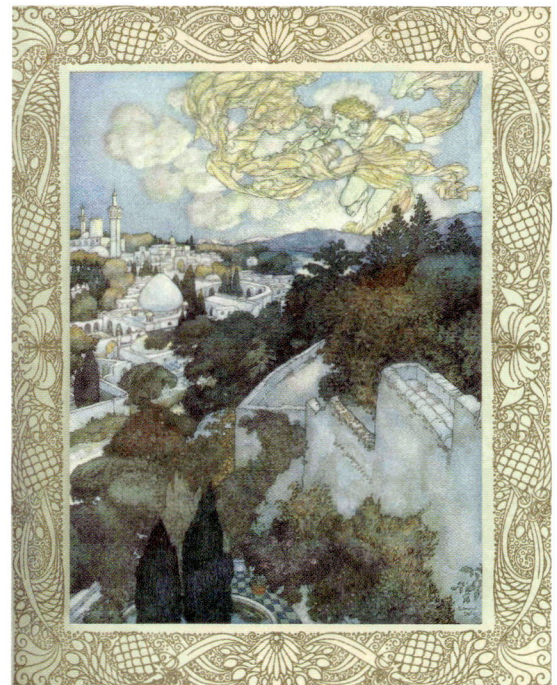

[left]
22. Illustration of quatrain 1 text from the second edition (E. Dulac, 1909).

[right]
23. Illustration of quatrain 1 text from the fifth edition (J. Hill, 1956).

The imagery of 'the Hunter' has disappeared and, in the three subsequent versions, FitzGerald changed the first two lines again to produce the following:

Wake! For the Sun before him into night
A Signal flung that put the Stars to flight.

Thus, in order to appreciate what an illustrator has been trying to do, it is a help not only to know the quatrain well, but also to be aware of which of the different FitzGerald versions the artist has been using. These aspects of the illustrations of *The Rubaiyat* are highlighted in the detailed analysis in Part 2.

A CENTURY OF CHANGE IN ILLUSTRATION

Three periods and many artists

In order to look in more detail at the changes in the way FitzGerald's *Rubaiyat* has been illustrated over the last 120 years, we have, somewhat arbitrarily, divided the period into three, as follows:

- from 1884 up to the end of the First World War in 1918 – the 'art nouveau' period;
- from 1919 up to the end of the Second World War in 1945 – the 'art deco' period;
- from 1946 to date – the 'modern' period.

In this chapter, we look more closely at the illustrators who were active in each period and the type of illustrations that they created. Further information on the illustrators and the edition of *The Rubaiyat* in which their work was first published is given in Appendices 1 and 2. Examples of the work of most of the illustrators can be found in the detailed analysis in Part 2. The overall index gives a guide to page references for each artist.

Our use of summary titles to describe the three periods does not mean that any of them is monolithic in terms of style or content of illustration. There is a variety of styles within each period, and, while many artists have only one or a very few editions of their illustrations, and fall clearly within one period, there are a number of artists whose work publishers have chosen to repeat, from the earliest to a later period. This includes the work of Gilbert James, first published in 1896–98 (see comment on p. 21, and illustration 27), which continued to be used at least up until 1978. Meanwhile, as mentioned above, the publishers Harrap and their successors have continued to use the earlier work of Willy Pogany (illustration 24) from 1909 up to 1979 and beyond. There is also a problem of precision with this historical analysis, in that many publishers fail to put dates of publication in their editions. For example, in the period up to 1918, we have found 26 editions or reprints for which precise dates cannot be established.

Pogany and James are two of the big names in the history of the illustration of

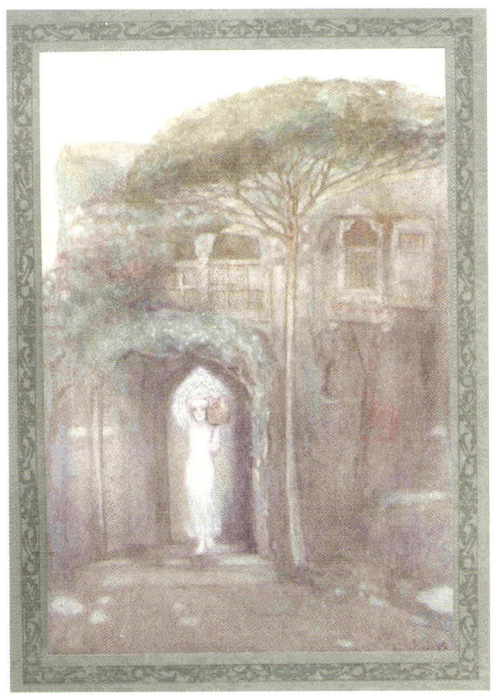

24. Quatrain 42 in Pogany's first portfolio (W. Pogany, 1909).

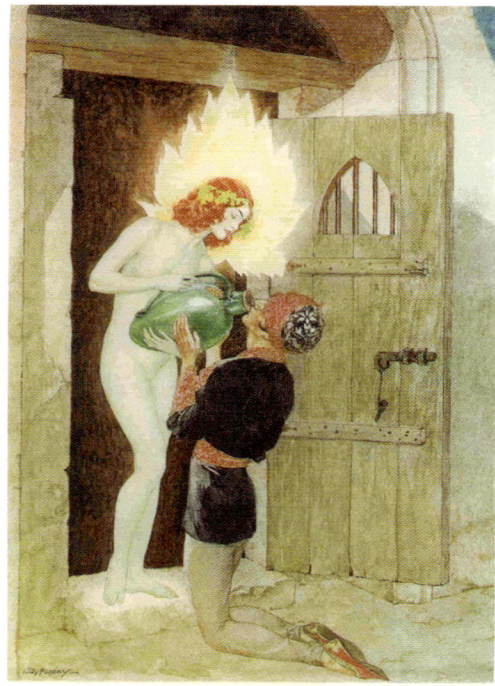

portfolio of illustrations for *The Rubaiyat*; Dulac also used his FitzGerald paintings to illuminate his own French translation, published in 1910. Dulac's illustrations, first published by Hodder & Stoughton in the anniversary year of 1909, have been reissued continually over the years, most recently, to our knowledge, in 1996.

One further general feature of the illustration of *The Rubaiyat* is that most of the artists concerned were specialists in book illustration. A key exception is the well-known Welsh artist Sir Frank Brangwyn.[47] He produced a first set of oil paintings, which were used in an edition of FitzGerald's *Rubaiyat* published by Gibbings in London in 1906. These illustrations were reprinted by Lipincott in the USA in 1909, and by other publishers later. Brangwyn also produced a slightly varied portfolio, which was published by Foulis in the UK

FitzGerald's *Rubaiyat*.[46] Both of them had more than ten different editions of their original work, plus many other reprints. They also both created more than one portfolio of illustrations for this work. James's later portfolios (see illustration 17), while distinct, were mostly variants of the original illustrations; his second and third sets of illustrations appeared relatively closely together, in 1907 and 1909 respectively, and not so long after the original work, created in 1896–98. In contrast, Pogany's two additional portfolios, first published in 1930 and 1942 respectively, are completely different interpretations, and were created much later than his first 1909 portfolio (compare illustrations 24, 25 and 26).

Other key illustrators who straddle the whole of the past century with their new editions and reprints are the two Edmunds, Dulac (illustration 22) and Sullivan (illustration 28). Both produced only one

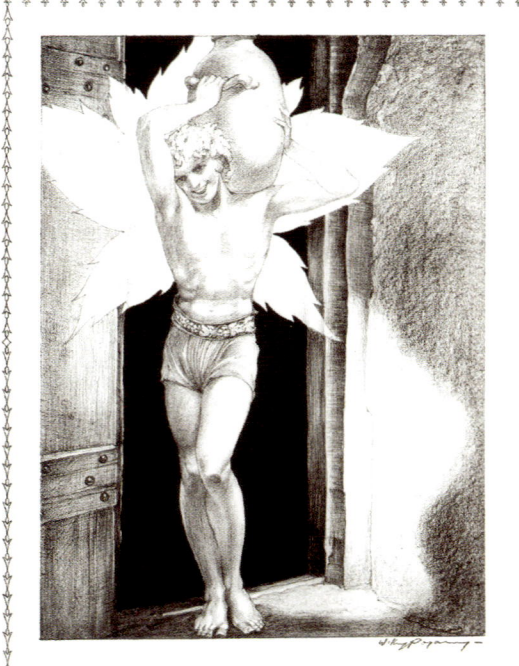

[top]
25. *Quatrain 42 in Pogany's second portfolio (W. Pogany, 1930).*

[bottom]
26. *Quatrain 42 in Pogany's third portfolio (W. Pogany, 1942).*

in 1910, and a year later in the USA, again by Lipincott (see quatrains 11 and 19 in Part 2). The absence of other big-name artists of the period among *Rubaiyat* illustrators is paralleled by the similar absence of some of the most widely known book illustrators. For example, as far as we can establish, neither Aubrey Beardsley nor Arthur Rackham appear to have ventured into the world of *Rubaiyat* illustration, although they both could have done so, and the latter was especially active in the period of peak publication of illustrated editions of this work. It is interesting to speculate about the interpretations either of them might have produced.

1884–1918
– the art nouveau period

When Houghton Mifflin commissioned Elihu Vedder to illustrate *The Rubaiyat*, they employed an artist with a rich sense of classical interpretation (illustration 19). Vedder spent 11 months in Rome fulfilling the commission, producing monochrome illustrations in a Greco-Roman style, which caused the London journal *Athenaeum* to describe Vedder as the latest follower of Michaelangelo. Nonetheless, the *Grove Art Online* encyclopedia comments on the Vedder drawings as 'some of the earliest examples of Art Nouveau in America'.[48] In the Vedder edition, the quatrains, from FitzGerald's third edition (1872), were slightly rearranged, and, in defiance of the idea of a quatrain being complete in itself, they were grouped mostly in twos, threes and fours for the purposes of Vedder's illustrations and his interpretations of the meanings of the verses. Houghton Mifflin reissued the Vedder *Rubaiyat* in different formats in 1886. New editions and reprints continued into the 1920s. A Vedder-based *Rubaiyat* calendar was published in 1995.

Eighteen ninety-eight was a momentous year for the publication of FitzGerald's *Rubaiyat*. The number of new editions, illustrated and not illustrated, jumped to at least nineteen in the year, after single-figure publications in the previous five years. The 1898 publications included seven new illustrated editions, the first since the Vedder versions. Two of these new publications contained old Persian miniatures, and three the work of Gilbert James, of which a selection was presented in two separate editions from L.C. Page of Boston in conjunction with some engravings by Edmund Garrett. One of Garrett's engravings was also published in a separate edition by the same publisher. The third edition with James's work appeared in London; it was a looseleaf version containing the first full set of 14 black-and-white drawings by this artist, but the text only of the quatrains illustrated (illustration 27). This James portfolio was originally published as separate drawings, mainly in the periodical *The Sketch*, between 1896 and 1898. The final illustrated edition published in 1898 was one illustrated by Blanche McManus (illustration 8).

Both the James and McManus portfolios were used again in new editions in 1899 and subsequent years. In total up to 1918, nearly twenty editions and reprints of James's different portfolios were published, divided between London and the main literary cities in the USA, through no fewer than ten publishers. They include coloured versions of the original black-and-white illustrations. The partially coloured line drawings of Blanche McManus, also first published in 1898, were rather less in demand in publication terms, with only 13 editions and reprints up to 1925, through four publishers, in London, New York and Boston.

With the turn of the century, the number of new artists and illustrations expanded rapidly. From 1898 to 1914, illustrated editions and reprints of FitzGerald's *Rubaiyat* averaged seven to eight each year in the UK and the USA together, rising to the peak of 15 identified in the anniversary year of 1909 (out of a total of 37 new versions) (see charts above). In 1910, the number of illustrated editions exceeded the number of unillustrated editions for the first time. From the time of Vedder's first *Rubaiyat* in 1884 up to 1919, over fifty individual illustrators were employed on this work.

The art nouveau illustrators and their style

Among the many illustrators of *The Rubaiyat* in this early period, not all would be categorised legitimately as art nouveau artists. Stylistically, in addition to the art nouveau work, there was a strong influence of Victorian realism in some of the illustrations. Given the use of engraving and other black-and-white illustrations by Vedder and others, it was fortunate that the growing popularity of *The Rubaiyat* coincided with the development of photogravure, which enabled these artists' interpretations to be reproduced more precisely, with greater contrasts, and a finer use of light and shade, stippling and pattern. After the 1890s, colour photogravure was being used, and this allowed the paintings of artists like Brangwyn and Pogany to be reproduced in the Edwardian period, and permitted the rash of editions of *The Rubaiyat* that were issued as coloured gift books.

The artists in this early period include quite a number who stand out for their endurance as popular illustrators. The continuing popularity of the work of Gilbert James, Willy Pogany and Edmund Dulac has already been highlighted. Dulac is often seen as the most successful illustrator of Omar Khayyam, though some people do not like his romantic approach. Rene Bull is another romantic art nouveau artist whose work has had a long period of popularity, starting in 1913, and with a reprint as late as 1995. A further successful and long-lasting illustrator, Edmund Sullivan, first published by Methuen in 1913, was still being reproduced in the 1970s. He appears to be the first artist to illustrate every one of the 75 quatrains of FitzGerald's first edition, which he did in an imaginative and somewhat humorous manner (illustration 28).

Also successful in publishing terms, though very different in approach, was Adelaide Hanscom in New York, who used colour photographs of men and women in different poses as illustrations (see,

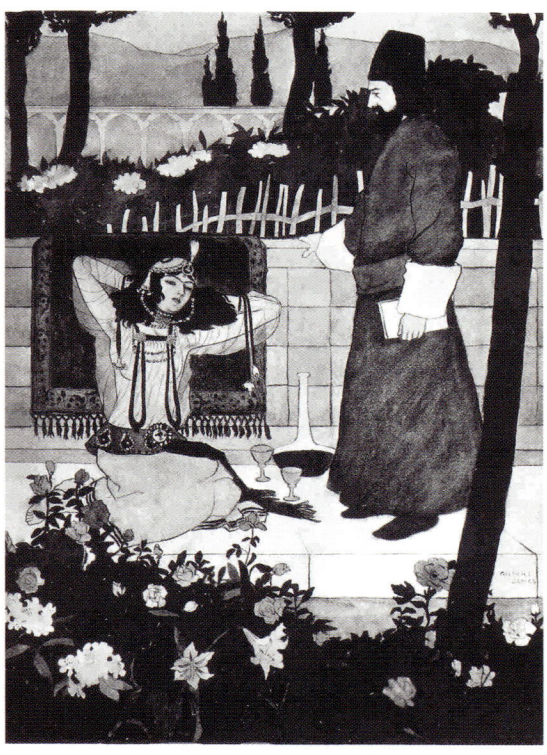

27. *One of the earliest illustrations (G. James, 1898, quatrain 13).*

A CENTURY OF CHANGE IN ILLUSTRATION | 23

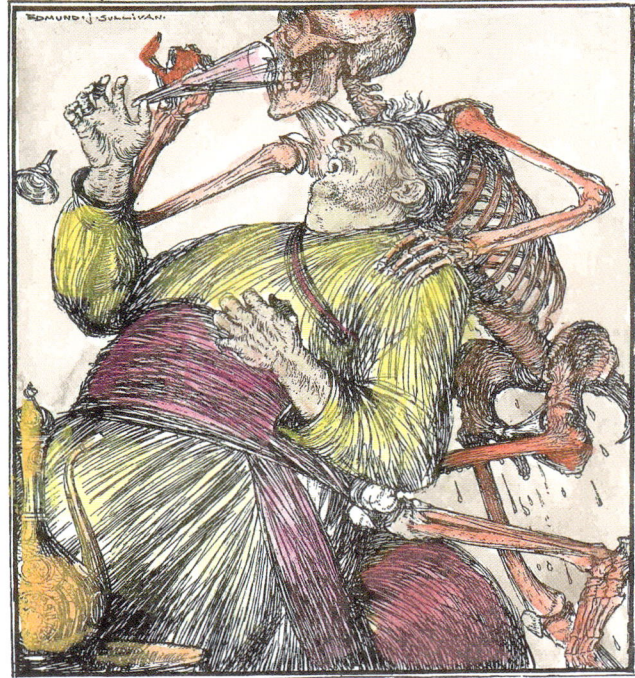

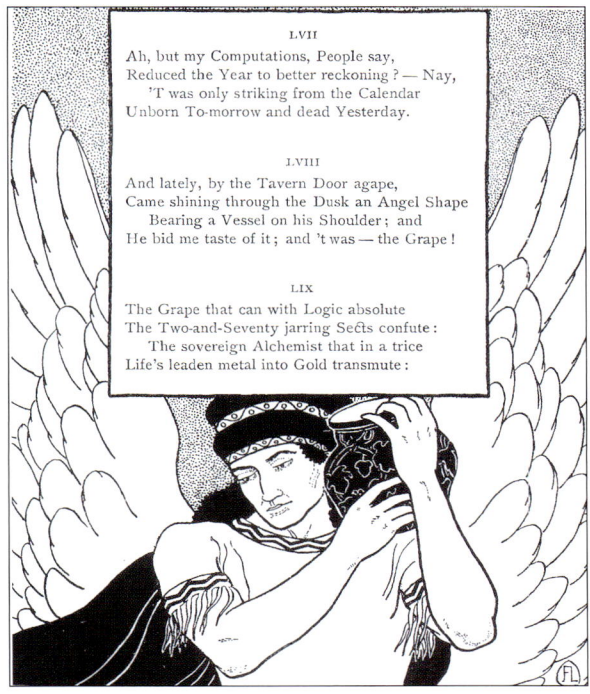

[left]
*28. Sullivan the humorist
(E.J. Sullivan, 1913, quatrain 35, from a hand-coloured edition).*

[right]
29. Lundborg's integration of words and picture (F. Lundborg, 1900, quatrain 58 in the fourth edition).

for example, illustration 16). She worked initially on her own, but later editions acknowledge the co-operation of Blanche Cumming. However, Hanscom's period of publication was limited to the 11 years from 1905. No other publisher seems to have used this technique of posed photography for illustration, but, in 1912, Kegan Paul Trench published a version of FitzGerald's *Rubaiyat* containing 38 pictures from photographs taken in Persia by Mabel Eardley-Wilmot. One other American edition of note was that published in 1900 by Doxey's of New York. This was illustrated by Florence Lundborg with line drawings of somewhat pre-Raphaelite characters. As shown in illustration 29, this work had a distinctive presentation, with the quatrains printed in groups of two or three inside the illustrations. The approach and the binding of the book resemble the earlier Vedder editions.

Some of the early illustrators, such as Gilbert James, had clear elements of the oriental in their presentations, and, during the first two decades of the new century, a more orientalist element crept into many illustrations; see, for example, the work of Marie Preaud Webb, Maurice Greiffenhagen, S.C. Vincent Jarvis and Isabel Hawxhurst Hall shown in Part 2. But it was not until 1910 that more realistic Eastern interpretations appeared, notably the illustrations of Abanindro Nath Tagore from India (illustration 30). Rene Bull, who was published first in 1913, had also travelled and studied in parts of the East, and his illustrations have a definite oriental feel to them (see p.109). In contrast, Mera K. Sett, an artist from Calcutta, produced a very idiosyncratic basically Western interpretation of *The Rubaiyat* while resident in England in 1914 (illustration 31). He was dubbed a follower of Aubrey Beardsley, partly because

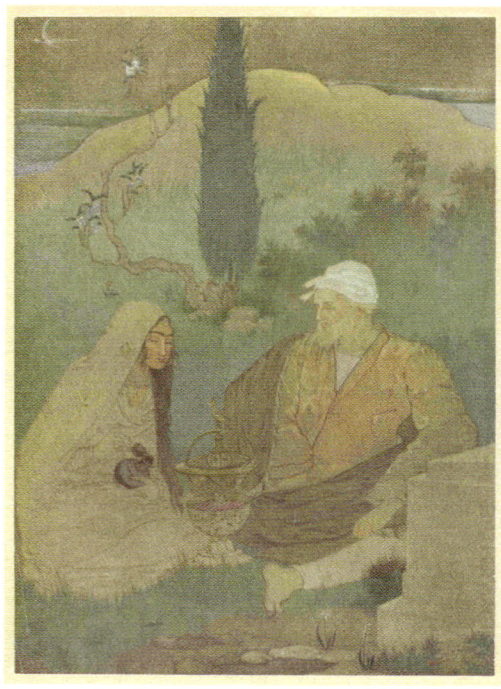
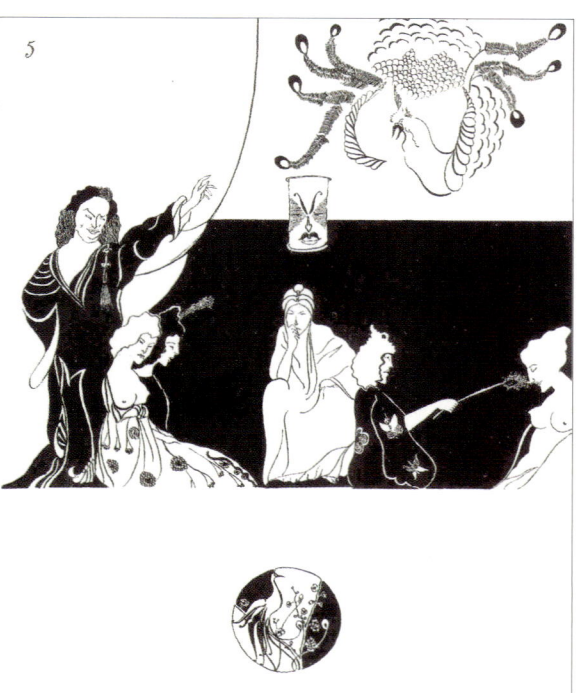

of his black-and-white drawings, but he claimed no allegiance and only a belated knowledge of Beardsley, who had died in 1898, some time before Sett had arrived in Europe. Beardsley's influence is more apparent in the work of some of the other illustrators of this period, for example Jessie King (see quatrain 75 in Part 2), and in the period following the First World War.

1919–1945 – the art deco period

In the years between the two world wars, new editions of FitzGerald's *Rubaiyat* continued to be published, but, as the charts above show, there were relatively fewer on average than in the earlier period. As we have seen, a few of the pre-war illustrators remained popular, especially Pogany's first portfolio, but fashions in illustration were changing and a new generation of illustrators was being employed. The vogue for art deco in the 1920s found expression in *Rubaiyat* illustration, with Anne Fish (illustration 32), Ronald Balfour (see p. 2) and Doris Palmer (see p. 32) exemplifying this fashion.

Many of the new illustrators, including Fish and Palmer, produced images that were essentially orientalist in style. John Buckland-Wright, working towards the end of the period, was also among this group (illustration 33). Others, including Balfour (see p. 87) and, later in the period, Willy Pogany in his third portfolio (illustration 26), remained clearly Western in their imagery. Gordon Ross produced a full set of 75 black-and-white illustrations, published in 1941, which have many parallels with Edmund Sullivan's earlier work (see illustration 11, and other examples in Part 2).

Impressionism and other developing movements in art generally seem to have had little impact on the style of individual

[left]
30. *An Indian interpretation*
(A.N. Tagore, 1910, quatrain 73).

[middle]
31. *Another Indian interpretation*
(M.K. Sett, 1914, quatrain 27).

[right]
32. *An early art deco approach*
(A.H. Fish, 1922, quatrain 72).

[left]
33. Orientalism in the 1930s (J. Buckland-Wright, 1938, unrelated to a specific quatrain).

[right]
34. A highly decorative view (A. Szyk, 1940, unrelated to a specific quatrain).

illustrators. In particular, with the apparent need for an element of meaning and realism in illustration, book illustrators of *The Rubaiyat* were, for the most part, not seriously affected by the extremes of abstract art in this middle period. Apart from the continuing publication of work by Dulac, James, Pogany and Sullivan, few illustrators in this period had more than one or two new editions, though some like Szyk, first published in 1940, were reprinted several times (illustration 34).

One feature of the years after 1919 was the widening global interest in Omar Khayyam. Edward FitzGerald's version was an important basis for translations into other languages, but overseas publishers also used English translators other than FitzGerald, such as Le Gallienne's and Rosen's English versions,[49] as well as direct interpretations in their own languages. There was also a growth in use of illustration in the non-English versions (see Appendix 3). In continental Europe, the Netherlands, France and Germany saw the most new editions of Khayyam's work in this period, but several other European countries also produced their own versions of *The Rubaiyat*. In the East, the principal countries with an interest in *Rubaiyat* production were Iran, India and Turkey, while, in the rest of the world, there were new editions in South America, notably in Argentina, and versions were published in this period in Japan, Mexico and Australia.

1946 to date – the modern period

Although the overall frequency of publication of FitzGerald's *Rubaiyat* has declined further in the years following the Second World War, there has been, nevertheless, a continuing but irregular stream of between one and three new illustrated editions in most years. These have included the work of another generation of illustrators, but none have achieved the lasting prominence of the earlier illustrators like Dulac, James, Pogany and Sullivan.

There have also been new editions published in Iran, especially prior to the 1979 Revolution, to meet the growing tourist market and the demand of international pilgrims to Omar Khayyam's tomb at Nishapur (see illustration 35). Such editions frequently have the text (usually but not always FitzGerald's) translated into a variety of languages, as well as a Persian version. Eight is the largest number of languages that we have so far found in one edition.

In terms of style, there have not been any clear directions of development in this period. An element of realism has generally been retained, with many illustrators attempting to reflect the contents of individual quatrains. In the editions outside Iran, there has been some simplification

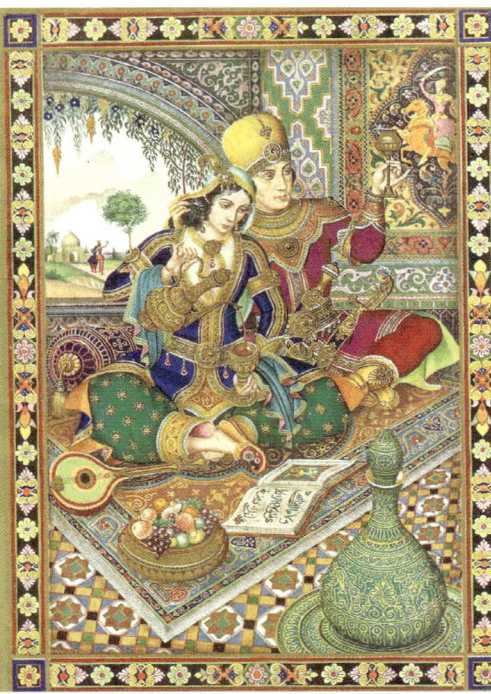

26 | ILLUSTRATING FITZGERALD'S *RUBAIYAT*

of line; the work of Jeanyee Wong and Jeff Hill provides examples of this (see, for example, illustration 23). The majority of the new illustrators might be called broadly orientalist in style, including Robert Sherriffs (see quatrain 1 in Part 2) and Joseph Low (see quatrain 15) in the early post-war years and Lynette Hemmant (see quatrain 19). But, more recently, there has been something of a revival in the use of

35. An Iranian image of Khayyam's tomb (H. Shakiba, 1999, unrelated to a specific quatrain, but based on the actual tomb of Khayyam in Nishapur).

36. *An abstract view (S. Morris, 1970, attributed to quatrain 24).*

broadly Western imagery, by for example Vera Bock, Susan Allix and K. Belsey. One feature has been the introduction of an element of abstraction and symbolism, as demonstrated by Steven Morris in a limited edition by the Black Knight Press (illustration 36). Such private presses have been evident among the recent publishers; an example is Nicholas Parry's publication with his own illustrations at the Tern Press in 1996 (see illustration 40). And several publishing houses specialising in the collectors' market have produced new editions, including the Folio Society in the UK and the Peter Pauper Press with several different illustrators in the USA (see Appendix 1 for details).

Another aspect of the illustrated *Rubaiyats* produced in this period has been the number of Eastern artists, especially from Iran, who have been employed as illustrators for new editions. One artist of note is Sarkis Katchadourian, an Iranian, later based in the USA, whose illustrations were published in New York and Tehran in 1946 (see quatrain 41 in Part 2). Others were Hossein Behzad Miniatur, whose *Rubaiyat* was reprinted in Tehran several times from 1972, Mahmoud Sayah, who was also based in New York, and Akhbar Tajvidi, whose rather explicit illustrations were widely used in various foreign-language versions of *The Rubaiyat* produced in Iran before the 1979 Revolution (see Part 2 for examples of their work). More recently, Hojat Shakiba has become a popular illustrator of *The Rubaiyat* in Iran, serving both the renewed tourist market and the demand from Iranian collectors (see illustration 35).

The wider global interest in the quatrains of Omar Khayyam has continued in recent years, with new issues of *The Rubaiyat* being published in a variety of European countries and languages, as well as in English-speaking countries like South Africa, Canada and New Zealand, and in the Middle East and South America. Again, many of these editions are based on FitzGerald's English versions, though there are also a number of new translations from the original Persian. There has also been a revival of interest in editions presenting the Persian text in ornate calligraphy. These include some of the Iranian editions, and a major edition from publishers Souffles; the latter contains illustrations by the photographer Shahrokh Golestan, and has been published in two versions based on new translations into French and English.[50]

A note on eroticism and interpretation

There has been much discussion as to whether the wording of the verses of Khayyam and FitzGerald should be taken at their face value or given a religious, possibly Sufi, interpretation.[51] A particular issue is whether the frequent mention of wine and the beloved should be taken as having a spiritual rather than a realistic meaning. Some publishers and illustrators have taken the spiritual approach, notably in the edition published by the Self Realisation Fellowship of Los Angeles in 1994, although

37. An explicit view of the text (J.Y. Bateman, 1958, unrelated to a specific quatrain).

the illustrations by Helen Marie et al. are generally quite realistic (see, for example, quatrain 28 in Part 2). Other illustrators have taken a very literal view of the words.

At the extreme end of realism, over the whole of the period since 1884 there have been publishers and illustrators who have introduced a strong component of nudity and mild eroticism in their *Rubaiyats*. This is the case even though there is little or nothing about sexuality in any of FitzGerald's versions of *The Rubaiyat*, or in the underlying Persian quatrains attributed to Omar Khayyam. FitzGerald, in a very few of his verses, uses the word love, while, in the underlying verses of Khayyam, there is reference to the 'houris [maidens] in paradise' and to the idea of 'a happy opportunity with a moon faced one'.

A cynical view would be that publishers and illustrators have chosen to interpret quatrains in this explicit manner to encourage the popularity of their editions. Whatever the reason, notable examples of such interpretations include, in the early years, some of the work of George Tobin, Edmund Garrett and Edmund Sullivan, and, in our middle period, Willy Pogany's third portfolio (see illustration 26). More recently, John Yunge Bateman (illustration 37) and Eugene Karlin have followed this interpretative approach to some degree, as have some of the modern Iranian editions published in the pre-revolutionary period.[52] (See Part 2 for more details of these artists' work).

STILL POPULAR – AT HOME AND ABROAD

[left]
38. A new illustrator for the twenty-first century (A. Peno, 2001, quatrain 18).

[right]
39. Recycling some earlier work (M. Chugtai, 2001, unrelated to a specific quatrain).

Versions of *The Rubaiyat* continue to be published regularly, but not as frequently as a century ago. New publications include reprints of earlier versions, both illustrated and not, speculative new editions with new illustrators or using older paintings (see illustrations 38 and 39), and, occasionally, special versions from private presses. There is an active collectors' market, both for illustrated and unillustrated versions, in the UK and overseas. Versions in other languages are also still being published from time to time, for example in the Netherlands, France, Germany and Russia recently. In Iran there is an active reproduction market for tourists, generally in multi-language form and profusely decorated or illustrated; Shakiba's work, mentioned above, is an example.

Although the heyday of Edward FitzGerald's version of *The Rubaiyat of Omar Khayyam* may have passed, the verses continue to have resonance in today's world. At the same time, academic and popular interest in Omar Khayyam's quatrains remains significant, reflecting the quality and substance of the verses themselves, as well as of FitzGerald's versions.[53] The

year 2009 will be especially important for *The Rubaiyat of Omar Khayyam* and Edward FitzGerald. It is the two-hundredth anniversary of the latter's birth, and the one hundred and fiftieth anniversary of the publication of his *Rubaiyat*. It is to be hoped that, as the anniversary approaches, renewed recognition will be given to this unique book of verse, reflecting both the longevity and breadth of its popularity and, in our view, the continued relevance of its underlying philosophy to the modern world.

40. A recent private-press edition (N. Parry, 1996, unrelated to a specific quatrain).

PART 2

Illustrating individual quatrains

PRESENTING THE QUATRAINS

Aim of the presentation

In this part of the book, we present in more detail the very wide range of illustrations that have been created for each quatrain of FitzGerald's *Rubaiyat*. There are separate sections for each of the 75 quatrains in FitzGerald's first edition. The aim of this presentation is twofold. The first is to show the work of the different artists who have illustrated *The Rubaiyat* over the past 120 years. The second is to analyse the nature of the interpretation that artists have given to FitzGerald's and Khayyam's verses, and, by doing so, to give some insights into the approaches to, and problems of, illustrating this type of work.

Layout used

The layout adopted for each quatrain is as follows. The text of the first edition is given, followed by a short analysis of the sources of the verse in the various manuscripts attributed to Khayyam, and of changes made by FitzGerald in subsequent editions, and a comment on the underlying theme and meaning of the quatrain. Here we have drawn extensively on the work of earlier commentators, notably Heron-Allen, Batson and Arberry:[1] more information is given in the table in Appendix 5. In some places, we quote from Heron-Allen's literal translation of the Persian original, in order to highlight the changes that FitzGerald made in creating his poem.

There is then a summary analysis of the extent and nature of the illustrations for the quatrain. This is based on our detailed analysis of the illustrated editions of FitzGerald's *Rubaiyat*; more results of this are presented in Appendix 3. Finally, some examples of the work of selected artists are given. Here, we draw attention to specific aspects of each of the illustrations shown, including our assessment of the nature of the interpretation that the artist has chosen for the verse. This comment is not intended to be a critique of the illustrator's work. Rather, it provides a personal reaction to what the artist has presented, and focuses on what seems to us to be of interest in the particular illustrations.[2]

Selection of illustrations

It has not been possible to show anything like all the illustrations that exist for *The Rubaiyat*. The number of illustrators varies greatly between quatrains; the most popular quatrain has over fifty different illustrators identified, while for the least popular quatrain we have identified only four illustrated editions (see Appendix 3). In selecting the artists to reproduce for each verse, we have attempted both to provide a reasonable view of how the individual quatrain has been illustrated and to ensure that, over the whole 75 quatrains, we show a representative selection of those artists to whose work we are able to have access. In the text, we have also referred to the work of

[opposite]

D.M. Palmer, 1921. *(Quatrain 20 in the first edition).*
Ah, my Beloved, fill the Cup that clears
TO-DAY of past Regrets and future
Fears –
To-morrow? – Why, To-morrow I
may be,
Myself with Yesterday's Sev'n
Thousand Years.

other artists who have illustrated a particular quatrain, in order to give a wider flavour of the illustrations that exist. In referencing the illustrations shown, we have given the date of the first publication of the artist's work for *The Rubaiyat*. This is not always the source we have used for reproduction; details of the precise sources are given in Appendix 2.

In total, in Part 2, we have shown illustrations of 86 out of the 135 artists whom we have identified as working on *The Rubaiyat*. There are others that would ideally have been added to the total, but we believe that those shown provide a rounded view of the art of *The Rubaiyat* over this period. Appendices 1 and 2 give more details on the artists and their work.

Later editions and unrelated illustrations

Two special sections follow the detail on quatrains 1–75 of the first edition. The first of these deals with the illustration of the quatrains which FitzGerald added to subsequent editions of his *Rubaiyat*. As we discuss on p. 159, these extra verses have generally been less illustrated than those contained in the first edition, but there is some interesting work by various artists. In the second special section, we deal with the illustrations that we have not been able to relate to specific quatrains. As we commented in Part 1, in quite a number of editions of *The Rubaiyat*, it is very difficult to tell whether the illustration has any reference to a particular quatrain.[3] This final section covers the work of a number of artists who have not been represented elsewhere in the book.

The Astronomer-Poet – a modern Iranian image (A. Jamalipur, 1996).

The beginning of illustration for FitzGerald's Rubaiyat *(E. Vedder, 1884, quatrain 54 in the third edition).*

*AWAKE! for Morning in the Bowl of Night
Has flung the Stone that puts the Stars to Flight:
And Lo! the Hunter of the East has caught
The Sultan's Turret in a Noose of Light.*

QUATRAIN 1

Perhaps naturally, this first verse has been very popular with illustrators. With almost fifty interpretations, it ranks second behind quatrain 11, the most popular of all. FitzGerald chose this verse of Khayyam's to start the poet's day, and his interpretation of the quatrain is close, in sense, to the Calcutta manuscript he used. He gave some useful concrete subjects to the illustrator, such as the dawn, the stone and the stars, the Sultan's turret and the noose of light, and most illustrators have focused on these identifiable elements in the verse. Some interpreters of the verse see a spiritual dimension in the various items,[4] with the awakening being that of the soul coming out of the darkness of ignorance to the light of wisdom, but this is only incidentally reflected in the images used.

Most illustrators have chosen either the theme of people awakening, or buildings showing the change from night to day. A few of the more adventurous, like the Sherriffs version opposite, have combined the themes. Stylistically, artists have frequently elected for an orientalist approach. But, in the earliest period, prior to the First World War, there were several examples of illustrations in a Western mode, with figures in Western dress; such artists include Vedder (1884) and Cole (1901), as well as Geddes, whose work is illustrated above. (See also illustrations 21–23 in Part 1.)

E. Geddes, 1910. *Geddes's illustration is an example of the art nouveau style of the early twentieth century, with the use of highly decorated borders and initial letters, as well as painting. It is difficult to identify the geographical origin of the two figures. The white girl on the left appears to be throwing roses to put the stars to flight, as dawn reveals a muezzin's tower in the distance.*

[top]
A. Rado, 1940. *Behind Rado's attractive Eastern roofscape, there is an enigmatic angel-like figure with arms outstretched. This could be the soul coming out of the darkness of ignorance.*

[left]
R.S. Sherriffs, 1947. *This is a lively symbolic interpretation of the quatrain, with the hunter lassoing the distant spire. The relevance of the flying leopard is uncertain, except perhaps as the hunter's prey, from which he is temporarily distracted.*

[right]
J. Isom, 1967. *Although produced in the 1960s, Isom's imaginative representation of the hunter and the Sultan's tower is very much in the earlier art deco style, with an echo of the work of the Austrian painter Klimt.*

*Dreaming when Dawn's Left Hand was in the Sky
I heard a Voice within the Tavern cry,
'Awake, my Little ones, and fill the Cup
Before Life's Liquor in its Cup be dry.'*

QUATRAIN 2

The theme of dawn and awakening continues in this second quatrain, with a first mention of the tavern and the cup, images that continually recur in FitzGerald's *Rubaiyat* and its illustrations. The idea of drinking at dawn may seem somewhat extreme to us, but it has been said that the fore-dawn glass of wine to the toper was like the fore-dawn prayer to the devout.[5] FitzGerald's verse is quite close in interpretation to the comparable quatrain of Khayyam, but he

[left]
W. Pogany, 1909. *This comes from Pogany's first, most popular and long-lived portfolio of illustrations for* The Rubaiyat. *He has chosen to show a dissolute group lying in front of the temple-like tavern door, with an angelic figure coming out with a goblet of wine.*

[right]
W. Pogany, 1930. *Pogany's second portfolio of illustrations for* The Rubaiyat *has a notably cleaner line than the first set, and he picked up different themes from the quatrains. He focuses this time on the awakening at dawn, though the wine jar next to the sleeping lover suggests some earlier filling of the cup.*

[left]
G. Ross, 1941. *Ross provided small black-and-white engravings in a basically Western style for every one of the 75 quatrains in FitzGerald's first edition. Here he simply presents a jovial, Father Christmas-like toper greeting the dawn, which is shown in the form of a cock.*

[right]
A.N. Tagore, 1910. *Although earlier than the second Pogany illustration, Tagore's work has a more modern feel to it, with its seated figures delineated by simple blocks of colour. The image suggests something of the pessimism in FitzGerald's fourth line, with the sense that 'Life's Liquor in its Cup be dry'.*

made considerable changes in his second and subsequent editions. In particular, he changed the last two lines to: 'When all the Temple is prepared within,/Why lags [nods] the drowsy Worshipper outside?'.

This quatrain has not been a popular verse for illustrators, especially in the period before the First World War, and a more than average number of the illustrations are Western in style. The images shown here by Pogany and Tagore are exceptions to this. The artists who have chosen to illustrate the quatrain have mostly focused either on the dreaming and awakening theme, or on the filling of the cup.

And, as the Cock crew, those who stood before
The Tavern shouted – 'Open then the Door!
You know how little while we have to stay,
And, once departed, may return no more.'

QUATRAIN 3

This quatrain repeats the key themes of the previous two. FitzGerald based the verse on several quatrains from the original manuscripts that dealt with the drinking of wine at dawn – 'it is the dawn! Softly, softly drink wine,' as Heron-Allen elegantly expresses it. Sufic interpretations would identify symbolism in the major subjects of 'Cock', 'Tavern' and 'Door' as wisdom, life and inner silence.[6] The last two lines of the quatrain include the first mention

AND, AS THE COCK CREW, THOSE WHO STOOD BEFORE THE TAVERN SHOUTED—" OPEN THEN THE DOOR !"
B

[left]
R.A. Bell 1902. *In one of only four illustrations that he made for FitzGerald's* Rubaiyat, *Bell also focuses on the obvious imagery, with his figures at the tavern door. His black-and-white pictures seem old-fashioned against other full colour images of the same period (see, for example, Brangwyn's work for quatrain 11), and, out of context, the illustration could be interpreted as showing customers entering a mediaeval Western tavern.*

[right]
M.K. Sett, 1914. *Sett offers a distinctive style of black-and-white line drawing, often compared with Beardsley.[7] Sett has flouted convention, in the West in his period as well as in oriental terms, by depicting a sole woman wishing to enter the tavern.*

[opposite left]
E.S. Hardy, 1907. *Hardy's interpretation is very straightforward, expressing the obvious meaning of the verse with people anxious to enter the tavern door, and little feeling for any mystical undertones. The style is essentially Western realistic, with only the headgear of the lead man betraying any oriental context.*

[right]
O. McCannell, 1953. *This is a much later version than the others shown, and seems richer in character. The dress of the visitors is clearly oriental, and the whole image has more of a feel of urgency to it. Unusually, the crowing cock has also been included.*

of the brevity of life, which is another recurring theme throughout *The Rubaiyat*.

The quatrain has attracted an above average number of illustrators, with the tavern door as the main focus of attention. Stylistically, the interpretations have been evenly spread between an oriental presentation and a fully Western one. The popularity of the verse among illustrators continued throughout the twentieth century, with later artists like Gordon Ross (1941), Popoff (1948), Gorter (1989) and Peno (2001) choosing to illustrate this verse, as well as McCannell, whose work is shown below.

Now the New Year reviving old Desires,
The thoughtful Soul to Solitude retires,
Where the WHITE HAND OF MOSES on the Bough
Puts out, and Jesus from the Ground suspires.

QUATRAIN 4

This somewhat obscure verse was based on two quatrains from the Ouseley manuscript. The Persian new year comes at the time of the spring solstice, when plants and trees start to blossom and flowers appear from the soil. The biblical imagery is taken from Khayyam's original. The white hand of Moses refers to an earlier legend: when God told Moses to put his hand into his

[left]
B. McManus, 1898. *Blanche McManus seems to be illustrating the thoughtful soul of the second line. Her contemplative man looks out over the wide landscape towards a distant town. The whole design is both oriental in character and typical of the art nouveau style, with its highly decorated border.*

[right]
N... (name not known), 1907. *In his only illustration for* The Rubaiyat, *this anonymous artist has also gone for the contemplative aspect of the quatrain. But, instead of being in a spring scene, the man is surrounded by bunches of grapes as he pours out a cup of wine. The style of the drawing harks back to an earlier period.*

QUATRAIN No. IV.

"THE THOUGHTFUL SOUL TO SOLITUDE RETIRES."

[left]
E. Vedder, 1884. *As usual, Vedder covers several quatrains in his illustration, and incorporates the text in the picture. His style is essentially classical.*[8] *He has elected for an arboreal scene, including a young foal (a sign of spring?), together with an urn and a contemplative man in the background.*

[right]
E.J. Sullivan, 1913. *Although Sullivan's originals are black-and-white engravings, his style feels freer and more modern than either Vedder or the anonymous artist of 1907. Sullivan has opted to present the reviving of old desires as he shows a young girl clearly enjoying the joie-de-vivre. The illustration reproduced here comes from a hand-coloured copy of the book.*

bosom, it came out 'leprous as snow', that is as white as snow, like the early blossom on the bough. The image of Jesus suspiring from the ground is based on the idea that, for Muslims, Jesus was the 'Breath of God' because his breath had healing powers.[9]

Despite the difficulty of interpretation, the verse has been reasonably often illustrated, generally in an oriental mode. Some illustrators have pictured the idea of contemplation, especially those in the earlier period, including Tobin (1899) and Geddes (1910), as well as McManus and the unknown artist from 1907 shown here. But most have gone for illustrating spring, with young maidens and white blossom. There is little sign of the obvious biblical images.

*Iram indeed is gone with all its Rose,
And Jamshyd's Sev'n-ring'd Cup where no one knows;
But still the Vine her ancient Ruby yields,
And still a Garden by the Water blows.*

QUATRAIN 5

None of the expert analysts have been able to find any Khayyam quatrain in the manuscripts which matches, in detail, the content of FitzGerald's verse. There are references in the original to Jamshyd, a legendary Iranian king, but not to a seven-ringed cup. The 'Ruby' in the 'Vine' and the 'Garden by the Water' are also mentioned, but not Iram, the fabled garden city, believed to be under the sands of Arabia.

Despite quite strong imagery in the verse, it has been selected by relatively few illustrators. The idea of the garden is the most popular image for illustration, usually with a man and a woman. Unusually, Sullivan (1913) opts to show a jovial drinker.

*And David's Lips are lock't; but in divine
High piping Pehlevi, with 'Wine! Wine! Wine!
Red Wine!' – the Nightingale cries to the Rose
That yellow Cheek of her's to incarnadine.*

[opposite left]
R. Bull, 1913. *Bull's paintings have a more florid and romantic feel about them. The depiction of the irises in the foreground is very realistic, and, in his illustration, we have, unusually, an image of Iram with its gardens in the distance.*

[opposite right]
G. James, 1898. *This illustration come from the first of James's three portfolios prepared for* The Rubaiyat. *He has elected for a straightforward composition using the garden as the basis, complete with vines and grapes and roses. The style is relatively spare and unromantic for the period at the turn of the twentieth century. The original version was in black-and-white.*

[left]
H. Behzad Miniatur, 1970. *Behzad Miniatur, an artist of Persian origin, chose the classical picture of a Persian garden, in which to include the nightingale(s) and the roses. There is a jug of wine shown. But it seems unlikely that the man in the picture is supposed to represent David.*

[right]
L. Hemmant, 1979. *Lynette Hemmant has taken a very straightforward approach to this verse, with the nightingale and the roses shown in great detail in a fairly traditional Western style. But, contrary to the sense of the verse, the roses are already incarnadine!*

QUATRAIN 6

This is another obscure verse of FitzGerald's, where he has used, in his last two lines, the last two lines of a quatrain from Khayyam in the Ouseley manuscript. But he has created an entirely different beginning from that in the manuscript, which talks about the weather and how the rain washes the dust from the faces of the roses. It is not known where FitzGerald got his inspiration for this variation. There is no reference to David in Khayyam manuscripts, though he occurs quite often in other Persian literature.[10] 'Pehlevi' refers to the old Persian language, more commonly transcribed as 'Pahlavi'.

Only 11 illustrators have elected to illuminate this quatrain, most of them in the period after the Second World War. They have generally selected the obvious themes of the nightingale and the rose for their illustrations.

Come, fill the Cup, and in the Fire of Spring
The Winter Garment of Repentance fling:
The Bird of Time has but a little way
To fly – and Lo! the Bird is on the Wing.

QUATRAIN 7

Here, FitzGerald has once again combined the sentiments of two of Khayyam's quatrains for his verse. The theme that time is flying is repeated with the new imagery of the 'Bird of Time', coupled with the joy of spring renewed, which overrides the idea of repentance. The spiritually minded see the 'Fire of Spring' as spiritual enthusiasm and 'Repentance' as that which follows indulgence in life. The 'Bird of Time' is life and 'on the wing' is the idea that this life is running away without purpose.

This has been one of the more popular verses for illustrators, chosen by nearly thirty on our list, especially by artists in the earlier period, including major names such as Brangwyn (1910), James (1907/1909; see illustration 17 in Part I) and Bull (1913). Our selection here shows some less well-know illustrators. There are obvious subjects for them to use, notably filling the cup, spring, repentance and the bird on the wing. The first line has been the most commonly represented in practice, followed by the bird on the wing. In a few cases, these ideas have been combined.

R. Balfour, 1920. *Balfour has provided an attractive example of art deco design, reminiscent of other artists of the period like Bakst and Erte. But the imagery seems to owe little to the quatrain, except a small bird on the hand of the maiden. Her sad face and the bereft naked figure in the background could symbolise repentance and coming loss of life.*

[top left]
N. Parry, 1996. *This modern woodcut appears to focus on the idea of repentance, with a bird flying away in the background. But it is hard to fathom the significance of the statue, or the apparently sleeping couple in the foreground. Certainly there is no sense of the joy of spring felt in the first line of the quatrain.*

[bottom left]
G.A. Sheehan, 1912. *Also from the early period, this black-and-white drawing provides a fairly conventional presentation of drinker and wine bearer, again showing the cup and birds. There is a suggestion of the Orient in the clothing, and the budding tree indicates the timing of spring.*

[right]
B. McManus, 1898. *Blanche McManus is one of the illustrators to have combined the two ideas of cup and bird. But the wine is being squeezed directly from the grape (in Spring?), by a somewhat strange saki (wine bearer), with wings like an angel. The picture is highly stylised, unusually in two colours only, with extensively decorated borders.*

*And look – a thousand Blossoms with the Day
Woke – and a thousand scatter'd into Clay:
And this first Summer Month that brings the Rose
Shall take Jamshyd and Kaikobad away.*

QUATRAIN 8

In this verse, FitzGerald used several quatrains from two separate manuscripts. In the second and subsequent versions of *The Rubaiyat*, this became quatrain 9, and FitzGerald changed some of the wording. But the essential theme of the flowering and dying of the blossoms and roses remained. The reference to Jamshyd and Kaikobad, from the royal dynasties of ancient Persia, does appear in one of the manuscript quatrains. The verse suggests again the impermanence of life, even for those of high rank. This is a theme that recurs in later quatrains (for example numbers 16 and 17).

Not very many illustrators have taken up the challenge of representing Jamshyd and Kaikobad, though two illustrators of Persian origin, Behzad Miniatur (1970) and Akhbar Tajvidi (1955) explicitly depict the scattering of blossoms as people flying away in the sky. Most illustrators of this verse have presented broadly Western-style images of blossoms, roses and other flowers, but in a wide range of interpretations; compare, for example, the work of Palmer and Peno shown here.

[opposite]
F. Lundborg, 1900. *Florence Lundborg, one of the earliest illustrators of FitzGerald's* Rubaiyat, *has settled for two maidens, one with a chain of rose buds. The style is that of art nouveau, and Lundborg follows Vedder in incorporating the text (of fourth edition) into the design of the picture.*

[left]
A. Peno, 2001. *This very recent interpretation by Peno has produced an imaginative symbolic illustration. The meaning is not very clear, but the two women could be seen as among the blossoms woken with the day, stretching out to those who came before, now 'scatter'd into Clay'. The style is uncompromisingly Western.*

[top right]
W.G. Easton, 1910. *Easton's highly complex engravings have a somewhat Victorian feel to them. They are enclosed in equally ornate borders. He has focused on the idea of a garden in full bloom to illustrate the positive side of the thousand blossoms highlighted in the quatrain.*

[bottom right]
D.M. Palmer, 1921. *Doris Palmer has adopted a florid art deco style to give the sense of many flowers. But the person in the middle of the illustration with a white stick is something of a mystery. His stance, gazing at the city in the far distance, has some suggestion of the loss of those who have been taken away.*

And look—a thousand blossoms with the Day Woke—

But come with old Khayyam, and leave the Lot
Of Kaikobad and Kaikhosru forgot:
Let Rustum lay about him as he will,
Or Hatim Tai cry Supper – heed them not.

QUATRAIN 9

FitzGerald continues in this verse to follow Khayyam's use of the imagery of the characters from Persian mythology to add colour to his theme. It is thought that FitzGerald adapted this verse from up to three of Khayyam's quatrains taken from two distinct manuscripts. His interpretation seems rather loose, emphasising the general rejection of fame and fortune in this life. Although FitzGerald retained the general sentiment and the names of the kings and heroes used in the original quatrains, he changed words in each of his four main versions.

No more than eight illustrators have chosen to illustrate this verse, perhaps reflecting a difficulty among Western artists in knowing enough about the people whose names are mentioned, and the deeds referred to. Some, like Stirling (see below) and Balfour (1920), present a generalised image of a hero or king, while others, including Gordon Ross (1941) as well as Greiffenhagen (left) focus on a Khayyam-like representation.

[left]
M. Greiffenhagen, 1909. *Greiffenhagen takes a highly decorated approach, typical of the art nouveau work in the early part of the twentieth century. He focuses on presenting a view of the 'old Khayyam' who is to be followed, complete with white beard, book and flask of wine.*

[right]
W.G. Stirling, 1932. *Stirling has taken a much more simple approach, with his black-and-white drawing. He is probably representing Rustam, the great warrior of Persian mythology, though in the manner of an oriental strong man, rather than the armed and behorsed hero of Ferdowsi's Shah-Nama.*

With me along some Strip of Herbage strown
That just divides the desert from the sown,
Where name of Slave and Sultan scarce is known,
And pity Sultan Mahmud on his Throne.

QUATRAIN 10

This verse is related to the one that follows and is mainly based on two very similar quatrains from the Ouseley manuscript. It appears to act as a preface, introducing the theme of a place of bliss and the idea of simplicity as a basis for happiness. The original verses only refer to a sultan, and the specific name of Sultan Mahmud, who reigned in Ghazna (now in Afghanistan) around 1000 CE, was FitzGerald's introduction.

In contrast to the great popularity of the next quatrain, this verse has received limited attention from illustrators. We have identified only 11 artists who used it, with few in the pre-First World War period. A number present a couple in an outside scene, as in the two shown. But other representations focus on a single unhappy-looking figure, presumably Sultan Mahmud, sometimes but not always on his throne.

[left]
E.J. Sullivan 1913. *Sullivan's engraving has a simple, bucolic feel to it, with little noticeably oriental except the pointed hat and shoes of the male figure. The pointed hat recurs frequently in this artist's illustrations of each of the 75 quatrains. The reproduction is again from a hand-coloured copy of the artist's work.*

[right]
R.G.T. (name not known), 1940s. *This more modern illustration from a New Zealand publisher has the feel of an old sepia photograph, though it is actually a painting. The artist may also be a New Zealander, and the natural background has something of the non-European about it. The naked woman has no basis in the quatrain, and may simply reflect a desire to increase sales.*[11]

Here with a Loaf of Bread beneath the Bough,
A Flask of Wine, a Book of Verse – and Thou
Beside me singing in the Wilderness –
And Wilderness is Paradise enow.

QUATRAIN 11

This is the best-known verse of FitzGerald's *Rubaiyat* and has attracted the greatest number of illustrators; we have identified 56 so far. Although FitzGerald retained the last two lines virtually unaltered in all of his four versions, from his third version he reversed the order of the three ingredients, 'Loaf of Bread', 'Flask of Wine' and 'Book of Verse'. Most artists include

F. Brangwyn, 1910. *This oil painting is part of Brangwyn's second portfolio of illustrations for* The Rubaiyat. *Typically of the artist, the image is dark and rather obscure in its background, but with strong colour contrast in the foreground images of the man and the woman.*

all three possible subjects, but some leave out the bread, while others include a musical instrument for the singer.

Illustrators have used a wide range of scenarios and styles in which to present the obvious imagery of the quatrain. The wilderness is mostly just a generalised outdoor scene with a tree (the bough), but one or two artists, notably Karr in 1938, give a greater sense of isolation. The 'Thou/Beside me' of the verse is generally depicted as a woman beside a man, although it has been suggested that 'Thou' could be a nightingale,[12] while a more mystical interpretation would see 'Thou' as a manifestation of God. Unusually, Vedder (1884) and Sherriffs (1947) show a woman on her own, and Sherriffs also includes a bird.

[top]
A.E. Jackson, 1911. *Jackson has a well balanced, rather conventional illustration, with all the ingredients of the verse. The feel is slightly oriental, but the girl looks rather Western in her dress. The illustration forms the end papers of an edition of* The Rubaiyat *issued as a calendar for 1912.*

[bottom left]
G.T. Tobin, 1899. *In this early black-and-white lithograph, Tobin has set the scene in a wooded wilderness and has given the singer a harp or lute. The style appears deliberately rather impressionistic and the effect is of an old-fashioned, very Western interpretation.*

[bottom right]
C. Stewart, 1955. *Stewart presents a much closer physical contact between the man and woman than many other artists. The composition and pose are clearly in the style of Persian miniatures, though the colouring and lack of background detail gives a modern feel.*

'How sweet is mortal Sovranty!' – think some:
Others – 'How blest the Paradise to come!'
Ah, take the Cash in hand and waive the Rest;
Oh, the brave Music of a distant Drum!

QUATRAIN 12

This verse is based upon at least two quatrains in the manuscripts that are similar in content and meaning; there are three others on which FitzGerald may possibly have drawn. Two related themes are highlighted, though the meaning of the second half is somewhat obscure. In the first two lines, the idea is clearly that some enjoy their lives here today, while others think more of 'Paradise to come'. In the second part of the quatrain, there is a sense that one should be satisfied with the cash one has; in Khayyam's originals, 'Cash in hand' is preferred to credits. But it is not clear whether the 'brave Music of a *distant* Drum' is something to seek or to be avoided.

For the illustrator, each line presents a different opportunity, notably the idea of longing for the future or enjoying the reality of having cash. Comparatively few artists have selected this verse, and, for quite a number of them, the idea of the distant drum has suggested a military element, with an oriental image of men on horseback, banners and spears.

G. James, 1898/1909. *James used one version of this illustration in his first portfolio for FitzGerald's* Rubaiyat, *originally published at the end of the nineteenth century, and another in his third portfolio of 1909, reproduced here. He puts a strong emphasis on the military image, with a very realistic depiction of an army dominating the space. It seems that the figure in the foreground is ignoring the call of the drum and concentrating on the book and his own thoughts.*

[top]
G. Ross, 1941. *In his drawing, Ross has elected to put an oriental army in the background. But the enjoyment of the day forms the main part of his picture. The man and woman shown are typical of the characters represented in Ross's many illustrations for* The Rubaiyat.

[bottom left]
A. Tajvidi, 1955. *In this illustration, Tajvidi has also emphasised enjoyment with a very typical Persian-style image of a man drinking wine, with a woman under a tree in blossom. The drum appears to be sounding far away in the distance. Typically for this artist, the painting is enclosed in an ornate border.*

[bottom right]
H. Behzad Miniatur, 1970. *Behzad Miniatur's very unusual dark picture is difficult to decipher. There is a strong image of a person drinking wine in the foreground and possibly some other figures below. The manic stance of the drinker, and the barren tree and rocks, suggest that the enjoyment of the present is not proving a very satisfactory experience.*

*Look to the Rose that blows about us – 'Lo,
Laughing,' she says, 'into the World I blow:
At once the silken Tassel of my Purse
Tear, and its Treasure on the Garden throw.'*

QUATRAIN 13

In this quatrain, FitzGerald's version is very close to the original manuscript verse. He retained it for his four versions with only minor changes in the words. The source is one of the quatrains which does not appears in the Ouseley manuscript, only in the Calcutta one. For many illustrators, it presents a fairly simple theme of light-heartedness, with concrete images of the rose, the purse and the garden. The underlying theme seems to be the recurring one of birth, death and rebirth.

Published interpretations mostly show one or two people outside in a garden. Presentations have ranged from an exuberance of colour and pattern, as in Dulac (see opposite) and Fish (1922), to simple designs like those of Lundborg (1900) and Hill (1956). Both the latter artists are unusual in focusing very strongly on the rose. Gordon Ross (1941) also does this, but shows a very aged man, highlighting the underlying theme of decay in the verse. In contrast to many other quatrains, this verse was more popular among artists in the inter-war period than at other times, with a greater emphasis on Western style.

A.N. Tagore, 1910. *This is a subdued interpretation of the verse, with the rose strongly in the main ground. The figures are painted in an Eastern style, but there is little background detail. The sense that the man is plucking the petals of the rose he holds fits with the instruction in the verse to tear the silken tassel.*

[left]
J. Hill, 1956. *Hill's simple line and design throws all the emphasis on the rose itself. It is as though the man has just heard the instructions in the verse and is contemplating the future destruction of the beautiful object. The decorative border on the left is unusually not a frame but an integral part of the design.*

[top right]
E. Dulac, 1909. *Dulac has produced a delightful floral illustration, in typically art nouveau style. The picture is contained within a fine decorative border. Roses are in full bloom, but the rather pensive girl may reflect the underlying impermanence of the season.*

[bottom right]
W. Pogany, 1942. *This black-and-white drawing comes from Pogany's third portfolio of illustrations for* The Rubaiyat. *The style and content are radically different from the artist's earlier work.[13] For this verse, Pogany has created a charming personification of the rose, dancing as her petals blow into the world.*

*The Worldly Hope men set their Hearts upon
Turns Ashes – or it prospers; and anon,
Like Snow upon the Desert's dusty Face
Lighting a little Hour or two – is gone.*

QUATRAIN 14

FitzGerald here stayed close to the meaning of the quatrain in the original manuscript attributed to Khayyam. The theme is again that of impermanence of existence in this world, even when things seem to prosper for the time being, The metaphor of snow in the desert, expressing the briefness of life, is the only concrete image for the artist to draw on.

The verse has been more popular with illustrators after the Second World War, perhaps reflecting their particular understanding of its message. Some artists have a focus on the idea of resignation in the first two lines, for example Marie et al (1994) and Behzad Miniatur (1970), who both show a man alone in what seems like the desert. Others show a view of the worldly life, like Mohammad Tajvidi, left. Sullivan (1913) has a particularly graphic view of two old men dicing, with the figure of a death's head sitting at their side.

[left]
M. Tajvidi, 1959. *Tajvidi appears to have opted to depict worldly hopes, showing an image of a man and a woman, enjoying life while they may. The pose is one found frequently in his work and in older Persian paintings. It was also picked up by other modern Western artists (see Stewart for quatrain 11). The underlying pessimism of the quatrain is left to the mind of the beholder.*

[right]
J. Laudermilk, 1925. *In this black-and-white print, Laudermilk focuses on the first line of the quatrain. Unusually for an artist of this period, both the text and the borders are an integral part of the picture. The imagery is essentially oriental in style, with the arabesques of the border reflected in the branch of the tree showing through the window.*

And those who husbanded the Golden Grain,
And those who flung it to the Winds like Rain,
Alike to no such aureate Earth are turn'd
As, buried once, Men want dug up again.

[left]
H. Marie et al., 1994. *This highly ornate modern illustration is part of a publication giving a spiritual interpretation of* The Rubaiyat *for today. The imagery is a combination of an other-worldly and a literal view of ploughing, sowing and reaping. The woman in the foreground has gathered a sheaf of wheat from the rather insubstantial earth.*

[right]
J. Low, 1947. *In his prints, Low has literally presented the two activities of sowing and reaping to illustrate the verse. The actions are taking place simultaneously, carried out by two men in Low's typical, oriental, almost Chinese, style. The picture is contained within a large, double spread, frame, which includes the text of three quatrains.*

QUATRAIN 15

This is another somewhat obscure quatrain, both in the original and in FitzGerald's interpretation. The idea of 'aureate Earth', buried and dug up again, is believed to refer to the custom of villagers burying their gold or other treasure for fear of robbers attacking and looting their homes. Perhaps the underlying meaning is that, regardless of whether in life you are a saver or a spendthrift, when you die and are buried, you become clay again, not gold.

It has not been a particularly popular verse for illustrators, though it is more common among artists in the post-Second World War period. Most of those who selected it have taken a literal view of the sense of the verse, with an image of harvesting or broadcasting grain. Unusually, Gordon Ross (1941) presents an old accountant and a death head figure weighing up the balance of debits and credits of life in a ledger. Sullivan (1913) is even stranger, with a grave purporting to be that of Adam and Eve, with a memorial erected 'in loving memory by their son Cain'.

*Think, in this batter'd Caravanserai
Whose Doorways are alternate Night and Day,
How Sultan after Sultan with his Pomp
Abode his Hour or two, and went his way.*

QUATRAIN 16

With this quatrain FitzGerald has kept close to the original, especially in the first two lines. Underlying the obvious imagery, there is a more profound interpretation that the caravanserai is the world, while night and day are birth and death, and life on earth is short in the eternal shape of things. This is a frequently recurring theme in Khayyam's verse and FitzGerald's presentation of it.

Although the verse has been a popular one to illustrate, both in orientalist and in Western style, most illustrators have ignored the underlying meaning. They have generally focused on the idea of sultans enjoying life while they are alive. In some cases, such as Fish (see opposite), Pogany (1909) and Cole (1901), there is a sense that the enjoyment has come to an end.

A. Hanscom, 1905. *Adelaide Hanscom has included in her illustration the idea of night and day in the doorways, and the elderly sultan in the centre going towards night. Hanscom's work, done together with Blanche Cumming, is based on photography of men and women, placed in specific poses for the illustrations.*

[opposite top left]
N. Ault, 1904. *The style here is art nouveau, with the text and illustration enclosed in an elaborate border of scrolls and curls. The sultan and his escort of bare-breasted girls are observed by a large crowd of courtiers in the background of the picture.*

[opposite bottom left]
A.H. Fish, 1922. *This slightly confusing illustration by Anne Fish depicts the idea of a procession of sultans disappearing into the distance. The art deco style is expressed in a rich contrast of colours.*

[opposite right]
T.H. Robinson, 1907. *Robinson exemplifies the idea of a sultan enjoying life. The imagery is orientalist, with a dancing girl and musician, and others in attendance.*

QUATRAIN 16 | 63

SULTÁN after Sultán with his Pomp.

They say the Lion and the Lizard keep
The Courts where Jamshyd gloried and drank deep;
And Bahram, that great Hunter – the Wild Ass
Stamps o'er his Head, and he lies fast asleep.

QUATRAIN 17

FitzGerald has taken most of the sense of the original quatrain, but he substitutes the lizard for foxes, and introduces Jamshyd, not present in any of the manuscript equivalents. Jamshyd was a mythical Persian king, and it is not clear why FitzGerald chose him to name as holding court, rather than keeping the emphasis on Bahram. Scholars have highlighted the fact that FitzGerald misses the pun associated with Bahram in the original of the second two lines. The Persian word for a wild ass is 'gur', the same word as for a grave, so Bahram, who caught 'gur', is finally caught himself by the 'gur'.[14]

The obvious physical imagery has drawn many illustrators to this quatrain, with some 25 different artists identified. Both modern and early artists have presented the lion in majesty, generally in the setting of a ruined Persepolis-like palace (see Alice Ross, overleaf). Sherriffs (1947) and Hemmant (1979) both have compositions in this form, as well as Vedder (1884). Others have shown the hunter and wild asses, but there are few images of Bahram in his grave (see Stewart, opposite).

M.R. Caird, 1910s. *Margaret Caird has focused on Bahram as the hunter, with a rather Persian-style presentation of the horse, rider and floral carpet. The prey seems more of a deer than a wild ass.*

C. Stewart, **1955**. *Stewart has made a brave attempt to include as much as possible of the imagery of the verse in his composition. The lion is there, in the ruined court with other animals (though no obvious lizard), and Bahram is clearly depicted in his grave, with bow and arrows. The style is reminiscent of miniatures, particularly with the picture spreading out of the frame.*

[next page left]
A. Ross, **1910**. *The illustration by Alice Ross highlights the first two lines of the quatrain. Her painting depicts a very realistic pride of lions, majestically occupying the ruins of the erstwhile sultan's palace. The lizards are there too, but there is no sign of Bahram or the wild ass stamping above his head.*

[next page right]
A. Rado, **1940**. *This is a somewhat surreal interpretation, with a majestic lion, and the hunter shown in profile as a traditional carving on an orange cloud. The sense is that the hunter is a dream image of the lion (almost enclosed in a thought bubble, cartoon-style). Wild animals cavort in the background.*

64 | QUATRAIN 17

I sometimes think that never blows so red
The Rose as where some buried Caesar bled;
That every Hyacinth the Garden wears
Dropt in its Lap from some once lovely Head.

[left]
S. Morris, 1970. *Morris's modern abstract illustrations are very difficult to interpret. In this one, there is a sense of garden fence, or a series of upright gravestones. The laurel wreath, placed on the outline of a head, must relate to Caesar.*

[right]
W.F. Coles, 1913. *This early black-and-white drawing is a fairly straightforward interpretation of the garden of roses, with an image of an ebullient maiden depicting the 'lovely Head' in the verse. Unusually, the man in the picture is shown pouring some wine onto the earth, perhaps following the old custom of giving a libation to a god or goddess.*

QUATRAIN 18

This verse of FitzGerald's is quite close to the quatrain of Khayyam's in the original Ouseley manuscript. But he substituted a hyacinth for a violet and missed Khayyam's idea that the flower came from the mole of a beautiful face. Once again there is clear symbolism in the verse of the life that continues to grow from the death of earlier beings, whether the famous king or the beautiful maiden.

Despite the obvious garden imagery, only 12 artists have chose to illustrate this verse. Many of them are from the modern period, and the pictures are mainly either Western or modern Persian in style. The main emphasis is on the rose, either one or many, in a garden. Both Gordon Ross (1941) and Sullivan (1913) show an isolated rose bush in the middle of the landscape. Tagore (1910) depicts a pensive seated man, contemplating a fairly barren garden with a mosque in the background.

I sometimes think that never blows so red.
The Rose as where some buried Cæsar bled;

*And this delightful Herb whose tender Green
Fledges the River's Lip on which we lean –
Ah, lean upon it lightly! for who knows
From what once lovely Lip it springs unseen!*

QUATRAIN 19

FitzGerald's verse is quite close to Khayyam's quatrain in its meanings. It contains another graphic depiction of the underlying theme of growth that comes from earlier decay. The parallel of the lip of the 'once lovely one' and the lip of the river, together with the accompanying alliteration, illustrate FitzGerald's skill as a poet in English.

The verse has been popular with illustrators, presumably because of the ease, and attraction, of presenting a river bank on which there sits a couple. Some artists, like Brangwyn (see opposite), Akhbar Tajvidi (1955) and Sullivan (1913) just show the couple with little sense of the underlying meaning. In contrast, Vedder (1884) and Bull (1913) have a girl alone on the bank of a stream, with a greater sense of the melancholy that the verse contains.

R. Balfour, 1920. *Balfour, in his art deco mode, has produced a somewhat confusing interpretation involving two females, dressed in party mode. There is a small stream in the front, with another figure, difficult to see, out of which a tree may be growing.*

[opposite top]
F. Brangwyn, 1910. *Brangwyn's illustration, with its rich combination of colour and atmosphere, well reflects the original oil painting. The style is generally Western and rather impressionistic.*

[bottom left]
G. James, 1898. *This picture, from James's first portfolio of illustrations for The Rubaiyat, is the only one we have found that shows fully the imagery of FitzGerald's verse. The growth of the grass from the lip of the once lovely one is explicitly depicted, albeit in a rather rigid and artificial style.*

[bottom right]
L. Hemmant, 1979. *Unusually, this artist has produced a black-and-white composition in a rather old-fashioned style, with the girl in the front looking pensively at a flower floating by in the water. There is a feeling that perhaps she could turn into the Ophelia out of which more roses might grow. Meanwhile, her two companions seem to be enjoying a cup of wine.*

*Ah, my Belovéd, fill the Cup that clears
TO-DAY of past Regrets and future Fears –
To-morrow? – Why, To-morrow I may be
Myself with Yesterday's Sev'n Thousand Years.*

QUATRAIN 20

Once again, the original Khayyam quatrain expresses the philosophy that one should enjoy today with love and wine, since tomorrow you may join all those who have already died. In the time that Khayyam was writing, seven thousand years was reckoned to be the age of the earth. FitzGerald's version is close to that of the original manuscript.

[left]
E.A. Cox, 1944. *Cox also shows the beloved as more of a servant figure, providing wine to her seated master. The artist has added a lute player and another servitor to the cup bearer. The text is incorporated into the picture, with a heavily decorated initial letter.*

[right]
M. Anderson, 1940s. *The style of this black-and-white picture by Marjorie Anderson harks back to an earlier period, although it is one of the more recent illustrations to FitzGerald's* Rubaiyat. *The clothing seems very Western, but the setting and background, particularly the branch of the tree in the window, are more oriental.*

[left]
W.J. Jones, 1921. *This illustration seems more to show a sage and his wine bearer, rather than the lovers personified in the verse. Although the clothing and figures are vaguely oriental in style, the colouring has something of the brightness of Gauguin's paintings of the South Pacific islands.*

[right]
J. Wong, 1961. *Jeanyee Wong's print seems to present a couple in a more equal relationship, even though the woman is still standing and the man is seated. The figures and the background are strongly oriental in style. The artist's use of two colours to give a multi-tone reproduction is quite uncommon in Rubaiyat illustration.*

The beloved and the cup are the only obvious physical images in the quatrain. But it is one that has been well used by illustrators over the whole period of publication of FitzGerald's *Rubaiyat*. Nearly all the artists have made a similar choice of subject for their compositions, namely a man and a woman, sometimes with attendants, with wine cups and flask. Unusually, Hanscom (1905) shows a woman on her own. Peno (2001), in his very recent interpretation, takes quite a different approach, showing an old man looking at a jug out of which many bubbles rise, perhaps symbolising the souls of 'Yesterday's Sev'n Thousand Years'.

*Lo! some we loved, the loveliest and best
That Time and Fate of all their Vintage prest,
Have drunk their Cup a Round or two before,
And one by one crept silently to Rest.*

QUATRAIN 21

Here FitzGerald has again stayed close to the sentiment of the verse in the early Persian manuscripts, but has changed some words, in order to express the meaning more poetically. The sentiment is once more the recognition that others have gone away before, and we must inevitably follow them. The imagery of the first two lines, of the 'Vintage prest' from the 'loveliest and best', is particularly striking.

This verse has been very popular with illustrators. Twenty-six of the artists we have identified have selected the verse, with a particular interest in the early part of the twentieth century. In the majority, illustrators have chosen the last line to illuminate the verse, showing the departing ones creeping silently to rest. But there are some interesting exceptions. Geddes (1910) and Sullivan (1913) both depict a kind of old angel or Father Time figure, helping the departed ones on their way, while Rose (1907) and Pogany in his third portfolio of 1942 show a couple in the wilderness, bereft of possessions, and most of their clothes.

A. Tajvidi, 1955. *Tajvidi depicts the two time periods of the last two lines of the verse. In the foreground, the lovers are still drinking their cup of the round before, while, in the background, the departed stumble on their way. The whole picture is contained in a decorated border, typical of the presentation of the work of this modern Iranian artist.*

[top left]
A.H. Fish, 1922. *Anne Fish has expressed the last line in her own distinctive art deco style. The clothing and heads of the three ladies produce an almost abstract image, through a combination of repetition and pattern.*

[bottom left]
R.A. Bell, 1902. *Bell's black-and-white print shows the scene in a fairly straightforward Western fashion. The departure of one of the loved ones takes place in the foreground, while the drinking continues behind.*

[right]
S. Gooden, 1940. *Like many of Gooden's illustrations, this print contains a skeleton for the main subject, with a traditional oriental turban. He carries a candle, and it is not clear whether he is the one calling the souls from among the sleepers shown, or is himself a beloved departing.*

AND ONE BY ONE CREPT SILENTLY TO REST.

*And we, that now make merry in the Room
They left, and Summer dresses in new Bloom,
Ourselves must we beneath the Couch of Earth
Descend, ourselves to make a Couch – for whom?*

QUATRAIN 22

FitzGerald used up to three separate quatrains as the basis for his verse, but, having fixed on his interpretation, he made virtually no changes from his first version in the subsequent editions. The sentiments follow on from, and echo, those of the previous quatrain, and earlier ones such as numbers 18 and 19. The loved ones have departed, we must follow, and we shall provide a couch for those who come after us.

Despite the potential in the visual subjects of the verse, making merry where others have departed and the idea of newness in summer, this quatrain has not been much used by illustrators. There has been a range of interpretations, both orientalist and Western in style, with the main focus on the idea of enjoyment before death comes.

[left]
H. Marie et al., 1994. *Helen Marie and her collaborators have chosen the happiest idea of this verse for the centre of their picture, with a group of young people dancing in the summer. But the highly elaborate root structure for the tree speaks of more sombre matters, since it contains the body of one who has gone before. The whole presentation is in a decorative border.*

[right]
E.J. Sullivan, 1913. *Exceptionally, Sullivan has gone straight to the idea of death personified, ready to take his next victim. The scene of Father Time and the skeleton figure attending a girl's deathbed is essentially Western in character.*

Ah, make the most of what we yet may spend,
Before we too into the Dust descend;
Dust into Dust, and under Dust, to lie,
Sans Wine, sans Song, sans Singer, and – sans End!

G. James, 1909. *This picture comes from James's third portfolio of illustrations for* The Rubaiyat. *It shows a girl sitting serenely, but death, robed in white, is just behind her. The style of garden and clothing has only a slight sense of the oriental about it.*

QUATRAIN 23

Although FitzGerald used at least two further quatrains from the Khayyam manuscripts as the basis for this verse, its overall meaning is very close to number 22 and earlier quatrains, with its philosophy of 'eat and drink, for tomorrow we die!' In the third line, there is a biblical echo of 'dust to dust, ashes to ashes'; the original speaks of the 'earth enfold[ing] thee'. The last line is mostly FitzGerald's own, and has in turn echoes of Shakespeare (Jaques's speech on the seven ages of man in *As You Like It*).[15]

A fair number of illustrators have selected this verse over the past century. They have come mostly from the early years, or from the post-Second World War period. They focus mainly on the more positive sides of living and drinking. But some, such as Halder (1930) and Bull (see overleaf) present a notably more pessimistic approach.

R. Bull, 1913. *In Bull's interpretation, the threat of the end is put much more forcefully. The girl is descending like a sleepwalker into the unknown, with the giant image of death, strongly skull faced, following behind. As with all Bull's original illustrations, the art nouveau design is enclosed in a decorated border.*

[opposite left]
Unknown artist, 1918. *This picture, with its essentially Chinese characters, is focused on pleasures. The lamps and other items suggest it may be opium, not wine, that the participants are taking. The hovering bat, with its sinister head, suggests bad things to come, while the strange face on the wall is an enigma.*

[opposite right]
M. Tajvidi, 1959. *Mohammad Tajvidi took a simple approach to this illustration. The girl, with typically Persian robe and stance, drinks wine against the garden background. She glances at, but seems not to be worried by, the stone head of one of the departed that is lying on the ground.*

QUATRAIN 23

Alike for those who for TO-DAY prepare,
And those that after a TO-MORROW stare,
A Muezzin from the Tower of Darkness cries
'Fools! your Reward is neither Here nor There!'

QUATRAIN 24

FitzGerald has come close in meaning to the original quatrain, but he complicated the imagery by introducing a 'Tower of Darkness' from which the muezzin cries, rather than keeping the minaret mentioned by Khayyam. He also brought in the idea of future reward, in place of the original sense of a road or way to be followed. The sentiment is even more unfocused than in the previous few quatrains, since the emphasis is on our not knowing what will happen today or tomorrow. Even so, there is a suggestion that there may be a reward (or way) if we could find it.

The quatrain has been quite frequently illustrated, with versions by major names from the early period like Dulac (1909), Bull (1913) and Pogany (1909), as well as more modern artists, including Morris (1970) and Rado (1940). Many illustrators have latched onto the subject of the muezzin in the tower/minaret. Marie et al. (1994) and Behzad Miniatur (1970) both show a large crowd of people hearing the cry of the muezzin, while Akhbar Tajvidi (1955) elected to show Khayyam's version of a road with walkers on it.

[left]
R.G.T. (name not known), 1940s.
The unknown artist in this New Zealand version of The Rubaiyat *produced a very traditional image of the muezzin calling from a minaret. However, the audience for the call appears to be the clouds and the birds, reflecting the feeling in the verse that no one is listening. The style of a grey wash painting is unusual for Rubaiyat illustrations of this later period.*

[opposite right]
W.G. Stirling, **1932**. *The three sages in the illustration are deep in a discussion of doctrine and faith, reflecting more of the sense of the original manuscript. They are clearly oriental in character, and are figures frequently repeated by Stirling in his very clean-cut illustrations.*

[left]
W.J. Jones, **1921**. *This illustration is labelled with the last two lines of the quatrain, and there is a tower in the distance. But it could be that the main subject, a kind of John the Baptist figure, is actually making the cry of the muezzin. The significance of the kneeling, turbaned man in the foreground, and the offering of fruit, is not clear.*

[right]
A. Szyk, **1940**. *Here is a richly clad muezzin preaching from the minaret. But, while the opulence of the decoration is in tune with orientalist ideas, the clothing seems to be more that of a mediaeval nobleman than of a religious speaker. The highly decorated patterns and border are typical of the work of this Polish-American artist.*

*Why, all the Saints and Sages who discuss'd
Of the Two Worlds so learnedly, are thrust
Like foolish Prophets forth; their Words to Scorn
Are scatter'd, and their Mouths are stopt with Dust.*

QUATRAIN 25

FitzGerald combined at least two manuscript quatrains to create this verse, and he retained much of the sense of the originals. Having focused on the impermanence of both kings and lovers, Khayyam and FitzGerald now move on to the limitations of learning and study in this world, stressing that all the learned words will soon be forgotten. It is believed that Khayyam's original was an attack on astrology, a subject of which, as an astronomer, he might well be dismissive.[16]

Unlike quatrain 27, which also speaks of learning and its limitations, this is one of the least favoured verses for illustrators. Only seven identified artists included it in their selection, most, like Gordon Ross (see left), being those who covered the bulk of the 75 quatrains. The neglect probably reflects the relative obscurity of the sentiments. The 'Saints and Sages' have been the favourite subject for illustration.

[left]
G. Ross, 1941. *Ross provides a very idiosyncratic image of the content of this verse, using a Western context and allusion. His image shows two rather kingly sages, one who seems to have a cross on his mitre, leaning over a fence. In the foreground are some large pigs, and the sages appear to be casting pearls from a broken necklace in front of the swine, perhaps a biblical reference.*

[right]
H. Marie et al., 1994. *Helen Marie shows a more traditional view of oriental wise men in discussion. But the accompanying comment in this spiritual interpretation of* The Rubaiyat *seems to suggest that they are three false prophets who preach immortality. The picture is contained in a finely decorated frame.*

Oh, come with old Khayyam, and leave the Wise
To talk; one thing is certain, that Life flies;
One thing is certain, and the Rest is Lies;
The Flower that once has blown for ever dies.

[left]
R. Bull, **1913**. *This illustration seems to portray Khayyam trying to persuade someone to go with him. The design of the picture is less ornate than some of Bull's work, and the frame structure at the top of the picture is typical of an art nouveau interpretation of oriental design.*

[right]
H. Behzad Miniatur, **1970**. *Behzad Miniatur has firmly chosen to highlight the last line, with a good selection of flowers whose petals are beginning to drop. The floating figures, above, could portray Khayyam again trying to convince a lady to accompany him on his way. The over-large butterflies are an interesting decorative addition.*

QUATRAIN 26

This is another obscure verse by FitzGerald, based on parts of a quatrain from the Ouseley manuscript. In later versions, the phrase 'Oh threats of Hell and Hopes of Paradise' replaces the first line. The underlying meaning is again that wisdom, or the conceptions by thinkers of hell and paradise, are products of the imagination, while, for us, as well as the 'Flower', only death is certain.

There is little concrete imagery for the artist to get hold of in this verse, and, as a result, there have been only a few illustrators prepared to deal with it. Perhaps naturally, either Khayyam himself, or the blown flower from the final line, have been the most used subjects.

Myself when young did eagerly frequent
Doctor and Saint, and heard great Argument
About it and about: but evermore
Came out by the same Door as in I went.

QUATRAIN 27

This verse, and the next one, are based on two, possibly three, quatrains in the original manuscripts of Khayyam's *Rubaiyat*. Again the message is about the limitations of knowledge. Despite all the words and arguments, the discussions of the wise ones do not lead one forward on the true road of life. It is interesting that here, and in the earlier verses with similar themes, there is a sense that there should be a way forward of some kind. Other quatrains of Khayyam and FitzGerald are more negative about this possibility (see quatrains 29 and 30).

Given the rather abstract subject, it is perhaps surprising that this has been one of the most popular verses in *The Rubaiyat*, both for readers and illustrators. Nearly forty artists have chosen to use it as their inspiration. They are broadly representative of all periods and styles of *Rubaiyat* illustration, and they include most of the well-known names, like Brangwyn (1910), James (1898) and Pogany (1909). Virtually all the compositions include the doctor and saint in discussion in some form, often with the young Khayyam in evidence as well.

D.M. Palmer, 1921. *Doris Palmer has produced a colourful interpretation of the wise men in discussion. The young Khayyam sits at the back, with other students also listening to the argument. The style is art deco, with strongly oriental imagery in the clothing and the shape of the opening at the back. The stylised trees are unusual; the artist used them in others illustrations, for example for quatrain 74.*

[left]
G. Popoff, 1948. *Unusually, in this interpretation the doctors and saints have ceased their argument and are all looking rather confused. Young Khayyam seems to be firmly on the way out of the door again. The turbans and cloaks again suggest the Orient, though some of the faces are more Western.*

[top right]
A.H. Fish, 1922. *Anne Fish has chosen to add a satirical and amusing note to her composition, in sympathy with the sense of the verse. Here young Khayyam sits in front of the discussants, with his back to us. Fish presents a quite another manifestation of the art deco trend from Palmer's, but the oriental touches in the arches and curtaining are clear.*

[bottom right]
W. Murray, 1946. *Murray has composed a more impressionistic view of the scene, with young Khayyam standing at the left and looking over the serious group of seated discussants. The style is a much more traditional one, but the feel is still oriental, particularly in the presentation of the lamp in the upper part of the picture.*

With them the Seed of Wisdom did I sow,
And with my own hand labour'd it to grow:
And this was all the Harvest that I reap'd –
'I came like Water, and like Wind I go.'

QUATRAIN 28

Apart from the last line, this verse is very much FitzGerald's own making. The 'them' refers to the 'Doctor and Saint' of the previous verse. In using the analogy of the water and wind flowing hither and thither, FitzGerald here anticipates a new theme and a graphic presentation of fundamental uncertainties that will recur in the following verses.

There are not many illustrators for this quatrain, only 11 on our list. Most artists have latched on to the imagery of wind and water in the last line.

[left]
H. Marie et al., 1994, *Helen Marie and her colleagues have attempted twice to interpret the last line, in both cases in a highly decorative manner. The use of a woman's figure to show the wind blowing provides great vitality to both pictures. But the sense of absolute loss in the verse is not strongly portrayed.*

[right]
O'Brien, 1920s. *O'Brien has given an unusual and imaginative view of the sense of the last line. Human beings are buffeted to and fro in a kind of cosmic chaos. There is a sense of a depiction of both the beginning and the possible end of existence. The style has echoes of sculptured friezes of similar scenes, such as those by the Norwegian Viegland.*

[opposite]
E. Geddes, 1910. *The character in Geddes's illustration is lost in an amorphous world and blinded by a pair of hands. The style is still generally classical, but the ornate border has both art nouveau and oriental overtones.*

Into this Universe, and why *not knowing,*
Nor whence, *like Water willy-nilly flowing:*
And out of it, as Wind along the Waste,
I know not whither, *willy-nilly blowing.*

QUATRAIN 29

In this verse, in contrast to the previous one, FitzGerald returned to the early manuscripts for his inspiration, though he has chosen to combine at least two of Khayyam's quatrains in his interpretation. At this stage in the poem, he moves on to question the whole notion of existence, focusing on the coming into being and departure from life, in an apparently undirected way like wind and water. Once again, FitzGerald's alliterative use of words is effective in creating a powerful and memorable verse.

Despite its strength as a verse, FitzGerald does not give the illustrator much in the way of specific images on which to focus. Quite a number of artists were nonetheless drawn to the verse. It is not surprising, however, that illustrators have taken a wide range of subjects to express the underlying sentiments. These range from pictures of quiet contemplation through to the image of stormy winds and water, some in a similar fashion to that of O'Brien's interpretation of quatrain 28.

84 | QUATRAIN 29

[top left]
H.A.-U. Karr, 1938. *The solitary man in Karr's colourful image could perhaps be declaiming to the winds the question at the heart of the verse. The man seems resigned, almost happy, in his uncertainty. The Orient is conveyed through the clothing and the mosque among the background roofs.*

[top right]
M. Tajvidi, 1959. *The girl in this image by Mohammad Tajvidi does not seem to be especially buffetted by the wind. She holds her bowl of wine quite serenely, apparently resigned to the uncertainty and observing something on her right side. But the rather impressionistic background gives a feeling of leaves or blossom blowing round, bringing more of the sense of the verse.*

[bottom]
E. Vedder, 1884. *Vedder's composition gives the two girls blown by the wind a strong sense of uncertainty and instability in their environment. As usual for this artist, the text forms part of the picture and the style is classical nineteenth century.*

What, without asking, hither hurried whence?
And, without asking, whither *hurried hence!*
Another and another Cup to drown
The Memory of this Impertinence!

QUATRAIN 30

This is another quatrain dealing with the question of coming into existence, being and dying. FitzGerald continues to find variations on the theme, this time with the help of two further manuscript quatrains. FitzGerald's use of wordplay is again memorable.

The verse has seen little response from illustrators, and those who have used it have struggled to illuminate the words. Most of the interpretations give a feeling of contemplation, or resignation at the situation, with some emphasis on the cup that drowns the memory.

[left]
H. Beck, 1950. *Beck's strange drawing is full of symbols, highlighting different aspects of the verse. The wind seems to be supporting the flying girl, while the grapes are on the vine, ready to fill the cup. The artist also includes sun (rising or setting?) and moon, as well as Saturn with its rings, perhaps referring forward to the next of FitzGerald's quatrains. The Orient is conveyed by the distant townscape and, presumably, the palm trees on the river.*

[right]
A.H. Fish, 1922. *Unusually Anne Fish gives a good sense of protest in her imagery. Her strange, magician-like character shouts out to the world the question in the first two lines. The curves of the different levels of the background are beautifully used to give both depth and pattern to the picture.*

*Up from Earth's Centre through the Seventh Gate
I rose, and on the Throne of Saturn sate,
And many Knots unravel'd by the Road;
But not the Knot of Human Death and Fate.*

QUATRAIN 31

FitzGerald here used one quatrain of Khayyam's, to which he has added the idea of the seventh gate, which Khayyam refers to elsewhere in his verses. This gate is seen as the entry point to the highest heaven, where the throne of God is situated. But, although the poet claims to have attained this high level, he still could not untie the master-knot of human fate, the secret of life and death.

This verse has been quite popular with illustrators, especially those active before the First World War. Nearly all of them have used the astronomical references in their compositions. Some, like Ault (1904), Bull (1913) and Vedder (1884), focus on the image of Saturn with its rings. Others, including Weston (1923) and Hanscom (see opposite) confine themselves to a view of contemplation of the mysteries of life.

[opposite]
R. Balfour, 1920. *Balfour presents a somewhat surreal black-and-white picture in a complex art deco style. A figure rises from the earth, as in the verse, but with fairies and others surrounding it, and backed by a much larger figure of a girl in a bulging, swirling, black dress. Perhaps she is dreaming the whole scene from the first two lines?*

[top left]
A. Tajvidi, 1955. *Akhbar Tajvidi presents a view of the old astronomer as he rises towards the heavens. The imagery of sun and stars is clearly shown by this modern Iranian artist, but it is unclear who the dark-faced figure in the back is supposed to represent. Western imagery might suggest the devil, who continues to confuse the understanding of the purpose of life.*

[bottom left]
A. Hanscom, 1905. *Adelaide Hanscom has chosen the image of a sage (astronomer?) sitting on what seems like a throne, studying a large book. Like the other illustrations by this artist, the picture is derived from a colour photograph of a carefully posed model.*

[right]
J. Watson Davis, 1920s. *Watson Davis has produced a fairly obvious illustration of the first part of the text, with a person rising above earth to touch Saturn and its rings. There is little of the oriental about the scene, or of the failure of the final search, as described in the verse.*

There was a Door to which I found no Key:
There was a Veil past which I could not see:
Some little Talk awhile of ME and THEE
There seem'd – and then no more of THEE and ME.

QUATRAIN 32

This verse of FitzGerald's is probably based on a combination of three quatrains from the original Persian manuscripts. It manages succinctly to present the essential meaning of these quatrains. The message continues to be that of an inability to find a way to understand the world outside our limited existence. The second half emphasises a belief in the loss of personality with death.

The obvious imagery of the door and the key has attracted a good many illustrators, especially in the period since the Second World War. Few artists have followed up the idea of the veil; Low (1947) is an exception in depicting the barriers of both door and veil. Some illustrators have chosen to present the 'ME and THEE' of the second half of the verse. They include Halder (1930) and Akhbar Tajvidi (1955).

R. Bull, 1913. *Bull has chosen to illustrate the verse with a large, ornate and clearly impenetrable door, dominating the seeker in white robes in the foreground. The latter seems to be crying out in his or her plight, while there is a suggestion of others who have succumbed in their search immediately in front of the door. The rocks and architectural surrounds have the sense of an Egyptian tomb.*

[top left]
N. Parry, 1996. *In his illustration, Parry has shown that there are keys, and possibly a door opening with them. The background of buildings appears rather Western in character, almost like a cathedral cloister, and the figure in the foreground could even be seen as an angel with a halo.*

[top right]
A. Rado, 1940. *Rado's depiction of the impassable door has something of a South Asian feel to it, with the large elephant guardians. But the figure of the seeker seems to be in Arabic dress.*

[bottom right]
M. Anderson, 1940s. *Marjorie Anderson's print feels as though it is more on a domestic scale than the tomb or palace entrances that are shown elsewhere. The seeker seems more humble, like a servant kneeling and knocking, rather than crying out to the heavens. Although quite a recent work, the imagery is relatively traditional, perhaps intended to reflect the historical period of The Rubaiyat.*

*Then to the rolling Heav'n itself I cried,
Asking, 'What Lamp had Destiny to guide
Her little Children stumbling in the Dark?'
And – 'A blind Understanding!' Heav'n replied.*

QUATRAIN 33

The original text for this verse was not that of Khayyam, but of another slightly later Persian poet, Farid ud-Din Attar. The text is from his *Conference of the Birds* (*Mantiq at-Tair*), on which FitzGerald had been working previously.[17] FitzGerald had considerable trouble with his interpretation of the verse, changing it drastically in his final version, closer to the original text. The message of having blind faith in what Heaven has in store seems to clash with some of Khayyam's more pessimistic quatrains, for example numbers 29 and 30.

This verse has been illustrated quite frequently, notably in the modern period and in more Western style. The theme of those stumbling in the dark is prominent, sometimes in a procession as with the Pogany first version shown left. Some artists, like Geddes (1910), Gorter (1989) and James (1909) have single desolate figures, while others depict the blindness with a simple blindfold. Peno (2001) presents the head and shoulders of an oriental man with eyes covered, while Sullivan (1913) is more provocative with a blindfolded naked woman.

W. Pogany, 1909. *Pogany's first set of illustrations for* The Rubaiyat *was based on a slightly impressionistic set of paintings. The depiction of this group of lost 'Children' stumbling in what seems like night (or a fog), gives a good feel of the sense of loss in the verse. There is just a faint sun (or moon) up to which they can look for guidance.*

H. Marie et al., 1994. *This provides a clear image of the man stumbling as he follows, with metaphorically blind understanding, another figure over difficult terrain. The leader is hooded with little of the face visible, but the stance conveys a sense of calm. The whole image is presented in a traditional decorative border.*

Then to this earthen Bowl did I adjourn
My Lip the secret Well of Life to learn:
And Lip to Lip it murmur'd – 'While you live
Drink! – for once dead you never shall return.'

[left]
G. James, 1909. *This illustration comes from Gilbert James's third set of paintings for* The Rubaiyat. *He did not include this verse in his earlier portfolios. The style is somewhat impressionistic, with the image of a rather unrelaxed outdoor meal. The formal fountain in the foreground is perhaps a reference to the 'Well of Life' in the verse. The detail shows goldfish in the water and blue birds hovering round.*

[right]
D.M. Palmer, 1921. *Doris Palmer presents the drinker relaxing indoors in a highly colourful setting. The use of the bold mixture of patterning and general art deco style are typical of this artist. The imagery of turban, flask and table or stand are broadly oriental.*

QUATRAIN 34

In this verse, FitzGerald returned to the manuscripts of Omar Khayyam for his inspiration. He stayed close to the meanings of the two quatrains that he used. It is the first quatrain in which the idea of a bowl or pot speaking to the poet occurs. The use of the pot to convey key thoughts is used extensively in later verses, especially in quatrains 59–66, which comprise the so-called 'Kuza-Nama' ('Book of the Pots'). The theme of the verse is once more the search for understanding and the impermanence of existence. The wordplay on 'Lip' is notable.

This verse has not been chosen much by illustrators. We have identified only ten different illustrators, and these include the five artists who cover all, or nearly all, the quatrains: Vedder (1884), Sullivan (1913), Gordon Ross (1941), and the two Iranian illustrators, Mohammad Tajvidi (1959) and Akhbar Tajvidi (1955). All the interpretations have been fairly straightforward, with drinkers, always male, bringing a cup or jug to their lips.

*I think the Vessel, that with fugitive
Articulation answer'd, once did live,
And merry-make; and the cold Lip I kiss'd
How many Kisses might it take – and give!*

QUATRAIN 35

FitzGerald's verse is loosely based on one Khayyam quatrain, carrying a broadly similar sentiment. The imagery carries further that of the previous verse, bringing in the thought that the clay of the pots is made from the dust of previously existing human beings. This parallels the sentiment of quatrain 19, with its picture of the green grass that springs from an unseen lip.

Despite the element of obscurity in the verse, it has been selected by a good number of illustrators. The interpretations again focus mainly on the image of a man drinking from a vessel of some kind, but, as shown here, both Lundborg and Balfour are unusual in presenting women drinkers. Sullivan (1913) has a distinctive version, with a skeletal figure sharing the cup of an old toper (see illustration 28 in Part 1).

A. Tajvidi, 1955. *Akhbar Tajvidi provided a fuller, as well as a much more Persian, style of interpretation of the drinker. The man seems to be talking to the jug, which has a face and a person trapped within. Out of the vessel rises a ghostly couple. They may represent those who shared the many kisses of a previous life.*

[opposite left]
R. Balfour, 1920. *The illustration by Balfour is a riot of art deco, with strong echoes of Aubrey Beardsley's work. Several figures are women, and the artist seems to have stressed the suggestion of merry-making in the verse, rather than the more sombre conclusion.*

[opposite top right]
F. Lundborg, 1900. *Florence Lundborg's drawing is a typical art nouveau image of a woman drinker. The picture is relatively plain in style and the integration of it with the text of several verses, normal for this artist, is fairly nominal in this case.*

[opposite bottom right]
J. Low, 1947. *This small, single-colour print is very representative of Low's work for* The Rubaiyat. *It shows an Eastern man drinking wine, seemingly quite happily. Again the sentiment of the last line of the verse seems to have been ignored. The colour and style of the print is reflected in the decorative border of the whole page.*

QUATRAIN 35

XXXVI

I think the Vessel, that with fugitive
Articulation answer'd, once did live,
 And drink; and Ah! the passive Lip I kiss'd,
How many Kisses might it take — and give!

XXXVII

For I remember stopping by the way
To watch a Potter thumping his wet Clay
 And with its all-obliterated Tongue
It murmur'd — "Gently, Brother, gently, pray!"

XXXVIII

And has not such a Story from of Old
Down Man's successive generations roll'd
 Of such a cloud of saturated Earth
Cast by the Maker into Human mould?

XXXVI

I think the Vessel, that with fugitive

Articulation answer'd, once did live,

 And drink; and Ah! the passive Lip I kiss'd,

How many Kisses might it take—and give!

For in the Market-place, one Dusk of Day,
I watch'd the Potter thumping his wet Clay:
And with its all obliterated Tongue
It murmur'd – 'Gently, Brother, gently, pray!'

QUATRAIN 36

The speaking pot returns again in this quatrain, this time in the hands of the potter. FitzGerald has interpreted quite closely the original from the Khayyam manuscripts. It is one of the better-known verses of *The Rubaiyat*, probably because of its clear and vivid imagery. The underlying theme remains the continual recycling of the dust of human and other existence.

Some thirty illustrators have chosen to interpret this verse. Nearly all of them have made a simple composition of marketplace, potter and clay, generally in some kind of an Eastern setting. They are broadly representative of the main periods in the history of FitzGerald's *Rubaiyat*, and of the different artistic styles that have flourished. The potter is most usually presented seated on the ground, with the observer/poet, if present, standing at a slight distance.

"A Potter thumping his wet Clay, and with its all obliterated Tongue it murmured, 'Gently, Brother, gently, pray.'"
O.K. — Quatrain XXXVI

M.R. Caird, 1910s. *This sepia-washed painting gives a strong feel of the potter, who may be thumping too hard for the comfort of the clay. Vestiges of a face could be imagined in the lump of material being worked. The observing poet, and the marketplace, are absent in Margaret Caird's interpretation.*

[top left]
S. Katchadourian, 1946.
Katchadourian has provided quite a realistic view of the potter's shop, with a shovel and wheel visible, as well as many pots at different stages of production. Both observer and potter are more dark-skinned than is usual in Rubaiyat illustrations. Although the picture has a simple white frame, it is placed on a page with extensive background floral decoration.

[top right]
C. Robinson, 1910. *Robinson's picture shows the marketplace clearly, with the crouching potter busy at his work. Unusually, it seems that the potter and the observer may be in conversation. The style is generally orientalist, but the central figure could be seen as a representation of Christ in other circumstances.*

[bottom right]
E. Vedder, 1884. *Vedder is unusual in showing an angel-winged potter, in clearly classical style. There is a sense of the potter as a part of creation. The skulls and other raw material for the clay are clearly visible at the bottom of the picture, with the spade ready to extract them for use.*

*Ah, fill the Cup: – what boots it to repeat
How Time is slipping underneath our Feet:
Unborn TO-MORROW, and dead YESTERDAY,
Why fret about them if TO-DAY be sweet!*

QUATRAIN 37

This verse only appears in FitzGerald's first version of *The Rubaiyat* and was dropped from all subsequent editions. It is based loosely on two quatrains from the Khayyam manuscripts. The Epicurean, live-for-today, sentiment expressed in the quatrain could be said to sum up the philosophy of Omar Khayyam as found in FitzGerald's *Rubaiyat*.

Despite the centrality of the theme of the quatrain to *The Rubaiyat*, this verse has not been illustrated often. We have identified the work of only six artists that cover it. It is of interest that it is ignored by all the modern Iranian illustrators. Most of those who have tackled the quatrain have used the first phrase to sum up the verse, depicting wine drinking in some form. Gordon Ross (1941) and Sullivan (1913) both include a kind of globe-shaped sundial, presumably referring to the heavens and the passage of time in some way.

W.G. Stirling, 1932. *Stirling depicts his typical oriental gentlemen seated on the ground, enjoying their wine and discussion. The presentation in this black-and-white painting is very simple, with no background detail. Only the decoration on the men's clothing relieves the starkness.*

G. Popoff, 1948. *Popoff has produced a colourful interpretation of the enjoyment message of the verse. A surprising feature is the introduction of an angel as the saki pouring the wine. The faces of the two figures are almost Chinese, though the poses and the detail of the ground are more Persian in style.*

One Moment in Annihilation's Waste,
One Moment, of the Well of Life to taste –
The Stars are setting and the Caravan
Starts for the Dawn of Nothing – Oh, make haste!

QUATRAIN 38

One commentator has described this quatrain as 'richly varied', containing as it does a number of different metaphors for life.[18] FitzGerald has omitted the direct reference to wanting wine as a solace, which appears in the original, unless perhaps the final request to make haste is intended for the wine pourer. The well of life recalls the similar imagery in quatrain 34, while the description of the setting stars and the caravan with no destination are very graphic portrayals of the ending of existence. In later versions, FitzGerald changed the final two lines to 'And Lo! – the phantom Caravan has reach'd/The NOTHING it set out from – Oh, make haste!'

Nearly twenty illustrators have been inspired by this verse. It has been more commonly chosen by artists in the modern period and those whose imagery is Western in style. The caravan is the aspect of the verse most commonly depicted, usually through the symbolism of one or more camels.

J. Laudermilk, 1925. *Laudermilk is an exception to the general emphasis on a realistic caravan. Instead he has attempted to depict the last lines from the third edition with an endless flow of hooded people coming from and going into outer space. Their progress forms two shapes like mountain peaks, with a milky way of stars, perhaps containing those who have gone before. The black-and-white design is enclosed, with some text, in a decorative starry border.*

[top left]
W. Pogany, 1909. *This is from Pogany's first set of paintings to illustrate* The Rubaiyat. *Like other paintings from this portfolio, the style is soft and impressionistic. The caravan is visible, but with only a gradual feel of movement into the distance.*

[top right]
H.A.-U. Karr, 1938. *Here Karr gives us a fairly realistic version of an oriental caravan, unusually moving towards the viewer. The whole scene seems one of purposeful progress, denying the lack of goal, the dawn of nothing, in the verse. The simple gold background with no detail gives the sense of an oriental scroll painting.*

[bottom right]
W. Pogany, 1930. *Pogany had a complete change of style for his second portfolio. The image is much clearer and the naked girl in the foreground seems to be absorbed by tasting the water from the well of life. She ignores the watching man from the ghostly caravan in the background.*

How long, how long, in infinite Pursuit
Of This and That endeavour and dispute?
Better be merry with the fruitful Grape
Than sadden after none, or bitter, Fruit.

QUATRAIN 39

As in quatrain 37, Khayyam and FitzGerald return to the central idea that it is better to enjoy life with wine, rather than to waste time agonisingly trying to understand the meaning of things, and to answer the unanswerable. FitzGerald has used two separate quatrains from the manuscripts. The reference to 'endeavour and dispute' harks back to the dismissal of the search for useless knowledge, already emphasised in, for example, quatrains 26 and 27.

There is little in the way of obvious imagery in the quatrain, and fewer than ten artists have attempted to illuminate the text. Most of them focus on drinkers being 'merry with the fruitful Grape'. Some, like McCannell (shown left), also include a group of frustrated 'wise' discussants.

O. McCannell, 1953. *McCannell has the sages in the 'infinite Pursuit' of the first two lines, complete with their books and scrolls. They look suitably anxious, as the text suggests. In the background, there is a couple making merry with wine. Faces and clothing are all orientalist in style.*

D.M. Palmer, 1921. *Doris Palmer has opted, in her art deco style, to present the last two lines of the text. In the centre, characters in brightly patterned clothes are reposing and drinking wine. They watch a joyous parade of shadowy characters, who are framed by curtains as though in a theatre. There is little of the sense of melancholy of the whole verse.*

You know, my Friends, how long since in my House
For a new Marriage I did make Carouse:
Divorced old barren Reason from my Bed,
And took the Daughter of the Vine to Spouse.

QUATRAIN 40

The theme of giving up study for the delights of wine drinking is again the subject of the quatrain. But a new imagery has been introduced, with the divorce of reason and remarriage to 'the Daughter of the Vine'. In the verse FitzGerald stayed close to one quatrain of Khayyam's, though the latter makes no mention of a bed, referring instead to the Islamic divorce procedure in the words 'I will thrice pronounce the divorce from learning and faith'.

The visual contrast between 'old barren Reason' and 'the Daughter of the Vine' has drawn many illustrators to this quatrain. The daughter is generally personified as being young and beautiful. Twenty-six artists have selected the verse, including most of the well-known names. The version by Dulac is shown opposite. Most of the representations are strongly orientalist in style.

J.Y. Bateman, 1958. *Bateman has taken the words of the verse literally, with this bed scene situated somehow in the clouds. The head and shoulders of the rejected Reason are included. The style is very much Western and it is typical of the mildly erotic quality of Bateman's work. The representation could at first glance be taken as one of the Greek gods at play.*

[opposite top left]
E.A. Cox, 1944. *This illustration is from a highly decorated edition published by a small press in the middle of the Second World War. The imagery shows how the naked 'Daughter of the Vine', with her head wreathed with grapes and leaves, is tempting the seated poet. 'Old barren Reason' is clearly shown creeping away at the right, while a monkey plays at the front of the scene.*

[opposite top right]
R.S. Sherriffs, 1947. *This version appears to focus solely on the last line, with no representation of 'old barren Reason'. Sherriff's strong style and colours are very distinctive, with the emphasis on the foreground figures.*

[opposite bottom]
E. Dulac, 1909. *Dulac shows an oriental 'palace' scene in a fairly conventional style, peopled with quite a number of drinkers and their companions. The central two figures presumably represent the poet and his new spouse. But Dulac has not expressed the idea of substituting one 'bedfellow' for another.*

QUATRAIN 40 | 103

OU know, my friends, how long since in my House,
For a new marriage I did make Carouse:
Divorced old barren Reason from my Bed,
And took the Daughter of the Vine to Spouse.

*For 'IS' and 'IS-NOT' though with Rule and Line,
And 'UP-AND-DOWN' without, I could define,
I yet in all I only cared to know,
Was never deep in anything but — Wine.*

QUATRAIN 41

This is a rather convoluted verse, and, apart from the last line with its praise of wine, FitzGerald's meaning is not very clear. The sense is again that of the rejection of reason. The original quatrain in the Khayyam manuscripts refers, in lines one and two, to the 'outwardness of existence and non-existence', and the 'inwardness of all that is high and low'. In his later versions, FitzGerald omits 'without' in the second line, substituting 'by Logic', which perhaps helps to clarify the meaning.

This verse has had very few illustrators; we have identified no more than six artists who have chosen it. Most focus on a drinker in some guise, usually including some symbol of knowledge, such as books or a globe.

[left]
J. Hill, 1956. *In contrast to most illustrators of this verse, Hill contains no human figures in his print. The thought of the verse is shown symbolically, the wine flask being juxtaposed to the book and the globe/astrolabe. The imagery is essentially oriental, especially the shape and patterning of the background window.*

[right]
S. Katchadourian, 1946. *Katchadourian presents a conventional Persian-style image of a thoughtful drinker. There are no obvious symbols of logic or knowledge, but the flat-topped mountain in the background is unusual.*

And lately, by the Tavern Door agape,
Came stealing through the Dusk an Angel Shape
Bearing a Vessel on his Shoulder; and
He bid me taste of it; and 'twas – the Grape!

H. Cole, 1901. *The 'Angel' in Cole's black-and-white print has a classical feel about him. This naked young man, presented as the wine carrier of the text, would not be out of place in an image of a mediaeval bacchanalia. In contrast, the rather shadowy figure of the poet has more of an oriental appearance.*

"And lately by the Tavern Door agape,
"Came stealing through the Dusk an Angel Shape.'

QUATRAIN 42

FitzGerald and Khayyam both introduce new images in this quatrain, which again praises wine. The main commentators suggest that FitzGerald made a mistake in his translation, introducing the idea of an 'Angel Shape'.[19] The original verse contains the Farsi word 'piri', which means old man, and other translators talk of 'a drunken old man'. But it is believed that FitzGerald interpreted the Farsi as 'peri', or fairy. He then made the fairy male, *vide* 'his' shoulder in the third line, and turned the fairy into an angel!

FitzGerald's error has sent illustrators off in a different direction from the original quatrain. But the result has been fruitful, as this has been one of the most popular verses for illustrators. Some have ignored the masculine image of the text, choosing to interpret and use the female form to advantage. Other artists have elected to show a male angel. Pogany's three highly varied representations are shown as illustrations 24–26 in Part 1.

106 | QUATRAIN 42

[top left]
A. Szyk, 1940. *The 'Angel Shape' here is clearly female, and she is accompanied by a musician with a lute. The poet and his fellow drinkers are relegated to the background, sitting in the inner courtyard. Szyk's highly decorated presentation is very colourful and almost cheerful. It contrasts with the more sombre view taken by many other illustrators.*

[top right]
J. Watson Davis, 1920s. *Watson Davis's painting for this quatrain is very traditionally Western. There is a sense of the Annunciation in the presentation of the 'Angel' in a blaze of light. The poet is shown in the guise of a seeker. His clothing could be seen as mediaeval or oriental, depending on the viewpoint.*

[bottom]
G.A. Sheehan, 1912. *Sheehan presents a clearly oriental scene, with a strong upstanding figure for the poet. The vessel bearer is a more ghostly image, perhaps reflecting FitzGerald's use of the words 'Angel Shape'. The figure could be either male or female.*

The Grape that can with Logic absolute
The Two-and-Seventy jarring Sects confute:
The subtle Alchemist that in a Trice
Life's leaden Metal into Gold transmute.

QUATRAIN 43

[left]
E. Geddes, 1910. *Geddes has a rather romantic and Westernised image of an angel giving wine to an old man. The angel could almost be carried over from the previous verse (not illustrated by Geddes). The old man may be trying his hand as an alchemist, judging by the fire in front of him. The whole picture is contained in a heavily decorated border, apparently created by the binder, Sangorski.*

[right]
E.J. Sullivan, 1913. *This illustration, originally in black-and-white (see comment on quatrain 4), is a strange combination of symbols and imagery. The central figure of the teacher is presumably the representation of 'The Grape', which refutes muddled thinking with its own logic. The seated people around are perhaps the sectarian thinkers of the text, but the roaming yellow leopards are difficult to interpret. (Interestingly, Gordon Ross, in his equally symbolic illustration for this quatrain, portrays black panthers.)*

For this quatrain, both FitzGerald and Khayyam present logic and alchemy as positive attributes possessed by 'The Grape' that can be helpful to man. FitzGerald's verse is close in imagery and meaning to the quatrains in the manuscript. The 72 sects are the branches of religious thinking and dogma that confuse the ordinary mortal; wine can refute and banish all this speculation. Wine can also take on the role of the alchemist, helping to rid us of such human worries.

Few illustrators have attempted to illustrate these ideas. Our research shows only five artists, and these include the ever-present Gordon Ross (1941) and Sullivan (1913). Generally they try to portray the alchemy and the warring sects in some way.

*The mighty Mahmud, the victorious Lord,
That all the misbelieving and black Horde
Of Fears and Sorrows that infest the Soul
Scatters and slays with his enchanted Sword.*

QUATRAIN 44

FitzGerald's text for this verse owes only a little to Omar Khayyam. It is thought that, like quatrain 33, it is based partly on lines from Attar's *Conference of the Birds*. The mighty Mahmud of the first line is Mahmoud of Ghaznah, who, according to Heron-Allen, was in a battle with the 'black infidels of Hindostan' in the early eleventh century.[20] In his final version, FitzGerald changes 'victorious' in the first line to 'Allah-breathing', and 'enchanted' in the last line to 'whirlwind'.

Mahmud and his sword have been the theme represented most commonly by the illustrators who have used this verse. But the black horde of fear and sorrow is not often seen. Balfour (1920) and Fish (1922) both produced rather surreal, art deco, presentations of the theme, in black-and-white. The other illustrations are generally oriental in style.

[left]
A. Rado, 1940. *Rado has a convincingly 'mighty Mahmud' with the 'black Horde/Of Fears and Sorrows' surrounding him, in a rather impressionistic way. The central image of the horseback knight could be taken from the mediaeval crusades.*

[right]
A. Peno, 2001. *This is a much simpler interpretation of Mahmud. He is powerfully presented against a simple red background, with his sword clearly ready for use. The aura surrounding the sword perhaps indicates something of its enchanted qualities. Peno has omitted any image of the enemy.*

But leave the Wise to wrangle, and with me
The Quarrel of the Universe let be:
And, in some corner of the Hubbub coucht,
Make Game of that which makes as much of Thee.

QUATRAIN 45

[left]
Unknown artist, 1918. *This Eastern artist presents a contrasting interpretation of 'Make Game'. The focus is on solitary enjoyment of the hubbub couch, presented in Chinese style, apparently accompanied by an opium pipe. The symbolism of the smoker's dreams is rather obscure; the images could be interpreted as the wrangling of the wise from the first line.*

[right]
R. Bull, 1913. *Exceptionally, Bull has ignored the 'Make Game' theme and produced a rich scene of sages debating the 'Quarrel of the Universe', surrounded by reference books. As usual for Bull, the style is broadly art nouveau with an attractively decorated border.*

This is one of only two quatrains that FitzGerald dropped from his first version in subsequent editions, the other being quatrain 37. No basis for it has been found in the manuscripts of Khayyam himself. Once again the poet calls on us to give up the discussion and argument about the meaning of existence. But, in place of the usual call to drink wine, he suggests that we should relax in a corner and 'Make Game' in some way.

The illustrators who have chosen this verse have mostly interpreted 'making Game' as enjoying oneself in the company of the opposite sex. The imagery has been generally restrained and oriental in style. Brangwyn (1910), Pogany (1930) and Akhbar Tajvidi (1955) all followed this route. In contrast, O'Brien (1920s) created a more Western view, with many people taking part in something of an orgy.

For in and out, above, about, below,
'Tis nothing but a Magic Shadow-show,
Play'd in a Box whose Candle is the Sun,
Round which we Phantom Figures come and go.

QUATRAIN 46

Here FitzGerald and Khayyam introduce yet another set of images to illustrate the illusion and impermanence of existence. FitzGerald's verse is quite close to the original in the manuscript, which, in Heron-Allen's translation, speaks of 'a sort of magic-lantern', of which 'the sun is the flame and the universe is the lamp'. In his subsequent versions, FitzGerald changed some words and their order, but the central meanings remain the same.

This verse has been fairly popular with illustrators. But they have tended to emphasise the phantom figures, or the shadow shapes of the later versions. The more classical illustrators, such as Vedder (1884), Tobin (1899) and Cole (1901), all ignore the idea of the lantern or box, presenting instead groups or processions of robed figures, with sad mien. Some later artists have put more emphasis on the shadow box or lanterns, often ones which revolve with figures on the frame.

M.K. Sett, 1914. *Sett has produced one of his rather surrealistic and highly symbolic arrangements of the various subjects in the text. The sun and the candle flame are both there, but some of the central figures seem to be more substantial than shadows. The butterfly figure to the right of the picture may be drawn in by the central candle flame.*

[left]
A.H. Fish 1922. *In her illustration, Anne Fish has endeavoured to convey the idea of movement in the figures going round on the outside of the lantern. The rays of the sun are visible on the inside. The whole art deco design fills the page with colour and pattern.*

[top right]
A. Tajvidi, 1955. *This Iranian artist has produced one of the most comprehensive and imaginative illustrations for the text. The painting incorporates a sun-candle in the centre with the rays fanning out to illuminate the shapes twirling round at the top. The whole is presented as a kind of cosmic shadow show, against a background of stars. A face (of the master of the show perhaps) is visible in the top right corner.*

[bottom right]
R.S. Sherriffs, 1947. *Sherriffs's version is also very dynamic, but he has his figures visible in colour on the inside of the lantern at the back, leaving the shadow effect for the front. The lamp for the lantern looks more like an ordinary bulb than the sun or candle of the text.*

*And if the Wine you drink, the Lip you press,
End in the Nothing all Things end in – Yes –
Then fancy while Thou art, Thou art but what
Thou shalt be – Nothing – Thou shalt not be less.*

QUATRAIN 47

In the quatrain from which FitzGerald drew his main inspiration for this verse, Khayyam urges the poet (i.e. himself) to be happy, since 'the end of all things is that thou wilt be naught'. FitzGerald has retained this general sense in his interpretation. However, in his last two versions, he seems to have drawn on another of Khayyam's quatrains, and he changed the last two lines to read 'Think then you are TO-DAY what YESTERDAY/You were – TO-MORROW you shall not be less'.

Despite its rather abstract imagery, a reasonable number of artists have chosen to illustrate the verse. Relatively few images are in Western style, and, in their scenes, most illustrators pick up the sentiment in the first line of the wine drunk and the lip pressed.

[opposite]
H.A.-U. Karr, 1938. *Karr has chosen a simple presentation for the verse, with a sultan figure surrounded by his colourful harem. The style reflects that of the Persian miniature, though the plain background and hanging greenery in the top left seem more Chinese in style. The faces of the people are also more Mongol than Aryan in type.*

M. Tajvidi, 1959. *Mohammad Tajvidi uses an intriguing symbolism in his illustration. The foreground images show a group enjoying things while they may, surrounded by pots, anticipating the 'Book of the Pots' to come later in the poem. But the face in the background has no obvious inspiration from the text. It suggests a benevolent power watching over human progress.*

*While the Rose blows along the River Brink,
With old Khayyam the Ruby Vintage drink:
And when the Angel with his darker Draught
Draws up to Thee – take that, and do not shrink.*

QUATRAIN 48

Khayyam's original quatrain speaks of 'a cup which, in due time, they will cause all to drink'. The image of 'the Angel with his darker Draught' is FitzGerald's poetic invention. FitzGerald in subsequent versions of his *Rubaiyat* changed this verse to strengthen the imagery by bringing the Angel and the drink into the first line, so losing the mention of the rose and drinking wine with Khayyam. Both poets here introduce a more definite idea of fate catching up with man, rather than the more nebulous disappearance into nothingness of earlier quatrains.

This verse has been very popular with illustrators, especially in the early period before the First World War. Perhaps the mildly religious imagery appealed more to those living before the two world wars. Only a few artists have included the roses by the river bank, but virtually all have incorporated angels of death in some way. Some of the angels are threatening in character: Sullivan (1913) typically has a skeletal version. But others are quite radiant and gentle; they include work by artists as widely spaced as Halder (1930) and Hemmant (1979).

"And when the Angel with his darker Draught
"Draws up to Thee—take that, and do not shrink."

H. Cole, 1901. *This illustration is typical of some of the early depictions of the verse in a fairly classical Western style. The angel is shown as a rather muscular naked youth, seemingly offering comfort to the old man through his draught.*

[opposite left]
M. Greiffenhagen, 1909. *In his interpretation, Greiffenhagen shows an intimate acceptance of the drink of death by an old bearded man. The white-clad angel dominates him, but does not otherwise seem especially threatening. The artist has placed the whole scene in a garden, with the roses prominent in the foreground.*

[opposite top right]
J. Low, 1947. *Low provides a whimsical depiction of the verse. Both man and angel are rather Chinese in character, and the angel flies into the scene upside down. The whole makes an attractive design, with some detailed patterning on the man's clothes.*

[opposite bottom right]
E. Dulac, 1909. *Dulac presents a much sadder story, with the man lying on the ground accepting the drink to the despair of the woman beside him. The angel is grimmer in her black cloak, though she also has outstretched wings. The patterning of the art nouveau design is beautifully echoed in the surrounding frame.*

QUATRAIN 48 | 115

*'Tis all a Chequer-board of Nights and Days
Where Destiny with Men for Pieces plays:
Hither and thither moves, and mates, and slays,
And one by one back in the Closet lays.*

QUATRAIN 49

Apart from some changes in the first two lines in his later versions, FitzGerald has kept close to the original meanings in Khayyam's quatrain. Khayyam refers to the 'chess board of existence' and the 'box of non-existence'. Chess has been long established as a game in Iran, and the imagery of the chequerboard, with the men as pieces, provides the poets with a new way of expressing the unfathomable nature of fate. But it is clear that, in this verse at least, there is a 'Destiny' which controls man, rather than a simple nothingness beyond today.

The verse offers some very concrete images to stimulate the illustrator. Despite this, it was not a quatrain very much illustrated in the pre-First World War period. Since then, it has been quite frequently selected, in nearly all cases using a depiction of the chess board in some form. The range of scenes in which the game is presented is very wide.

J. Isom, 1967. *Isom depicts destiny as a dominant oriental figure who is clearly playing with 'Men for Pieces'. The overall design of the picture has an unusual perspective and an interesting view of the game.*

[top left]
N. Parry, 1996. *Parry's wood block provides a rich mixture of images to illuminate the verse. The remaining pieces sit on the board, looking up at others flying in a confused fashion in the sky. The mosque and minaret provide a strong central focal point. But again, the controller of the game seems to be absent.*

[top right]
O. McCannell, 1953. *McCannell has used a rather Western image, with a very large God-like figure controlling the game. The 'king' on the chess board has something of an oriental feel, particularly the turban, but the 'queen' is more a figure from Lewis Carroll's* Alice in Wonderland. *The other pieces lie around 'slain', as in the text.*

[bottom]
L. Hemmant, 1979. *Lynette Hemmant clearly shows 'men' as pieces, though most of her figures are actually women. Her front figure conveys the sense of confusion in a game which someone else controls. But there is no sign of the controlling destiny.*

The Ball no Question makes of Ayes and Noes,
But Right or Left as strikes the Player goes;
And He that toss'd Thee down into the Field,
He knows about it all – HE knows – HE knows!

QUATRAIN 50

The theme of destiny, unknown to the individual but controlled by someone, is continued even more forcefully in this quatrain. The verse is one of FitzGerald's best known, probably thanks to its graphic reference to the ancient Persian game of polo. The new metaphor, replacing that of chess in the previous quatrain, is contained in the original Calcutta manuscript, to which FitzGerald stayed quite close in his interpretation. The perhaps unexpected sentiment of the last line, reiterating 'HE knows' is in the original Persian.

Sixteen illustrators have chosen to portray this verse, with those in the more modern period and artists with Iranian origins particularly prominent. Many of the artists have produced fairly straightforward polo-based interpretations, often in the style of the Persian miniaturists. But others have focused simply on the 'one who knows', here generally using more Western imagery. Sett (see left) and Sullivan (1913) are examples of this.

M.K. Sett, 1914. *Sett, who was Indian in origin, has produced not a polo player but a saint-like figure to illustrate this verse. He has used various symbols of religion and power, including the Christian cross. The figure appears to be juggling with these symbols, thus suggesting the random quality of fate. Bunches of grapes are shown on his robes.*

[top]
A. Tajvidi, 1955. *Akhbar Tajvidi here gives a typical Persian interpretation of the game. The scene is relatively formal, and for other purposes might have been used to depict a battle. The planets are strongly shown in the sky, presumably to reinforce the message of fate.*

[bottom left]
R.S. Sherriffs, 1947. *Sherriffs's depiction of the polo player is typically strong and colourful, with a real sense of movement. The presentation is straightforward and realistic, with no attempt to show the ball from the text in its human character. The mosque in the background reinforces the slightly religious sense of the verse.*

[bottom right]
J. Wong, 1961. *This print by Jeanyee Wong provides a much more stylised view of a number of polo players. Only the single ball indicates that a game may be taking place. Despite the lack of detailed background, the style of the players echoes that of the Persian miniature. Minarets in the background again give a mildly religious feel to the presentation.*

The Moving Finger writes; and, having writ,
Moves on: nor all thy Piety nor Wit
Shall lure it back to cancel half a Line,
Nor all thy Tears wash out a Word of it.

QUATRAIN 51

This is another very well-known verse of FitzGerald's. Again he has kept close to the ideas presented by Khayyam in the original quatrain, though the earlier poet puts even more stress on personifying the unchanging nature of destiny. The third line in the original is translated as 'on the First Day He appointed everything that must be'. But the image of the 'Moving Finger' is FitzGerald's. Khayyam had 'the Pen [writes]'.

The idea of a moving finger writing has drawn a large number of illustrators. We have found over twenty artists who used it as inspiration, more commonly in the modern period. Most interpretations use orientalist imagery, and the finger or its writing are almost always shown. Lundborg, with her early (1900) black-and-white figure of a crouching angel, is an exception.

M. Anderson, 1940s. *The overall design of this black-and-white print by Marjorie Anderson is remarkably similar to that of Murray's colour painting (opposite). Only one finger is clearly defined, though the other two cloudy shapes could be seen as pointing as well. The seated man in this presentation has more of the feel of a mediaeval gentleman.*

[top left]

W. Murray, **1946**. *The threat of the moving finger and its writing are strongly indicated in this illustration from just after the Second World War. In fact there seem to be two fingers, perhaps to show the continuity of the process. The man in oriental dress, seated on the floor, appears to ward off the fingers as they approach. His flasks of wine are on the table in front.*

[top right]

J. Hill, **1956**. *Hill's presentation is typically intimate, with simple lines and shapes in his one-colour drawing. It is not clear whether the figure is continuing to add to the frieze of writing round the arch, or is tracing out the message. The horn in his hand could be for wine, reminding the viewer of earlier messages of how, temporarily, to escape the dictates of fate.*

[bottom right]

A. Hanscom, **1905**. *Adelaide Hanscom has posed her two female figures with fingers stretched as though they were tracing out a text in the panel on the wall. This illustration, taken from a colour photo, is very Western in style. While being visually pleasing, it conveys little of the fatalistic sense of the verse.*

"The Moving Finger writes; and having writ, Moves on"

And that inverted Bowl we call The Sky,
Whereunder crawling coop't we live and die,
Lift not thy hands to It for help – for It
Rolls impotently on as Thou or I.

QUATRAIN 52

FitzGerald used two quatrains from the manuscripts as the basis for this verse. The image, in the first line, of the sky or heavens as an inverted bowl, is one probably drawn from Attar.[21] But Khayyam's original quatrain also includes the idea of mankind being caught helpless under the bowl. In contrast to the previous few quatrains, there is no sense here of any power that is controlling the way the world 'Rolls impotently on'.

This verse was particularly popular for illustrators in the pre-First World War period, with a greater emphasis on Western-style interpretations. Most artists show a figure, generally male, with hands outstretched towards the heavens. Balfour (see right) is an exception. Pogany, in his first set of paintings (1909), shows a whole set of people crying out to heaven, lost in the general fog that pervades much of this portfolio.

R. Balfour, 1920. *Balfour offers a very contrasting set of images, probably designed to illustrate both this verse and the previous one. His art deco presentation is typically difficult to interpret. The central swirling figure of the man has his finger pointed down and extended by a snake. It is directed towards a small upturned bowl with symbols on it.*

[left]

R.T. Rose, 1907. *Rose has made a very poignant illustration by including a whole family in his work. The image of distressed people, naked and lost in a desert, seems very modern for its time. The figure of the man with hands upheld is reminiscent of a famous post-war statue by Zadkine, now in Rotterdam.*

[top right]

W.J. Jones, 1921. *Again hands are raised in supplication in the illustration, despite the command, in the third line of the text, that this should not be done. The scene presented is generally oriental, with the sense of clear moonlight and whitewashed buildings. A shadowy minaret seems just visible at the right of the background.*

[bottom right]

A. Henkel, 1924. *Henkel also used a night scene to give a distinctive light and sense of the heavens. The seated figure looks upwards, but does not plead for help. The distant view, framed by an arch, is of a mosque and minarets.*

With Earth's first Clay They did the Last Man's knead,
And then of the Last Harvest sow'd the Seed:
Yea, the first Morning of Creation wrote
What the Last Dawn of Reckoning shall read.

QUATRAIN 53

This verse of FitzGerald's, though rich in metaphor, is a long way in word and sentiment from the quatrains in the manuscript that are said to be its influence. The first two lines, with their imagery of the beginning and the end of man, are essentially of FitzGerald's own making. But Khayyam, as well as FitzGerald, reverts to the idea of quatrain 51, with the pen, or finger, writing a record of life that cannot be expunged.

Only ten artists have been identified as choosing to illustrate this verse. Despite the small number, they are quite representative of periods and style of illustration. The range of interpretations is also very wide. For example, in addition to the two shown here, Bull (1913) has a black-cloaked death figure with scythe, set against a background of a caravan of camels, while Gordon Ross (1941) depicts a shipwrecked boat and the hand of a drowning person, with a large accounting ledger in the sky above.

[left]
H.A.-U. Karr, 1938. *Karr's picture at first sight seems to present a peaceful scene of a minaret with some trees, plus a roofscape of domes against a golden sky. But closer inspection shows that the tower is in process of disintegration and a strange, possibly sinister, bird is perched on top. There is a sense that perhaps the 'Last Dawn of Reckoning' of the last line of the text has arrived.*

[right]
E.Vedder, 1884. *Vedder has interpreted the verse quite tersely, with his picture of two young men, in very classical style, placed on a pile of skulls. The sombre presentation suggests the image of the last of creation. The text of the verse is incorporated in the image, but, unusually for Vedder, it is only the words of this one quatrain rather than the normal two or three.*

I tell Thee this – When, starting from the Goal,
Over the shoulders of the flaming Foal
Of Heav'n Parwin and Mushtara they flung,
In my predestin'd Plot of Dust and Soul.

[left]
H. Behzad Miniatur, 1970. *This modern Iranian artist has chosen here to use a style that has echoes of his namesake, the fifteenth-century Persian miniaturist. The heavens are indicated by a few stars, the moon and (perhaps) the sun. The young man about to mount the horse seems to have little to do with the powerful creation imagery of the text.*

[right]
A. Jamalipur, 1996. *Another Iranian painter provides a more surreal illustration of horse and heavenly bodies. The head of the creator is shown in very traditional style, and the whole illuminates well the message of the verse. The rather florid picture is typical of this modern artist, whose style seems to owe as much to popular Western painting as to his Persian heritage.*

QUATRAIN 54

This is not an easy verse to interpret, either in FitzGerald's version or in the original from the Calcutta manuscript. Khayyam appears to be referring to the beginning of time, when, as seen in the mythology, a stallion was attached to the sun for its journey round the earth. FitzGerald himself provides a note indicating that Parwin and Mushtara are the Pleiades and Jupiter, which are being pulled into their correct positions in the heavens. The last line refers to the idea, already mentioned in earlier quatrains, that all fate is predestined from the beginning.

Again, only ten illustrators have tackled the rather obscure images in this verse. Virtually all of them have chosen to represent the horse, often very realistically, and with a human-looking rider. The horse is generally depicted flying through the sky, in some cases surrounded by planets or other astronomical symbols.

The Vine had struck a Fibre; which about
If clings my Being – let the Sufi flout;
Of my Base Metal may be filed a Key,
That shall unlock the Door he howls without.

QUATRAIN 55

In the original inspiration for this quatrain, from the Calcutta manuscript, Khayyam gives a relatively clear view of predestination and the possibility of creating a key to a 'treasure house of substance'. FitzGerald took only the last two lines of the original, with the key and the door to the treasure house. But the first two lines of the verse are FitzGerald's own. There is no mention of 'Sufi' in the manuscript verse, or of 'dervish', which FitzGerald substituted in his later versions. Nor is the 'Vine' of the first line mentioned by Khayyam. The overall meaning of the FitzGerald verse seems rather confused; he appears to be suggesting that the Sufi has no way in to the treasure.

The complex message of the verse may explain why it has seldom been selected by illustrators. Our analysis shows that 11 artists have used it. The door and/or key are generally shown, together often with a portrayal of the searcher, sometimes 'howling without', at other times quietly seated.

[left]
A. Peno, 2001. *This looks like a sage trying to find a solution by studying. The key is prominent, but no door is visible. It is as though the reader were trying to match the pattern of the key to something in his book. The sense of searching is present in the picture, but not the 'howling' of the verse.*

[right]
G. Ross, 1941. *Ross's imagery suggests the Sufi or dervish trying to enter a place of richness. The figure is clearly that of a poor man, with ragged garments, bare feet and unkempt hair. His begging bowl has fallen to the ground. The background is oriental in style, with the dome of a mosque and figures of people looking on.*

*And this I know: whether the one True Light,
Kindle to Love, or Wrath consume me quite,
One glimpse of It within the Tavern caught
Better than in the Temple lost outright.*

QUATRAIN 56

Both FitzGerald and Khayyam show in their verses a sense of a greater power, which controls mankind's destiny. FitzGerald has it as 'the one True Light', while Khayyam speaks of 'the first and last of all created beings'. In his interpretation, FitzGerald has stayed close to the quatrain in the manuscript. The poet is suggesting that truth may be better found in the tavern than in the place of organised religion, the temple. But it is notable that, unlike in many earlier verses, the value of wine is not specifically mentioned.

Although wine is not mentioned in the text, it figures quite prominently in a number of illustrations of this verse. Some artists, like Ault (see right) and Sullivan (1913) make a drinker the centre of their composition. Others, such as Marie et al. (1994), have used an opening door to show the idea of the glimpse of the light. Gordon Ross (1941) has a very idiosyncratic image of two sages disputing, seated at the top of a pile of overlarge books, with a man offering a flask of wine standing ignored at the side.

[left]
S. Morris, 1970. *As always, it is difficult to interpret Morris's abstract print, but it is located just above quatrain 56 in the book, and therefore presumably may bear some reference to the text. The curving walls seem to lead down to an arch, which could be the entrance to the tavern, and enlightenment. The lanterns, on the right side, reinforce the sense of the true light. The sun and moon in the top corners could have been inspired by the previous quatrains, printed on the opposite page in that edition.*

[right]
N. Ault, 1904. *Ault has focused on the drinker, but unusually this is a woman, and the setting is not very tavern-like. Perhaps she is intended to be the glimpse of the true light that the poet sees. The setting in this early black-and-white print is oriental, with a pleasant courtyard in the background.*

Oh, Thou, who didst with Pitfall and with Gin
Beset the Road I was to wander in,
Thou wilt not with Predestination round
Enmesh me, and impute my Fall to Sin?

QUATRAIN 57

This is another quatrain where FitzGerald kept close to the meaning and imagery of the manuscript verse. Khayyam talks about the 'snares' on the 'road I walk', which FitzGerald interpreted as 'Pitfall and…Gin'. Gin here refers, not to a drink, but to a form of snare or trap. In using the final words 'my Fall to Sin', FitzGerald seems to echo Christian thinking. The original verse speaks of rebellion not 'Sin'.

The idea of snares or pitfalls has been quite freely interpreted by the limited number of artists who have chosen to illustrate this verse. The snare is most often presented in female form, sometimes offering wine as well. Other artists have shown the poet wandering in a lost fashion along an empty road. Pogany did this in his first portfolio in 1909, and the approach has been adopted by two much more modern illustrators, Parry (1996) and Peno (2001).

R.G.T. (name not known), 1940s. *This artist, whom we know only by his initials, has shown pitfalls and snares of another kind. The seated poet seems bemused by the wine that the naked beauty is offering him. The sepia wash of the drawing gives a quietness to the scene. There are elements of the Orient in the man's clothing and the arch just visible in the background.*

[opposite]
E.J. Sullivan 1913. *Sullivan has presented the poet caught in a man-size trap and what seems like a thicket of brambles. The trapped man is evidently crying out to a greater power for help. Like our other Sullivan reproductions, this comes from a hand-coloured copy of the black-and-white original.*

*Oh, Thou, who Man of baser Earth didst make,
And who with Eden didst devise the Snake;
For all the Sin wherewith the Face of Man
Is blacken'd, Man's Forgiveness give – and take!*

QUATRAIN 58

Heron-Allen comments that 'This is a very composite quatrain, round which some controversy has ranged'.[22] For example, none of the expert commentators has found reference to 'the Snake' in any of Khayyam's *rubai*. It is believed that FitzGerald got his idea for the second line from his translation of Attar's *Conference of the Birds*, where the Snake (Iblis or Satan) is in Paradise. Some links can be made for the rest of the verse with three quatrains in the Calcutta manuscript. But the meaning of the final phrase 'Man's Forgiveness give – and take!' has been disputed.[23] Is FitzGerald deliberately twisting the original to suggest that human beings can offer forgiveness to the creator?

This verse has been quite popular among illustrators, especially in the pre-First World War period. Many of the illustrations have been in Western style, reflecting the biblical imagery of the text. The emphasis has mostly been on an image of the snake, usually with an Eve-like figure included.

H. Behzad Miniatur, 1970. *This illustration by Behzad Miniatur is in a different world of the imagination. Instead of woman as the temptress, the artist has a small devilish figure of a man and a snake who are both watching the girl. The style has much of the traditional Persian design, with a highly decorated surround.*

QUATRAIN 58

[left]
G.T. Tobin, 1899. *Tobin's print has an Eve-like central figure as his snare. The serpent is present, but there are no apples visible. Instead the tree up to which the woman looks is covered with blossom in the style of the Persian miniatures. In addition to the symbolic lilies in the foreground, Tobin has a minaret tower in the far distance.*

[top right]
E. Vedder, 1884. *Vedder has created an illustration more in keeping with the Book of Genesis than with The Rubaiyat. The Eve figure has an apple in her hand, while the serpent flows down her hair and along her lower arm. This classical artist produced some fine detail in his depiction of plants and a spider's web. The strange castle high up in the background belies the general biblical feel.*

[bottom right]
E. Dulac, 1909. *Dulac's interpretation is more ambiguous, with a father seemingly mourning the death of his daughter. The artist may have taken his inspiration from the third line of the verse that, in the second edition of* The Rubaiyat *which Dulac illustrated, speaks of 'the Face of Wretched Man'. The result is a powerful image of human despair and tragedy.*

81
Oh, Thou, who Man of baser Earth didst make,
And ev'n with Paradise devise the Snake:
For all the Sin wherewith the Face of Man
Is blacken'd—Man's Forgiveness give—and take!

*Listen again. One Evening at the Close
Of Ramazan, ere the better Moon arose,
In that old Potter's Shop I stood alone
With the clay Population round in Rows.*

QUATRAIN 59

This verse marks the start of the 'Kuza-Nama', the 'Book of the Pots'. This is a set of eight verses in which FitzGerald brilliantly animates the pots to make their complaints about the potter. Heron-Allen comments that FitzGerald here draws his inspiration from the general comparison that Khayyam makes between humans and the pots made from earth, and the link with specific quatrains of Khayyam's is not always close. In the case of this first quatrain of the 'Kuza-Nama', FitzGerald made use of one quatrain describing the potter's shop, and another with the reference to Ramazan (the month of Islamic fasting, also known as Ramadan). The 'better Moon' of line two refers to the new moon at the end of Ramazan.

The solid image of the potter's shop provided many illustrators with inspiration. We have identified nearly thirty different artists who have worked on the quatrain. The main periods and styles of illustration are well represented among these illustrators, though it is interesting that few of the modern Iranian artists have chosen to depict this verse. Virtually every illustrator presents the potter's 'Shop' in some way. Many follow the verse closely, with the poet standing alone in the shop. Others are more impressionistic; Pogany (1909) has a group of seated men, James (1909) shows an outdoor scene, while Balfour (1920) exceptionally has a lady in a fine dress, with just a few pots below her to keep the link with the text.

J. Wong, 1961. *Jeanyee Wong depicts the poet leaning on a large pot as though he was already speaking to it. Despite the limited range of colours used, the patterns on the pots make a decorative impression.*

[opposite left]
A. Henkel, 1924. *Although he was working at the same time as Palmer and Balfour, Henkel has produced a much more traditional interpretation of the text. The poet stands in the entrance to the shop, surveying a rather impressionistic set of pots. The light from behind, reflected from the pots, is perhaps that of the 'better Moon' of the second line.*

[opposite top right]
D.M. Palmer, 1921. *Doris Palmer presents a striking and colourful image of the potter's shop, with an oriental townscape visible through the arches. The poet seems to be seated, or perhaps standing at a lower level. The clay population is depicted with a wide range of colour and size.*

[opposite bottom right]
W.F. Coles, 1913. *This early illustration is very close to the text. The poet is alone, and the potter's wheel stands idle behind him. The whole presentation is one of quiet contemplation, and from the poet's clothing the setting is clearly oriental.*

QUATRAIN 39 | 143

In that old Potter's Shop I stood alone
With the clay Population round in Rows.

And, strange to tell, among that Earthen Lot
Some could articulate, while others not:
And suddenly one more impatient cried –
'Who is the Potter, pray, and who the Pot?'

QUATRAIN 60

FitzGerald had some trouble with this verse, changing the first three lines in his successive versions, but retaining the last one. His inspiration seems to have come from one of the same manuscript quatrains that he also used for quatrain 59. But he rather reinterpreted the last line of Khayyam's verse, to give a different but stronger message. Others translate the original as 'Where are the pot-maker, (and) the pot-buyer, and the pot-seller?'[24]

Rather fewer illustrators have used this quatrain than the previous one. It has been slightly more popular in the period since World War Two, including among the modern Iranian artists. Some artists have added a humorous dimension, with faces or part-bodies for the speaking pots. They include Sullivan (1913), as well as Gordon Ross and Parry (shown opposite).

H. Behzad Miniatur, 1970. *This composition provides a more Persian feel to the potter's shop, and the figure of the poet (or potter) is almost hidden in the centre of the picture. Behzad Miniatur has retained the humour of the text, showing some of his colourful pots with heads and hands.*

[opposite left]
E.A. Cox, 1944. *Although the text is an integral part of his picture, Cox has ignored the idea of the speaking pots and the potter's shop. Instead, he seems to transfer the debate of the last line into the market place, with a variety of human disputants, plus a dog.*

[opposite top right]
N. Parry, 1996. *Parry's print shows a more complex image of potters and pots. Some of the potters seem still to be at work. An alternative interpretation is that the people have somehow emerged from their pots, in order to articulate their concerns. The whole provides an interesting interpretation of the question in the last line, 'Who is the Potter, pray, and who the Pot?'*

[opposite bottom right]
G. Ross, 1941. *Ross has typically gone for the humour of the situation. His central figure is clearly one of the articulate, and dominant, pots. The whole image has something of* Alice in Wonderland *about it. A small mouse is depicted left front, listening to the discourse.*

QUATRAIN 60 | 135

AND, strange to tell, among the Earthen Lot
Some could articulate, while others not:
And suddenly one more impatient cried—
"Who *is* the Potter, pray, and who the Pot?"

*Then said another – 'Surely not in vain
My Substance from the common Earth was ta'en,
That He who subtly wrought me into Shape
Should stamp me back to common Earth again.'*

QUATRAIN 61

In this verse FitzGerald turns the message in the original manuscript quatrain into a question from one of the loquacious pots. Khayyam's quatrain speaks of a sweet cup, acclaimed for its beauty, which 'this Potter of the World, Makes, and then shatters it upon the ground'. The underlying theme of both verses is the same; what is the point of existence if man is to be stamped back to common earth in the end?

This has not been a popular verse for illustrators, and those who have taken it on seem to have struggled to illuminate the words. Most show the creator, or potter, in the process of shattering the pot he has made.

[left]
C. Stewart, 1955. *It is not easy to interpret Stewart's composition. There is the suggestion of recycled shapes in the large pot, which two angels seem to be carrying upwards. The downward pointing hand is presumably that of the creator who will decide whether this pot is to be shattered or not. The touch of lace at the wrist of the hand almost suggests the hand of a woman?*

[right]
J. Low, 1947. *Low presents a conventional view of a potter at work. He works at his wheel with his past product around him. We are left to imagine that the potter is looking at the pot in his hand, considering whether to keep it or stamp it back to 'common Earth' and reshape it into something else.*

Another said – 'Why, ne'er a peevish Boy,
Would break the Bowl from which he drank in Joy;
Shall He that made the Vessel in pure Love
And Fancy, in an after Rage destroy!'

[left]
T.H. Robinson, **1907**. *Robinson's interpretation of the verse is curious. It appears to show a girl coming out of a large broken vessel. A man looks on from below, but it is not clear what his role is. Is he the previous user of the pot, who is watching the result of its destruction? In that case, the message is not as negative as the verse implies.*

[right]
F. Lundborg, **1900**. *Florence Lundborg makes the simple choice of presenting a young boy with a bowl. But there is no sense yet that the bowl will be broken. The blossom in the tree above gives a slightly oriental feel to the illustration. As usual with this artist, the text of several verses is incorporated into the picture.*

QUATRAIN 62

FitzGerald continues with his animated pots and the theme of destroying something that was previously created and enjoyed. In this verse, the destruction is envisioned not by the potter or creator, but by the drinker who uses the bowl 'in Joy'. The sense of the verse is close to that of the equivalent quatrain in the Khayyam manuscript. But the idea of 'a peevish Boy' in the first line is FitzGerald's invention. Khayyam speaks just of a drinker.

Perhaps surprisingly, given the clear imagery, this is another verse poorly represented by illustrators. The interpretations that exist are quite varied. For example, two modern Iranian artists, Behzad Miniatur (1970) and Akhbar Tajvidi (1955) both show the destruction and reshaping of the bowl, while Sullivan (1913) confines himself to showing the 'Boy' (actually more of a young man) drinking in joy from a flask.

None answer'd this; but after Silence spake
A Vessel of a more ungainly Make:
'They sneer at me for leaning all awry;
What! did the Hand then of the Potter shake?'

QUATRAIN 63

This verse is considered by Heron-Allen to have been pure FitzGerald. He could not find any quatrain in the key manuscripts to match the imagery used, though he suggests that the quatrain sums up the ideas in the 'Kuza-Nama' section. But both Heron-Allen and Arberry agree that FitzGerald may have been inspired by a couple of lines in another of Khayyam's quatrains. These, speaking of the elements of creation, read as follows: 'If they are good, why should He break them? And if they turn out bad, well, why is there any blame to these forms?'[25]

The verse seems to offer good opportunity for illustrators, with its image of the 'Vessel of a more ungainly Make'. But the challenge has been taken up by very few artists: we have found only five to date. Most illustrators who have used the verse have taken advantage of the opportunity for humour in the shapes of pots and/or people presented.

[left]
R. Balfour, 1920. *Balfour's art deco illustration does not appear to have a great deal to do with the potter's shop and the speaking pots. But the artist has produced a suitably ungainly character as the central image. The meaning of the candles flanking the figure is obscure.*

[right]
A. Tajvidi, 1955. *The illustration by Akhbar Tajvidi takes us into another world of imagery. His picture is filled with the making and destruction of pots. Out of those destroyed seem to be emerging beautiful girls, paralleling the image by T.H. Robinson for quatrain 62 and Marie et al. for quatrain 65. In the front lies another beauty with her seemingly unbroken bowl beside her.*

Said one – 'Folks of a surly Tapster tell,
And daub his Visage with the Smoke of Hell;
They talk of some strict Testing of us – Pish!
He's a Good Fellow, and 'twill all be well.'

[left]
E.J. Sullivan, **1913**. *Sullivan shows his humorous approach in presenting the sentiment of the last line. His pot is clearly a 'Good Fellow', even if of somewhat 'ungainly Make', as the speaker in the previous quatrain.*

[right]
G. Ross, **1941**. *Ross is in more sober mood here, picking up the first two lines. His devilish tapster seems to be a real source of concern to the animated pots, who look as though they are trying to escape from him as fast as they can waddle. There is no sense at all of Sullivan's 'Good Fellow'.*

QUATRAIN 64

FitzGerald appears to have framed this verse using two comparable quatrains in the manuscripts, one of which may also have inspired quatrain 63. The second of these original quatrains from Khayyam speaks specifically about the time of resurrection, something which is only implicit in FitzGerald's last two lines. The overall message is more optimistic than some of the previous verses, suggesting that in the end ''twill all be well'.

The image of the surly tapster with darkened visage is a strong one, but it has drawn only few illustrators, mostly those who have provided illustrations for all or nearly all the quatrains. Not all have kept their scene setting to the potter's shop. Both the Tajvidis (1955 and 1959) simply provide images of things going well. Others have gone for a humorous approach (see Sullivan, left). But there have also been depictions of the threat of testing in the third line.

*Then said another with a long-drawn Sigh,
'My Clay with long oblivion is gone dry:
But, fill me with the old familiar juice,
Methinks I might recover by-and-bye!'*

QUATRAIN 65

The idea that there could be hope for some kind of positive cycle in existence is retained in this verse. It is thought that FitzGerald based his verse on two quatrains from the original manuscripts. Both of these originals make mention of the idea of taking the clay made from the departed person to create a new pot. The wine that revives the departed one could be seen, in a Sufi interpretation, as the spirit of God.

Again most illustrators seem to have found it difficult to show the meanings of this verse, and have therefore neglected it. Those who have covered it have mostly tried to present the new life being breathed into the clay in some form. But Akhbar Tajvidi (1955) produced a straightforward picture showing wine being poured into a new jug, with little sense of the personal revival of the clay pot.

H. Marie et al., 1994. *Helen Marie and her colleagues provided two illustrations for this verse. They relate to the two separate sets of verses of FitzGerald's first edition of* The Rubaiyat *that are printed in this modern American publication, which gives a spiritual interpretation of the work. Both paintings present an ingenious representation of the recycling process. One picture illuminating this verse (right) has a woman seeming to emerge from the pot, holding a wine flask and with a man holding up a cup beside her. The second illustration is even closer to the text. The artist shows an image of a past person beginning to be restored in the jug as it receives the 'familiar juice' from a pouring hand above.*

So while the Vessels one by one were speaking,
One spied the little Crescent all were seeking:
And then they jogg'd each other, 'Brother! Brother!
Hark to the Porter's Shoulder-knot a-creaking!'

J. Isom, 1967. *Isom has ignored the porter and the moon, and has stayed in the potter's shop with the pots. His highly decorated image shows a rather frightened man (the poet or potter?) surrounded by pots that have clearly come alive. In this edition, the illustration is opposite both this and the previous quatrain, and the pots could possibly be those who have been receiving the 'familiar juice' of quatrain 65.*

QUATRAIN 66

This quatrain brings the 'Kuza-Nama' section to an end. FitzGerald dealt economically with the comparable quatrain from the manuscript, ignoring its explicit mentions of Ramazan, the month of fasting, and Shawwal, the following month. Instead he simply refers to the return of the new moon ('the little Crescent'), which marks the start of the new month, the celebration of the end of fasting, and the return to normal life. The pots are excited by the thought that they will again be filled and carried round to drinkers by the porter. Commentators have disputed the precise interpretation of the last line of Khayyam's quatrain.[26]

Rather more illustrators, over ten, have chosen to depict this verse, in contrast to the five to eight identified for many of the earlier quatrains of the 'Kuza-Nama'. But, there are relatively few illustrators from the inter-war period. The compositions mostly contain the key subjects of the verse, namely pots, porter and crescent moon.

142 | QUATRAIN 66

[top left]
W. Pogany, 1942. *Pogany in his third portfolio of drawings for The Rubaiyat puts his emphasis mainly on the last line of the verse. The porter is centre picture, burdened with his large pot, and with the creaking shoulder knot visible. The over-large new moon is also prominent.*

[top right]
E. Vedder, 1884. *Vedder has skilfully woven the pots and the porter into his design surrounding this verse. There is even a hint of the new moon in the sky. The style is less classical than is usual for this early illustrator. Buildings, pots and porters all show a sense of the Orient.*

[bottom]
R. Bull, 1913. *This is a direct representation of the porter, with his pots, and the new moon. The style is generally orientalist, the figure being set against a background of an Eastern town and palm trees. The single-colour wash, relatively unusual for this artist, gives a rather impressionistic feel to the picture.*

Ah, with the Grape my fading Life provide,
And wash my Body whence the Life has died,
And in a Windingsheet of Vine-leaf wrapt,
So bury me by some sweet Garden-side.

[left]
N. Ault, 1904. *Ault's picture emphasises the last two lines of the verse, which are enclosed with the picture in a decorative art nouveau border. He has gone a little further than the verse states, with the three mourners surrounding the bier. But the body does appear to be covered with vine leaves, as the verse requires.*

[right]
M. Tajvidi, 1959. *The imagery that Mohammad Tajvidi used to illustrate this verse is difficult to interpret. The scene is presumably that of the grave, and there is a sense of things falling apart, as the iron grille, wine flask and flowers (tulips?) topple over. Perhaps it is the time of resurrection mentioned in the Persian original, when the grave will break open.*

QUATRAIN 67

In the last part of *The Rubaiyat*, FitzGerald moves on to the thought of the poet's death. He also returns to focus more on the vine and grape again. In his detailed imagery for this verse, he wandered some way away from the content of the two quatrains in the manuscripts that are believed to have inspired him. They both refer to 'when I am dead wash me with wine'. But Khayyam says that, at the time of resurrection, his body should be sought 'in the earth of the tavern threshold', not 'by some sweet Garden-side', as in FitzGerald's version.

Although there seems to be some potential for illustrating this verse, with its subjects of grape, body and garden-side, not too many illustrators have taken up the challenge. Most focus on the scene of mourning, generally in a garden surrounding. But both Murray (1946) and Davies (1982) present the poet seeking to sustain his fading life with the grape.

*That ev'n my buried Ashes such a Snare
Of Perfume shall fling up into the Air,
As not a True Believer passing by
But shall be overtaken unaware.*

QUATRAIN 68

This quatrain of FitzGerald draws on one from the Calcutta manuscript. FitzGerald has somewhat obscured the original verse with his metaphors. He substitutes 'Snare/Of Perfume' for the 'aroma of wine' of the original, and 'True Believer' for Khayyam's 'drinker'. However, in later versions, FitzGerald reverts to 'snare/Of Vintage', closer to Khayyam. Underlying both verses is the poet's desire that some effect of his existence should remain after his death.

Illustrators seem to have found this verse a difficult one to present, so few have selected it. Of those who have, most show the tomb and the passer-by in some form. Some interpret the 'Snare/Of Perfume' as garden flowers. Gordon Ross (1941) has a butterfly landing on a flower, about to be entrapped in a snare net. Balfour (1920), typically, has his passer-by as an elegantly dressed woman.

[left]
W. Pogany, 1930. *Pogany in his second portfolio produced a realistic interpretation of this verse. There is little very oriental in the scene. What is not clear is whether the figure sitting on the tomb is the dead poet, or a traveller who has been drawn into the site. Further passers-by in the background seem to go on unawares.*

[right]
A. Rado, 1940. *Rado presents a picture of a beautiful garden, which surrounds the tombs. The garden is full of lilies, with their strong perfume, which has drawn the couple in. The man appears to be toasting the dead poet with his own supply of wine. The style, including the clothing of the people and the boughs of the tree, has quite a strong oriental flavour.*

Indeed the Idols I have loved so long
Have done my Credit in Men's Eye much wrong:
Have drown'd my Honour in a shallow Cup,
And sold my Reputation for a Song.

[left]
Unknown artist, 1918. *This version, with its Chinese feel, has used the idol theme of the first line as its prime focus. The naked man in the foreground, surrounded by the symbols of other temptations, clearly portrays the sense of guilt associated with the verse. Only a woman seems to be missing. This black-and-white drawing has beautiful patterning for the idol and his throne.*

[right]
W. Pogany, 1909. *The illustration is from Pogany's first, and most famous, set of paintings for* The Rubaiyat. *The reprobate poet is shown seated front right, with a female musician to keep him company. He watches a procession of notables, who pass by without acknowledging him. The painting is framed by a highly decorated oriental arch, with the gleaming towers of the mosque behind.*

QUATRAIN 69

After the death scenes of the last couple of quatrains, the poet here is living again. He is concerned about his reputation in this world, rather than with what will come after. FitzGerald produced an interpretation that is less directly religious, and more worldly, than that of the original manuscript quatrain. Khayyam there refers to the fact that his prayer, fasting and ritual washing were negated by his pleasures and wine-drinking. FitzGerald instead includes the love of idols, with other pleasures, as being what has done his 'Credit in Men's Eye much wrong'.

This is another verse that few illustrators have chosen, despite the obvious imagery available from the pleasures of the shallow cup, and song. Most artists manage to depict both the poet's pleasures and the world where his reputation is lost, often with greater emphasis on the latter. Vedder (1884) distinctively shows the poet with his books, looking sadly at a beautiful naked woman, presumably one of the pleasures that he should abjure.

Indeed, indeed, Repentance oft before
I swore – but was I sober when I swore?
And then and then came Spring, and Rose-in-hand
My thread-bare Penitence apieces tore.

QUATRAIN 70

FitzGerald's version of the underlying quatrain from the Calcutta manuscript is close in meaning to the original. He only hints at why the poet should be repenting, through the inference in the second line of being drunk at a previous time. Khayyam is more explicit, speaking of repentance from 'the brimful goblet and cup'. But both poets seem to feel that, in the season of roses, repentance is impossible.

This verse has been surprisingly popular with artists, presumably because the idea of the personification of spring as a young girl, plus the roses, seemed attractive subjects for illustration. Our analysis shows over twenty different illustrators for the quatrain. Many of them use basically Western imagery. Not all follow the obvious subjects. Some, like Hanscom (1905) and Marie et al. (1994), present the poet alone, struggling in his mind with his temptations.

E. Geddes, 1910. *Geddes has produced a highly decorated art nouveau image of the coming of spring. Interestingly, it is the man behind, presumably the no-longer-repentant poet, who holds up the garland of roses (and birds). There is no sense of penitence in this picture.*

[top left]

A.H. Fish, **1922**. *Anne Fish, in her art deco style, presents a very different composition from others, though again including both the erstwhile repenter and the figure of Spring. This time it is Spring who has the roses, but she is shown almost as though walking out of a circular picture or mirror.*

[top right]

E.A. Cox, **1944**. *In his own distinctive style, Cox shows a simple, rather static, version of the meeting of Spring and the relapsed repenter. The latter does not appear to be very happy to meet this new temptation. The presentation is reminiscent of a mediaeval manuscript, with the text incorporated in the picture.*

[bottom right]

W. Pogany, **1930**. *Pogany has created a vivacious meeting of Spring, as a beautiful naked maiden, and the poet, in his black covering. The covering of penitence is in process of being torn away, exactly as in the words of the last line of the verse. This painting is from Pogany's second set of illustrations for* The Rubaiyat, *which have a generally more Western style than his first.*

NDEED, indeed, Repentance oft before
I swore—but was I sober when I swore?
And then and then came Spring, and Rose-in-hand
My thread-bare Penitence apieces tore.

And much as Wine has play'd the Infidel,
And robb'd me of my Robe of Honour – well,
I often wonder what the Vintners buy
One half so precious as the Goods they sell.

QUATRAIN 71

The poet seems here still to be in unrepentant mode. He has lost his reputation, yet cannot understand the worthwhileness of things other than the joys that wine can give. FitzGerald's version is close to the original quatrain in the Ouseley manuscript, especially in the last two lines, where FitzGerald expresses Khayyam's words almost exactly. There is another version of this quatrain with a very different first two lines, which presumably FitzGerald did not see in its original, although it was in the Nicolas translation that he studied.[27]

Although the sentiment and potential imagery are not dissimilar from those of earlier verses, this quatrain has the distinction of being the verse least used by the illustrators that we have identified. We have found only four artists who have covered the verse, including three, Sullivan (1913), Gordon Ross (1941) and Akhbar Tajvidi (1955), who have illustrated virtually every verse of FitzGerald's first edition.

A. Tajvidi, 1955. *Akhbar Tajvidi has a much more lively interpretation of the verse than Katchadourian (opposite). The poet lies rather sadly with his wine in the front, while beautiful girls disport themselves around a large jar (of wine) behind him. In the background, there are some shadowy figures, perhaps either the vintners of the verse or the men of the world whose honour the poet has lost.*

S. Katchadourian, 1946. *This modern Iranian artist has presented a toper lost in contemplation. His turban has been put to one side, while his book and pens, as well as his wine, lie neglected at his feet. The style seems like a modernised version of a mediaeval Persian miniature.*

Alas, that Spring should vanish with the Rose!
That Youth's sweet-scented Manuscript should close!
The Nightingale that in the Branches sang,
Ah, whence, and whither flown again, who knows!

QUATRAIN 72

In the last four quatrains of his first edition, FitzGerald reverts to the theme of the loss of youthfulness and the approach of death. For quatrain 72, he produced an elegant version of the original quatrain in the Calcutta manuscript. Khayyam speaks there of the 'book of youth' being folded up, and the 'bird of joy, whose name is Youth'. FitzGerald's reference to the rose and the nightingale fits well with the tradition of Persian poetry.[28]

This verse has been very frequently selected by illustrators. Our analysis shows over twenty artists working on it, the majority providing broadly orientalist settings for their images. They divide into two main groups in terms of their subject matter, those choosing to present youth and spring, and those dealing with the sadness of growing old. The elusive nightingale is quite often, but not always, included.

J.Y. Bateman, 1958. *The black-and-white illustration Bateman produced for this verse is typically mildly erotic. Spring is shown as a naked beauty, stealing into the space, clutching a rose. She is accompanied by two gazelles, and two birds fly in the background, more resembling doves than nightingales. The man seated in front, with his manuscript, presumably represents the poet, though he is not the older man of the verse.*

[left]
G. James, 1909. *This is a painting from James's third, and most extensive, set of illustrations for* The Rubaiyat. *It is a typical variation on his oft-repeated composition of a man standing by a woman sitting. The trees look to be in the blossom of spring, while the man could be the older poet looking out on his lost youth. There is no sign of the nightingale.*

[top right]
H. Beck, 1950. *Beck has focused on the middle two lines, with a man, no longer youthful, looking at a manuscript. The twisted tree in the background has blossom on it, as does the unusual cactus on the left. The nightingale is clearly depicted on a branch of the tree.*

[bottom right]
E. Dulac, 1909. *Dulac has chosen to depict the trials of age, with an old man trudging along with a heavy load of firewood. The image could be one from this artist's many depictions of fairy tales and legends. But there is an apparition of Spring (flying as a bird) up in the tree.*

Ah Love! could thou and I with Fate conspire
To grasp this sorry Scheme of Things entire,
Would not we shatter it to bits – and then
Re-mould it nearer to the Heart's Desire!

QUATRAIN 73

This is a powerful verse of FitzGerald's in which he has, unusually, suggested the possibility of a better world in the future, rather than just the escape from the present, either to past youth, or through the oblivion of wine. In fact FitzGerald kept close to the sense of the original quatrain. His main change was the introduction of the 'thou' into the verse. Khayyam's version, from the Calcutta manuscript, refers only to the poet himself and his own wish to change things.

The abstract quality of the verse means that it has not particularly inspired illustrators to interpret it. Of the eight artists that we have identified as using it, four are in the post-Second World War period. Most of them have chosen either to present the 'thou and I' of the first line in some form, or to show the world being reshaped by a large pair of hands.

R. Balfour, 1920. *Balfour has approached this verse as though the process of re-creation was about to take place. His male figure, rather primitively clad, appears to be commanding things to change, and the volcanic mountains suggest the possibility of an eruption to come. Trees and landscape are patterned in great detail, and the whole design is more relevant to the verse than is sometimes the case with this illustrator.*

[opposite top left]
A. Tajvidi, 1955. *This is a fairly traditional image of a seated couple by Akhbar Tajvidi, with echoes of his miniaturist forebears. But a heavenly body in the sky seems about to break up. It is not clear whether the change menaces the couple, or comes at their instigation.*

[top right]
E.J. Sullivan, 1913. *Sullivan has taken the second line as the focus for his interpretation. As with Balfour, it seems as though the reshaping of the world is already happening, rather than being just the wish expressed by FitzGerald. A large pair of hands appears to be banging the globe, trying to bring it to a new form.*

[bottom right]
R. Bull, 1913. *In this illustration, Bull has opted for a simple romantic composition showing a couple together by moonlight. The picture is beautifully designed, with blossom and flowering tree echoed in the ornate floral border. But there is little to indicate the more serious sentiment of the verse.*

Ah, Moon of my Delight who know'st no wane,
The Moon of Heav'n is rising once again:
How oft hereafter rising shall she look
Through this same Garden after me – in vain!

QUATRAIN 74

In this penultimate verse of FitzGerald's first version, the poet prepares for death, reflecting the idea that existence will continue but he will no longer be there to share it. In fact, FitzGerald took only the more melancholic sentiments from the original quatrain, omitting Khayyam's customary suggestion to drink wine in the moonlight as a solace. The garden of the fourth line is also an innovation of FitzGerald's.

Many illustrators have selected this moonlit topic as inspiration. We have identified 37 different artists, more even than for the last quatrain of FitzGerald's *Rubaiyat*. The moon is mostly very visible in the illustrations, usually with either one or two people in a garden. The single person is sometimes the poet speaking to the moon, as in the first two lines. But several artists chose to show the 'she' of the third line, looking for the missing poet.

E.H. Garrett, 1898. *This early illustrator has produced a very sentimental Victorian interpretation of the verse. The image is that of the young love to which the poet looks back in this and previous verses. The moonlight and detail of the garden background come through well but slightly fuzzily in the black-and-white print.*

[top left]
D.M. Palmer, **1921**. *Doris Palmer presents a distinctive composition, with a watery Eastern landscape and a mosque in the background. Her focus is on the poet alone, calling out to the moon. The effect of the moonlight is cleverly shown through the shadows in the water.*

[top right]
A.H. Fish, **1922**. *Anne Fish has used a clear art deco style in her approach to the subject. She has chosen to portray the lover, left behind in the world, who sits in her grand pavilion looking for the poet at the rising of the moon. There is an ornate roofscape of mosques and domes below the pavilion.*

[bottom right]
G. James, **1898**. *James only covered this verse in his first portfolio. The view presented, of a man and a woman seated and standing, is very typical of all this artist's illustrations. But the background and skyscape of this picture are very striking, and clearly reflect the text. The image has the feel of the older poet, taking a farewell of moon and life.*

*And when Thyself with shining Foot shall pass
Among the Guests Star-scatter'd on the Grass,
And in thy joyous Errand reach the Spot
Where I made one – turn down an empty Glass!*

QUATRAIN 75

This is the final verse for all of FitzGerald's versions of *The Rubaiyat*. He made a significant change in the first line for the third and subsequent editions, removing 'Thyself with shining Foot' and substituting 'like her, oh Saki' (wine bearer). His inspiration came from two rather similar quatrains in the Ouseley manuscript. One of them includes the idea of the cup bearer and the other the symbol of turning a goblet upside down. Both of Khayyam's quatrains have the underlying call that friends, when meeting together, should 'remember a certain helpless one in your benediction'. But the image of guests out on the grass is FitzGerald's own addition.

It is to be expected that this last verse would be popular with illustrators. Our research shows that 30 artists were drawn to it, especially those from the pre-First World War period. Most illustrators have been unable to resist showing the turning down of the empty glass. The person doing this is nearly always a girl. But some artists, like Gordon Ross (1941) and Marie et al. (1994), have focused solely on the 'Glass', presented as a large goblet being reversed by unknown hands.

J.M. King, 1903. *Jessie King has produced a stylised Beardsley-like version of the garden scene. Her central figure of a woman bends very gracefully as she turns down the glass, pouring out a stream of wine as she does so. The elaborate patterning of clothing and flowers creates a wonderful swirling feeling in the picture.*

[top left]
E.S. Hardy, 1907. *Unusually Hardy has elected to show a man as turning down the glass. The painting is strongly oriental in terms of the clothing and the mosque in the background. But the scene is more one of wasteland than the garden of the text, and there are no other friends visible.*

[top right]
E. Dulac, 1909. *Dulac has a group of friends, fully reflecting the 'Guests Starscatter'd on the Grass' of the second line. The saki is a woman, and she is the one about to turn down the glass. The artist has interpreted the verse in an oriental art nouveau style, with the decorative border reflecting some of the detail of the picture.*

[bottom]
W.G. Stirling, 1932. *Stirling has two of his typical oriental characters standing, sombre-faced, in front of a grave. It seems that they are formally about to turn down the glass, in memory of their friend. The patterning of the front man's shawl relieves the starkness of the black-and-white image.*

158 | ILLUSTRATING INDIVIDUAL QUATRAINS

ILLUSTRATIONS FOR FITZGERALD'S OTHER EDITIONS OF *THE RUBAIYAT*

FitzGerald's first edition of *The Rubaiyat of Omar Khayyam*, published in 1859, contained only 75 quatrains. But, as discussed in Part 1,[29] after publishing this edition, FitzGerald continued work on the Persian originals. He also obtained a copy of the work of the French translator Nicolas,[30] which encouraged him to look again at some of the verses in the Ouseley and Calcutta manuscripts that he used for his first edition.

The outcome of this work was the second edition, published in 1868, which contained an extra 37 quatrains, less two he dropped from his first version, making a total of 110 verses. Heron-Allen's study[31] shows that most of the new verses have some basis in Khayyam's originals from the manuscripts. But there is one new quatrain that can only be attributed to Attar (36 in the second edition), a further three that seem to draw only on Nicolas (47, 106 and 107), and a further two (77 and 99) for which no source can be found, other than FitzGerald's own inspiration (for further analyses, see the comparative table in Appendix 5).

As well as adding to the total, FitzGerald also revised the wording of some of his earlier selections in his second edition. Further work led FitzGerald to produce a third edition in 1872, this time with a total of 101 verses, nine fewer than in the second edition, and with some more changes in wording. The total of verses remained unchanged in the fourth and fifth editions, 1879 and 1889 respectively, which have just minor changes in wording and punctuation from the third edition. In his detailed analysis of FitzGerald's *Rubaiyat*, Decker provides a full comparison of the changes made between the different editions.[32]

Quite a number of artists created their illustrations for these later editions of FitzGerald's *Rubaiyat*. They include important illustrators from the pre-First World War period, like Vedder (1884, third edition) and Dulac (1909, second edition), as well as the more modern Iranian artist H. Behzad Miniatur (1970, second and fifth editions in the same book).[33] Their illustrations for the quatrains that remained basically the same as in the first editions have been covered under quatrains 1–75 above. Most of these artists also provided some illustrations for the new quatrains found only in later editions.

Examples of this work are given below, along with the relevant text. Overall, the illustration of the additional quatrains is relatively sparse. Although we have identified a total of 17 artists who have worked on the additional quatrains, there are seldom more than one or two illustrators for each verse, and there are ten of the new verses for which we have found no illustration. This contrasts with the minimum of at least four artists as illustrators for each of the quatrains in FitzGerald's first edition.

[opposite]
H. Behzad Miniatur, 1970. *(Quatrain 14 in the second edition.)*
Were it not Folly, Spider-like to spin
The Thread of present Life away to win –
What? for ourselves, who know not if we shall
Breathe out the very Breath we now breathe in!

[top left]
G. James, 1898.
(Quatrain 33 in the fourth edition.)
Earth could not answer; nor the Seas that mourn
In flowing Purple, of their Lord forlorn;
Nor rolling Heaven, with all his signs reveal'd
And hidden by the sleeve of Night and Morn.

[top right]
G.T. Tobin, 1899.
(Quatrain 39 in the fourth edition.)
And not a drop that from our Cups we throw
For Earth to drink of, but may steal below
To quench the fire of Anguish in some Eye
There hidden – far beneath, and long ago.

[bottom left]
A. Hanscom, 1905.
(Quatrain 46 in the fourth edition.)
And fear not lest Existence closing your Account, and mine, should know the like no more;
The Eternal Saki from that Bowl has pour'd
Millions of Bubbles like us, and will pour.

[bottom right]
L. Hemmant, 1979.
(Quatrain 40 in the fifth edition.)
As then the Tulip for her morning sup
Of Heav'nly Vintage from the soil looks up,
Do you devoutly do the like, till Heav'n
To Earth invert you – like an empty Cup.

[top left]
S. Katchadourian, 1946.
(Quatrain 62 in the fourth edition.)
I must abjure the Balm of Life, I must,
Scared by some After-reckoning ta'en on trust,
Or lured with Hope of some Diviner Drink,
To fill the Cup – when crumbled into Dust!

[top right]
E. Dulac, 1909.
(Quatrain 70 in the second edition.)
But that is but a Tent wherein may rest
A Sultan to the realm of Death addrest;
The Sultan rises, and the dark Ferrash
Strikes, and prepares it for another guest.

[bottom left]
W. Pogany, 1930.
(Quatrain 45 in the fourth edition.)
'Tis but a Tent where takes his one day's rest
A Sultan to the realm of Death addrest;
The Sultan rises, and the dark Ferrash
Strikes, and prepares it for another guest.

[bottom right]
E. Vedder, 1884.
(Quatrain 66 in the third edition.)
(Vedder number differs.)
I sent my Soul through the Invisible,
Some letter of that After-life to spell:
And by and by my Soul return'd to me
And answer'd, 'I Myself am Heav'n and Hell.'

162 | ILLUSTRATING INDIVIDUAL QUATRAINS

J. Watson Davis, 1920s.
(Quatrain 98 in the fifth edition.)
Would but some winged Angel ere too late
Arrest the yet unfolded Roll of Fate,
And make the stern Recorder otherwise
Enregister, or quite obliterate!

ILLUSTRATIONS UNRELATED TO SPECIFIC QUATRAINS

E. Hallward, 1899. *This picture by Ella Hallward is the frontispiece from Heron-Allen's seminal analyses of FitzGerald's* Rubaiyat *and its sources. A different version of the same picture was also used as the frontispiece for Heron-Allen's own translation of the Bodleian manuscript.*[34]

It is frequently the case, in the illustrated editions of FitzGerald's *Rubaiyat* that publishers fail to label illustrations as referring to a specific quatrain, or the pictures are incorporated into the book at a page distant from the intended verse. As mentioned on p. 16, this can make for considerable difficulty in identifying the quatrain being illustrated, and we have had to conclude, for some editions, that all or part of the illustrations do not relate to specific quatrains. These we have described as 'unrelated' illustrations.

The reason for the existence of such unrelated illustrations can only be surmised. It may be deliberate, in that publishers have sought, through the illustrations, to provide only an atmosphere for the poem as a whole. For example, in one or two cases, publishers have chosen old Persian illustrations for their *Rubaiyat*, and here there can obviously be no direct link to particular quatrains.[35] Equally, the lack of relationship might be the choice of the illustrator, who has not wished to produce illustrations closely tied to specific quatrains, or has wished to keep to a fairly narrow style of illustration, producing what might be called variations on a theme; Buckland-Wright's depictions of a couple in different scenes, done for the Golden Cockerel Press in 1938, is a particular example.[36] Alternatively, the fact that the illustration seems not to bear any relationship to the content of a particular verse could be unintentional. It may be that the artist has misunderstood the theme of the quatrain, or just that, at least in the eyes of these observers, no link can be discerned by the viewer.

The versions of FitzGerald's *Rubaiyat* in which we have identified unrelated illustrations vary greatly. They have been published at all periods and in different forms. In some of the earlier editions, published around the turn of the twentieth century, there is only a single illustration as a frontispiece, with no apparent connections to any of the quatrains. Examples of this are the illustrations by Hallward (1899) (left) and Marcel (1900). In other editions, there have been a substantial number of illustrations (over thirty in some cases) that cannot be related to specific quatrains.

Some illustrators have included in their versions of *The Rubaiyat* both illustrations that can be specifically related to a particular quatrain, and some that do not. These are sometimes marked by a clear change in the style of the illustrator. For example, Balfour in 1920 moved away from his customary art deco mode of women in various forms of *déshabille* to produce one illustration of a mosque in a landscape in a different style. A little earlier, Hanscom (1905), with her photographs of constructed poses related to specific quatrains, appears to run out of ideas and to substitute simple photographs with little link to the verse. Another illustrator who produced some pictures with only mood relation to the verse was McPharlin (1940), who mixed monocoloured prints containing related subjects with prints of

objects in a still life composition. In 1967, Isom, with a collection of imaginative and distinctive illustrations, mixed fantasy and reality, only some of which could be related to individual quatrains. Looking East, in the post-Second World War period, Akhbar Tajvidi (1955) produced a large number of illustrations for the editions of *The Rubaiyat* aimed at the foreign tourist market. Although quite a number of his illustrations have been included in our analysis of FitzGerald's first edition, many other paintings by this artist defy a direct relationship to a specific quatrain.

Examples of the work of various artists who produced unrelated illustrations, and who are not represented in our earlier analysis, are given below. Interestingly, many of them are illustrators working in the period following the Second World War.

[left]
J. Buckland-Wright, 1938. *The celebrated Golden Cockerel Press commissioned Buckland-Wright to produced a series of elegant line engravings for* The Rubaiyat. *They are reproduced in black-and-white, all in an orientalist style, with a similar theme of boy and girl in love. Another example is shown as illustration 33 in Part 1.*

[right]
V. Burnett, 1970. *The set of line drawings by Burnett was published in a* Rubaiyat *by the Folio Society for a number of years from 1970. The artist has created pictures of various single figures who all look as though they came from the same family. The background to some of the figures (mosques etc.) or their equipment (armour and swords) suggest possible links to specific verses, but these are difficult to establish precisely.*

[top left]
Old Persian artists. *Where publishers have used early Persian miniatures to illustrate* The Rubaiyat, *it is difficult to see how they do relate to any specific verse. The example shown here, originally presented in the manuscript mentioned in Part 1,[37] illustrates the point. It simply gives a generally oriental feel to the book.*

[top right]
V. Angelo, 1935. *Angelo produced, for the Limited Editions Club in New York, a set of colourful and symbolic illustrations, that are difficult to relate to specific quatrains. The style is highly decorated; text pages as well as illustrations are included in patterned borders.*

[bottom left]
M. Sayah, 1947. *Sayah is an Iranian artist who settled in the US. His illustrations are part of a highly decorated edition of* The Rubaiyat *produced by Random House; as well as the paintings, all pages have a complex background design of birds, butterflies plants and animals. Sayah created a range of colourful prints, with a feel of the traditional Persian designs, mostly with the boy and girl in love theme.*

[bottom right]
H. Shakiba, 1999. *Shakiba is an artist working currently in Iran, whose illustrations have been used in several multi-lingual editions published in Tehran. The books themselves are large format, luxury productions, aimed at local collectors as well as the tourist market in Iran. The illustrator has produced some highly coloured and extravagant compositions, with a considerable Western influence in style.*

166 | ILLUSTRATING INDIVIDUAL QUATRAINS

[top left]
E. Karlin, 1964. *Thomas Y. Crowell produced a version of* The Rubaiyat *with a number of line drawings by this American artist. The black-and-white drawings were in a somewhat oriental style, often hinting at a relationship to a particular quatrain without referring clearly to it. The artist's work is beguilingly simple and often mildly erotic in detail.*

[top right]
P. McPharlin, 1940. *This set of red and white prints were produced by McPharlin for the American Peter Pauper Press in 1940. The edition is one of four that the publisher produced in the middle of the twentieth century (the other artists are Vera Bock, 1949, J. Hill, 1956, and Jeanyee Wong, 1961). The content of McPharlin's illustrations is generally symbolic, and in most cases without obvious relation to the verses they accompany.*

[bottom left]
M. Chugtai, 2001. *Very recently, Caxton Editions produced an imaginative* Rubaiyat, *using the earlier paintings by the Indo-Persian illustrator Muraqqa Chugtai. The latter flourished at the beginning of the twentieth century, working in a kind of art nouveau style in what was then British India. The pictures portray a variety of oriental scenes.*

[bottom right]
M. Karpuzas, 1997. *This edition from Uzbekistan contains the text of FitzGerald's* Rubaiyat *in English as well as versions in Farsi, Russian and Uzbek. Karpuzas has produced a variety of modernistic but rather enigmatic line drawings. They give a generally oriental atmosphere, but do not connect easily to a specific verse.*

APPENDIX 1
PUBLISHERS AND ILLUSTRATORS OF FITZGERALD'S *RUBAIYAT*

The table below shows, in date order, the 135 illustrated editions of FitzGerald's *Rubaiyat* in English for which we have been able to identify a distinct and different artist. There are, in addition, at least 17 editions in various libraries, which appear to be illustrated, but where we have not yet been able to check who the artist is. The list includes only the first publication in which the work of the specific illustrator was included. There have often been subsequent editions of the artist's work (in some cases, very many of these – see comments in Part 1, on pp.19–20). Some details of further editions are shown in Appendix 2, and there is more information on the earlier (pre-1929) reissues under the relevant numbers in Potter's invaluable listing (1929).[1]

Explanatory notes to the table

- *Date and publisher*. These are for first time of issue for that artist. Some dates are approximate only. 191x indicates sometime in the 1910s. 19xx indicates sometime in the twentieth century, i.e. effectively date unknown, but probably after the period covered by Potter (to 1929).
- *FitzGerald edition*. This shows which of the five editions are included in the publication. F6 indicates that verses were included from several editions. F+others indicates that the work of some other English translator was included.
- *Illustrator*. Surnames and initials are shown only. First names are given in Appendix 2; 'nnk' indicates 'name not known'. Names followed by (1), (2) or (3) show the different portfolios for one artist. Details of other editions using 'Persian old' illustrations are shown in a separate table at the end.
- *Illustrations number and format*. C indicates full colour paintings. O indicates other formats (e.g. prints, black-and-white drawing, photographs etc.). The examples of the artists' work in Part 2 give more information. In most cases, the analysis is based on an examination of a copy of the edition in question. Where this has not been possible, we have drawn on the best available information.
- *Potter no*. This refers to the listing of the publication in the Potter bibliography of 1929.[2]

Date	Publisher	Location	FitzGerald edition	Illustrator	Illustrations No	Format	Potter no
1879	Bernard Quaritch	London	F4	Persian old *	1	O	141
1. 1884–1918: the 'art nouveau' period							
1884	Houghton Mifflin	Boston	F3	Vedder E.	46	O	201
1898	L.C. Page	Boston	F6	Garrett E.H.	1	O	302
1898	Leonard Smithers	London	F1	James G. (1)	14	O	391
1898	L.C. Page	Boston	F6	James G. & Garrett E.H.	12	O	301
1898?	Mansfield & Wessels	New York	F6	McManus B.	12?	O	233
1899	Bernard Quaritch	London	F6	Hallward E.	1	O	564
1899	Frederick A. Stokes	New York	F4	Tobin G.T.	20	O	216
1900	Doxey's	New York	F4	Lundborg F.	36	O	240
1900	H.M. Caldwell	New York	F4	Marcel A.D.	1	O	243
1901	John Lane Publisher	London	F1	Cole H.	6	O	8
1901	Hacon & Ricketts	London	F1	Ricketts C.	1	O	4
1902	George Bell & Sons	London	F1	Bell R.A.	4	O	12
1902	J.F. Taylor	New York	F4	Bjerregaard C.H.A.	9	C	252
1903	George Routledge	London	F1	King J.M.	4	O	16
1904	Gay & Bird	London	F1	Ault N.	12	O	108
1904	Small Maynard	Boston	F+others	Hobson A.E.	1	O	404
1905	Essex House Press	London	F1	Ashbee C.R.	1	O	29
1905	Dodge Publishing	New York	F4	Hanscom A.	28	O	258
1906	Gibbings	London	F1	Brangwyn F. (1)	5	C	33
1906	S. Rosen	Venice	F1	Stella G.M.	6	O	169

Date	Publisher	Location	FitzGerald edition	Illustrator	Illustrations No	Format	Potter no
1907	E. Nister	London	F1	Hardy E.S.	4	C	40
1907	T.N. Foulis	London	F1	James G. (2)	4	C	44
1907	Cassell	London	F1	N... (nnk)	1	O	46
1907	E. Nister	London	F1	Robinson T.H.	5	C	41
1907	T.C. & E.C. Jack	London	F1	Rose R.T.	4	C	39
1907	J. Hewitson	London	F1	Webb M.P.	7	O	38
1909	Hodder & Stoughton	London	F2	Dulac E.	20	C	131
1909	T.N. Foulis	Edinburgh	F1	Greiffenhagen M.	4	C	66
1909	A. & C. Black	London	F1	James G. (3)	16	C	68
1909	Peacock Mansfield	London	F1	Morley T.W.	1	C	55
1909	George G. Harrap	London	F1	Pogany W. (1)	24	C	69
1910	T.N. Foulis	London	F1	Brangwyn F. (2)	8	C	78
1910	George G. Harrap	London	F1	Easton W.G.	1	O	74
1910	Siegle Hill	London	F1	Geddes E.	11	C	81
1910	Collins	London	F1	Robinson C.	4	C	70
1910	H.M. Nimmo	Edinburgh	F1	Ross A.	4	C	77
1910	The Studio	London	F1	Tagore A.N.	12	C	75
1911	Cassell	London	F1	Dixon A.A.	4	C	89
1911	Alice Harriman	New York	F4	Hall I.H.	19	O	272
1911	E. Nister	London	F1	Jackson A.E.	1	C	87
1911	H.R. Allenson	London	F2	Vincent-Jarvis S.C.	28	O	132
1912	Kegan Paul Trench Trubner	London	F1	Eardley-Wilmot M.	38	O	93
1912	George G. Harrap	London	F1	K.S. (nnk)	1	C	52

Date	Publisher	Location	FitzGerald edition	Illustrator	Illustrations No	Format	Potter no
1912	Simpkin Marshall	London	F1	Sheehan G.A. & Jones G.	5	C	92
1913	Hodder & Stoughton	London	F1	Bull R.	27	C	99
1913	H.J. Drane	London	F1, F2	Coles W.F.	5	0	160
1913	Methuen	London	F1	Sullivan E.J.	75	0	101
1914	Simpkin Marshall	London	F1	Anderson (F.M.?)	1	0	107
1914	Galloway & Porter	Cambridge	F1	Sett M.K.	14	0	104
1915	Barse & Hopkins	New York	F5	Seal E.D.	nk	0	276
1918	Lotus Library	Singapore	F1	Unknown artist (1)	17	0	174

2. 1919–1945: the 'art deco' period

Date	Publisher	Location	FitzGerald edition	Illustrator	Illustrations No	Format	Potter no
1919	Pownall (private press)	England	F2	Pownall G.A.	13	C	not in
191X	Collins	London	F1	Caird M.R.	5	0	not in
1920	Constable	London	F1	Balfour R.	38	C	116
1921	Harper & Bros	New York	F4	Jones W.J.	8	C	280
1921	Leopold B Hill	London	F1	Palmer D.M.	12	C	117
1922	John Lane Bodley Head	London	F1	Fish A.H.	20	C	118
1923	'Tis True (Col. R.J.R. Brown – private press)	Paris	F4	Mahamad R. et al.	many	C	176
1923	Kegan Paul Trench Trubner	London	F1	Weston H.	8	C	119
1924	Empire State Book	New York	F5	Henkel A.	6	C	282
1925	Regan Publishing	Chicago	F3	Laudermilk J.	6	0	not in
1925	Long's Publications	London	F+others	Paul Jones C.W.	10	0	390
1926	Johnck Kibbee	San Francisco	F4	Patterson L.A.	8	0	not in
1927	Gilmour's Bookshop	Sydney	F1	Wethered N.	10	nk	177
1928	Staple Inn Publishing	London	F2	Mickelwright G.	1	0	136
192X	The Mitre Press	London	F1	Doughty	6	0	not in
192X	Gornall The Publisher	Sydney	F1	O'Brien	4	C	not in
192X	A.L. Burt	New York	F5, F1	Watson Davis J.	4	C	not in
1930	The India Press	Allahabad	F1	Halder A.K.	12	C	
1930	George G. Harrap	London	F1, F4	Pogany W. (2)	13	C	
1932	Australasian Publishing	Sydney	F1	Stirling W. G	9	0	
1934	Ebenezer Baylis	Worcester	F1	Francis J.	6	0	
1934	C.W. Walton	Monroe NC	F5	Stack A.	5	0	
1935	The Limited Editions Club	New York	F4	Angelo V.	10	0	
1936	Minerva	Bogota	F1, F2	White E.U.	12	0	
1937	Birmingham School of Printing	Birmingham	F1	Gebhard C.	5	0	
1938	Golden Cockerel Press	London	F1	Buckland-Wright J.	8	0	
1938	Illustrated Editions	New York	F1, F5	Karr H.A.–U.	9	C	
1938	Sunnyside Press	Monroe NC	F5	Sprouse W.C.	nk	0	
1939	American Book & Printing	New Mexico?	F1	Hesketh R.C.	5	0	
1940	T Nelson & Sons	New York	F?+others	Buttera F.J.	1	0	
1940	George G. Harrap	London	F1	Gooden S.	4	0	
1940	Peter Pauper Press	Mt Vernon NY	F1	McPhralin P.	8	0	
1940	Edgar Backus	Leicester	F1	Rado A.	8	C	
1940	The Heritage Club	London	F1	Szyk A.	8	C	
1941	Pocket Books	New York	F1, F5	Ross G.	75	0	
1942	David McKay	Philadelphia	F5	Pogany W. (3)	20	0	
1944	F. Lewis	Leigh On Sea	F1	Cox E.A.	8	C	

3. 1946 to date: the 'modern' period

Date	Publisher	Location	FitzGerald edition	Illustrator	Illustrations No	Format	Potter no
1946	Grosset & Dunlap	New York	F4, F1	Katchadourian S.	11	C	
1946	R. Lesley	London	F1	Murray W.	12	C	
1947	Frederick Muller	London	F1	Buday G.	6	0	
1947	The World Publishing Co	Cleveland	F4	Low J.	33	0	
1947	Random House	New York	F6	Sayah M.	20	C	
1947	Collins	London	F6	Sherriffs R.S.	12	C	
1948	Jan Forlag	Stockholm	F1, F5	Popoff G.	9	C	
1949	Peter Pauper Press	Mt Vernon NY	F4	Bock V.	5	0	
194X	Collins	London	F6	Anderson M.	8	0	
194X	Whitcombe and Tombs	Christchurch	F1	R.G.T. (nnk)	9	0	
194X	Whitcombe and Tombs	Christchurch	F1	Unknown artist (2)	1	0	
1950	Juta	Johannesburg	F2+others	Beck H.	4	C	
1950	Lighthouse Books	London	F1	Pym R.	1	0	
1953	Ward Lock	London	F1	McCannell O.	8	C	
1955	The Rodale Press	London	F1	Stewart C.	6	C	
1955	Tahrir-Iran	Tehran	F1+others	Tajvidi A. et al.	55	C	
1956	Peter Pauper Press	Mt Vernon NY	F4	Hill J.	9	0	
1958	Golden Cockerel Press	London	F1	Bateman J.Y.	8	0	
1959	Amir Kabir	Tehran	F1	Tajvidi M.	28	C	
1961	Peter Pauper Press	Mt Vernon NY	F4	Wong J.	9	0	
1964	Thomas Y. Crowell	New York	F1, F4	Karlin E.	17	0	
1965?	Gray	Cambridge	F?	Noller N.H.	nk	nk	
1967	Hallmark Editions	Kansas City	F6	Isom J.	9	C	
1970	Istandiyari	Tehran	F6	Behzad Miniatur H.	50	C	
1970	The Folio Society	London	F1	Burnett V.	5	0	
1970	Black Knight (private press)	Leicester	F1	Morris S.	12	0	
1973	Quadrat Press	London	F1	Allix S.	18	0	
1974	Lion & Unicorn	London	F1	Gaman H.	21	0	
1978	New Horizon	Bognor Regis	F1	Belsey K.	65?	0	
1978	Pioneira	Sao Paulo	F4	de Santa Anna M.	39	0	
1979	World's Work	Tadworth	F5	Hemmant L.	27	C	
1980	Eldonejo Kardo	Glasgow	F1	Bomford J.	7	0	
1982	Holsworthy Publishing	London	F1	Davies I.	7	C	
1984	Mosaic Press	Cincinnati	F1	Nedelman S.	nk	nk	
1989	Ravenberg Pers	Oosterbeek	F1	Gorter H.	11	0	
1994	Self Realisation Fellowship	Los Angeles	F1	Marie H. et al.	50	C	
1995	Element Books	Shaftesbury	F6	Various	8?	C	
1996	Atelie Honar	Tehran	F1	Jamalipur A.	3	C	
1996	Tern Press	Market Drayton	F1	Parry N.	13	0	
1997	Sharq	Tashkent	F6	Karpuzas M.	8	0	
1999	Gooya House	Tehran	F6	Shakiba H.	38	C	
19XX	Oxford University Press	London	F1	Jameson M.	2	0	
19XX	Darke-Johnson	Padstow	F1	Johnson M.	7	0	
2001	Caxton Editions	London	F1	Chugtai M.	27	C	
2001	Grange Brooks	Rochester	F1	Peno A.	20	C	
2004	Luath Press	Edinburgh	F1	Cranston N.A.S.	11	0	

*See table below for more editions using 'Persian old' illustrations

Editions using 'Persian old' illustrations

Date	Publisher	Location	FitzGerald edition	Illustrator	Illustrations No	Illustrations Format	Potter no.
1879	Bernard Quaritch	London	F4	Persian old	1	O	141
1898	Henry T. Coates	Philadelphia	F1, F4	Persian old	1	O	388
1898	John C. Winston	Philadelphia	F6	Persian old	1	nk	388
1931?	Medici Society	London	F1	Persian old	7	O	
1943?	Susil Gupta	Calcutta	F1, F2	Persian old	8	O	
1955	The Folio Society	London	F1	Persian old	4	C	
1966	Graphic Society	New York	F?	Persian old	30	C	
1979	Miller Graphics	Fribourg/Geneva	F2	Persian old	59	C	
1992	Nashr-i Parsa	Tehran	F?	Persian old	40	nk	

APPENDIX 2
ARTISTS WHO HAVE ILLUSTRATED FITZGERALD'S *RUBAIYAT*

The alphabetical listing in the table below covers the same 135 artists who were identified and listed in Appendix 1, with further details of the artists, where known. A subsidiary table gives some information on the main artists identified who decorated rather than fully illustrated editions of *The Rubaiyat* (see comment in Part 1, p. 14). The main table also gives information about the edition of the artist's work which has been used for reproduction in this book. In the majority of cases, the illustrations reproduced come from the edition where the artist's work for *The Rubaiyat* was first published. But, in a number of cases, either that first published edition was not available for reproduction, or a later edition presented a better format of the illustrations for this purpose. Reproductions in this book do not correspond in size to that of the originals. More information on this is available from the authors.

Blanks in the listing of editions reproduced show where, for a variety of reasons (e.g. access, suitability for reproduction, cost), it was not possible to reproduce the work of the artist for the book. There are also blanks in the data on the artists themselves; this is, to us, a surprising finding of our research. We have made extensive use of existing reference works, such as Houfe and Horne,[3] as well as doing wide library and web-based searches, but there are still some important artists for whom we have been unable to establish even dates of birth and death; Gilbert James is an example of this. It would appear that book illustrators are a group of artists where sufficiently detailed research is still lacking.

Explanatory notes to the table (overleaf)

- *Artist*. The listing is presented alphabetically by surname; 'nnk' indicates 'name not known'. Artists with multiple portfolios are treated as multiple artists (e.g. James G [1], [2], [3]). Blank in first name indicates not known.
- *Dates*. Blank indicates not known; fl. indicates known to have been flourishing at this time.
- *First published*. Publisher and date when work of artist was first published. This ties up with chronological listing in Appendix 1, which gives further information on first publisher, the number and type of illustrations, and the FitzGerald edition used. X indicates exact year is not known.
- *Ed. used*. This shows the date of the edition that was used to provide the illustrations reproduced in this book. Where the publisher's name differs from that of the first publishing, this is shown with an asterisk, and more details are given at the end of the table. Blank indicates artist's work is not reproduced in this book (see comments above).

Artist		Dates (where known)		Illustrations for FitzGerald's *Rubaiyat*		Ed. used
Name	First name	Birth	Death	First published Publisher	Date	Date
Allix S.	Susan			Quadrat Press	1973	
Anderson (F.M.?)	Florence M.?		fl. 1914–1930	Simpkin Marshall	1914	
Anderson M.	Marjorie			Collins	194X	1986*
Angelo V.	Valenti	1897	1982	The Limited Editions Club	1935	1935
Ashbee C.R.	Charles R.	1863	1942	Essex House Press	1905	
Ault N.	Norman	1880	1950	Gay & Bird	1904	1912*
Balfour R.	Ronald	1896	1941	Constable	1920	1920
Bateman J.Y.	John Y.		fl. 1946–1959	Golden Cockerel Press	1958	1965*
Beck H.	Hope			Juta	1950	1950
Behzad Miniatur H.	Hossein	1894	1968	Isfandiyari	1970	1977
Bell R.A.	Robert A.	1863	1933	George Bell & Sons	1902	1911
Belsey K.	Karen			New Horizon	1978	
Bjerregaard C.H.A.	Carl H.A.			J.F. Taylor	1902	
Bock V.	Vera	1905		Peter Pauper Press	1949	
Bomford J.	Jean			Eldonejo Kardo	1980	
Brangwyn F. (1)	Frank	1867	1956	Gibbings	1906	
Brangwyn F. (2)	Frank	1867	1956	T.N. Foulis	1910	1919
Buckland-Wright J.	John	1897	1954	Golden Cockerel Press	1938	1938
Buday G.	George	1907	1990	Frederick Muller	1947	
Bull R.	Rene	1870	1942	Hodder & Stoughton	1913	1913
Burnett V.	Virgil	1928	alive	The Folio Society	1970	1970
Buttera F.J.				T. Nelson & Sons	1940	
Caird M.R.	Margaret R.			Collins	191X	191X
Chugtai M.	Muraqqa			Caxton Editions	2001	2001
Cole H.	Herbert	1867	1930	John Lane Publisher	1901	1901
Coles W.F.				H.J. Drane	1913	1913
Cox E.A.	Elijah A.	1876	1955	F. Lewis	1944	1944
Cranston N.A.S.				Luath Press	2004	
Davies I.	Ivor?	1935?		Holsworthy Publishing	1982	
de Santa Anna M.				Pioneira	1978	
Dixon A.A.	Arthur A.		fl. 1893–1920	Cassell	1911	
Doughty				The Mitre Press	192X	
Dulac E.	Edmund	1882	1953	Hodder & Stoughton	1909	1909
Eardley-Wilmot M.				Kegan Paul Trench Trubner	1912	
Easton W.G.	William G.	1879		George G. Harrap	1910	1910
Fish A.H.	Anne H.	1890	1964	John Lane Bodley Head	1922	1922
Francis J.				Ebenezer Baylis	1934	
Gaman H.				Lion & Unicorn	1974	
Garrett E.H.	Edmund H.	1853	1929	L.C. Page	1898	1899
Gebhard C.	Catherine			Birmingham School Of Printing	1937	
Geddes E.	Ewan?		1935?	Siegle Hill	1910	1910
Gooden S.	Stephen	1892	1955	George G. Harrap	1940	1940
Gorter H.	Hans			Ravenberg Pers	1989	
Greiffenhagen M.	Maurice	1862	1931/2	T.N. Foulis	1909	1909
Halder A.K.	Asit K.			The India Press	1930	

Artist		Dates (where known)		Illustrations for FitzGerald's *Rubaiyat*		Ed. used
Name	First name	Birth	Death	First published Publisher	Date	Date
Hall I.H.	Isabel H.			Alice Harriman	1911	
Hallward E.	Ella		fl. 1898	Bernard Quaritch	1899*	1899
Hanscom A.	Adelaide	1875	1931	Dodge Publishing	1905	1914*
Hardy E.S.	E. Stuart	1870		E. Nister	1907	1907
Hemmant L.	Lynette	1938	alive	World's Work	1979	1979
Henkel A.	August			Empire State Book	1924	1924
Hesketh R.C.				American Book & Printing	1939	
Hill J.	Jeff			Peter Pauper Press	1956	1970
Hobson A.E.				Small Maynard	1904	
Isom J.	Joseph			Hallmark Editions	1967	1967
Jackson A.E.	Albert E.	1873	1952	E. Nister	1911	1911
Jamalipur A.				Atelie Honar	1996	1996
James G. (1)	Gilbert		fl. 1895–1926	Leonard Smithers	1898	1908*
James G. (2)	Gilbert		fl. 1895–1926	T.N. Foulis	1907	1907
James G. (3)	Gilbert		fl. 1895–1926	A. & C. Black	1909	1909
James G. & Garrett E.H.	see separate entries for artists			L.C. Page	1898	
Jameson M.	Margaret			Oxford University Press	19XX	
Johnson M.	Maurice?	1920?		Darke-Johnson	19XX	
Jones W.J.	Wilfrid J.	1888	1968	Harper & Bros	1921	1921
K.S. (nnk)				George G. Harrap	1912	
Karin E.	Eugene	1918		Thomas Y. Crowell	1964	1964
Karpuzas M.				Sharq	1997	1997
Karr H.A.-U.	Hamzeh A.-U.			Illustrated Editions	1938	1938
Katchadourian S.	Sarkis	1886	1947	Grosset & Dunlap	1946	1946
King J.M.	Jessie M.	1876	1949	George Routledge	1903	1903
Laudermilk J.	Jerome			Regan Publishing	1925	1930
Low J.	Joseph	1911	alive	The World Publishing Co.	1947	1947
Lundborg F.	Florence	1871	1949	Doxey's	1900	1900
Mahamad R. et al.	Racim			'Tis True (Col. R.J.R. Brown – private press)	1923	
Marcel A.D.				H.M. Caldwell	1900	
Marie H. et al.	Helen			Self Realisation Fellowship	1994	1994
McCannell O.	Otway	1883	1969	Ward Lock	1953	1965
McManus B.	Blanche	1869		Mansfield & Wessels	1898?	1903*
McPharlin P.	Paul			Peter Pauper Press	1940	1940
Micklewright G.		1893	1951	Staple Inn Publishing	1928	
Morley T.W.		1859	1925	Peacock Mansfield	1909	
Morris S.	Steven			Black Knight (private press)	1970	1977*
Murray W.	Webster			R. Lesley	1946	1946
N... (nnk)				Cassell	1907	1907
Nedelman S.				Mosaic Press	1984	
Noller N.H.				Gray	1965?	
O'Brien				Gornall The Publisher	192X	192X
Palmer D.M.	Doris M.		1931	Leopold B. Hill	1921	1921

Illustrations for FitzGerald's *Rubaiyat*

Artist Name	First name	Birth	Death	Publisher	Date	Ed. used Date
Parry N.	Nicholas			Tern Press	1996	1996
Patterson L.A.	Laurence A.		alive	Johnck Kibbee	1926	
Paul Jones C.W.				Long's Publications	1925	
Peno A.	Andrew			Grange Brooks	2001	2001
Persian old				B. Quaritch	1879 *	1879
Pogany W. (1)	Willy	1882	1955	George G. Harrap	1909	1909
Pogany W. (2)	Willy	1882	1955	George G. Harrap	1930	1930
Pogany W. (3)	Willy	1882	1955	David McKay	1942	1942
Popoff G.	Georges			Jan Forlag	1948	1948
Pownall G.A.	Gilbert A.	1876		Pownall (private press)	1919	1919
Pym R.	Roland	1920		Lighthouse Books	1950	
R.G.T. (nnk)				Whitcombe and Tombs	194X	195X
Rado A.	Anthony			Edgar Backus	1940	1945?
Ricketts C.	Charles	1866	1931	Hacon & Ricketts	1901	
Robinson C.	Charles	1870	1937	Collins	1910	191X
Robinson T.H.	Thomas H.	1869	c1953	E. Nister	1907	1907
Rose R.T.		1863	1942	T.C. & E.C. Jack	1907	1907
Ross A.	Alice			H.M. Nimmo	1910	1911
Ross G.	Gordon	1873	1946	Pocket Books	1941	1948
Sayah M.	Mahmoud	1916		Random House	1947	1947
Seal E.D.				Barse & Hopkins	1915	
Sett M.K.	Mera K.			Galloway & Porter	1914	1914
Shakiba H.	Hojat	1949		Gooya House	1999	2002
Sheehan G.A. & Jones G.				Simpkin Marshall	1912	1912
Sherriffs R.S.	Robert S.	1906	1960	Collins	1947	1947
Sprouse W.C.				Sunnyside Press	1938	
Stack A.				C.W. Walton	1934	
Stella G.M.	Guido M.			S. Rosen	1906	
Stewart C.	Charles	1915	1989	The Rodale Press	1955	1955
Stirling W.G.	William G.			Australasian Publishing	1932	1935? *
Sullivan E.J.	Edmund J.	1869	1933	Methuen	1913	1938? *
Szyk A.	Arthur	1894	1951	The Heritage Club	1940	1940
Tagore A.N.	Abanindro N.	1871	1951	The Studio	1910	1920? *
Tajvidi A. et al.	Akhbar			Tahrir-Iran	1955 *	1964 *
Tajvidi M.	Mohammad	1924		Amir Kabir	1959 *	1959
Tobin G.T.	George T.	1864	1956	Frederick A. Stokes	1899	1899
Unknown artist (1)				Lotus Library	1918*	1918
Unknown artist (2)				Whitcombe and Tombs	194X	
Various				Element Books	1995	
Vedder E.	Elihu	1836	1923	Houghton Mifflin	1884	1894
Vincent Jarvis S.C.				H.R. Allenson	1911	
Watson Davis J.	John			A.L. Burt	192X	192X
Webb M.P.	Marie P.			J. Hewitson	1907	
Weston H.	Hope			Kegan Paul Trench Trubner	1923	
Wethered N.	Ned			Gilmour's Bookshop	1927	
White E.U.	Enrique U.			Minerva	1936	1936
Wong J.	Jeanyee			Peter Pauper Press	1961	1961

* See table below for notes on editions used for reproduction and other details

Artist	Comment
Anderson M.	1986 edition published by Guild Publishing, London
Ault N.	1912 edition published by Gay & Hancock, London
Bateman J.Y.	1965 edition published by A.S. Barnes, South Brunswick
Hallward E.	A variant of 1899 illustration was first published in Heron-Allen E., *The Rubaiyat of Omar Khayyam* (London, H.S. Nichols, 1898)
Hanscom A.	1914 edition published by George G. Harrap, London
James G. (1)	1908 edition published by R.F. Fenno, New York, with coloured illustrations
McManus B.	1903 edition published by De La More Press, London
Morris S.	1977 edition published by Kingsmead Press, Bath
Persian old	See Appendix 1 for table of other editions with Persian old illustrations
Stirling W.G.	1935 edition published by Printers Ltd, Singapore
Sullivan E.J.	1938 edition published by The World Publishing Co., Cleveland. Copy used for reproduction has hand coloured illustrations.
Tagore A.	1920 edition published by Leopold B. Hill, London
Tajvidi A.	1955 and 1964 editions included quatrains translated by Rosen as well as FitzGerald. Illustrations for Rosen were used again by Tahrir for an edition of FitzGerald in 1974. In our analysis, these illustrations have been allocated to FitzGerald quatrains on the basis of their use in the 1974 edition.
Tajvidi M.	These illustrations are thought to have been first used in an edition of translations by Forughi published by Amir Kabir, possibly in 1953. M. Tajvidi is believed to have been a close relative of A. Tajvidi.
Unknown artist (1)	Comparison of this edition with that of W.G. Stirling suggests the two artists could be the same.

Key artists who produced decorated editions of The Rubaiyat of Omar Khayyam

Name	Date	Publisher	Location
Bowers G.	1900	Roycroft Shop	East Aurora NY
Galambos M.	1922	Galambos (private press)	Budapest
Hunter D.?	1908	Roycrofters	East Aurora NY
Lefeaux S.W.	1910	George Routledge	London
Lowinsky T.	1926	Blackwell	Oxford
MacDougall W.B.	1898	Macmillan	London
Meacham C.	1931	Birmingham School of Printing	Birmingham
Morris W.	1981	Phaidon Press	Oxford
Ruzicka R.	1915	Carteret Press	Newark NJ
Ryder T.R.R.	1913	Gay & Hancock	London
Scharr G.	1991	Peter Pauper Press	Mount Vernon NY
Simpson J.W.	1903	R. Grant & Son	Edinburgh
Smith A.	1907	Duffield & Co.	New York
Turner R.	1902	University Press	Cambridge MA
Wilson E.	1908	Sisley's	London

APPENDIX 3
PUBLISHED VERSIONS OF *THE RUBAIYAT OF OMAR KHAYYAM*

As part of our research into the illustrated editions of FitzGerald's *Rubaiyat*, we have collected a large amount of information on other versions of *The Rubaiyat* published over the past two hundred years. As well as the versions of FitzGerald's work not illustrated, these publications included versions of *The Rubaiyat* produced by other translators into English (like Whinfield, Heron-Allen, Avery, Saidi and others),[4] and the many further translations into over seventy other languages.

In total, we have so far identified 1330 different versions of *The Rubaiyat*. This figure includes not only completely new editions, but also variant editions of existing works, and reprints of them in subsequent years. We believe that our coverage of the illustrated versions of FitzGerald's *Rubaiyat* is now quite good, though still not complete, and we welcome any additional information in this area. But we know that our coverage of the whole *Rubaiyat* publishing 'industry' is much less good, particularly as regards non-English versions and the reprints of the more popular works in English. We estimate that there may have been two thousand or more publications of *The Rubaiyat* in some printed form. This excludes the many different manuscripts that claim to include verses by Omar Khayyam. They are discussed further in Appendix 4.

We have summarised the general findings from our research in Part 1 on pp.7–8. The tables below provide some further information on various aspects of *The Rubaiyat* versions that we have identified. Additional analyses from our database are possible. The analyses given cover:
- the nature of *The Rubaiyat* versions we have identified;
- the nature of the illustrated versions within this total;
- the style and form of the illustrations for FitzGerald's *Rubaiyat*;
- the number of illustrations for different quatrains in FitzGerald's first version of *The Rubaiyat*.

Analysis of all versions identified

Identified versions of *ROK*

	Total number
Total	1330
FitzGerald	873
Other translations	457

	FitzGerald editions	Other translations
Illustrated	422	137
Decorated	22	2
Not illustrated	429	318
First edition	435	350
New edition	224	59
Reprint	214	48
Pre-1919	447	114
1919–1945	198	130
1946 to date	228	213

- Of the 1330 versions of *The Rubaiyat of Omar Khayyam* (*ROK*) identified, around two thirds are of FitzGerald's versions.
- Of FitzGerald's versions, about half are illustrated, compared with less than two thirds of those containing the work of other translators.
- Just under half of all the FitzGerald versions represent the first venture of the specific publisher into *Rubaiyat* publishing, the remainder being new versions or formats by the same publisher, or later reprints of the same edition. Non-FitzGerald versions have been much less frequently reprinted.
- More than one half of all the FitzGerald versions were published before 1919. In contrast, nearly half the other versions have been published since 1946.

Analysis of illustrated versions

- Three quarters of all the illustrated versions that we have identified are of FitzGerald's version of *The Rubaiyat of Omar Khayyam*.
- Less than half of the illustrated versions by FitzGerald represent the publishers' first entry into *Rubaiyat* publishing. Many publishers first produced a non-illustrated version. In contrast, illustrated versions of the work of other translators usually represent the publishers' first edition of *The Rubaiyat*.
- Illustrated versions of FitzGerald are more frequent in the period pre-1919, whereas for other translators over half of all illustrated versions have appeared since 1946.
- Some illustrators of FitzGerald's have worked for a number of publishers, so there are fewer illustrators, 150, with a first version of *The Rubaiyat*, than there are publishers with a first illustrated edition, 170. The same pattern is true for the illustrators of other translators' work.
- The listing in Appendix 1 shows 135 illustrators for which we have details. Together with a further 17 unidentified illustrators, this gives an overall total of 152, made up of 150 shown below with a first published edition, plus two others whose work was republished in this form.

Illustrated versions of *ROK*

	Total number
Total	559
FitzGerald	422
Other translations	137

	FitzGerald editions	Other translations
First edition	170	108
New edition	133	13
Reprint	119	16
Pre-1919	175	14
1919–1945	110	49
1946 to date	137	74
First publisher	150	96
New publisher/format	152	25
Reprint	120	16

Analysis of illustrators by style and format

- The table below gives the way in which the work of the illustrators of FitzGerald's *Rubaiyat* has varied in terms of style (Western, orientalist or Persian) and format (full colour or other).[5] The analysis is based on the 127 illustrators whose work we have been able to see so far.
- Over the whole period, just under two thirds of the illustrators fall into what we have termed the orientalist category, with a further one quarter providing a basically Western interpretation.
- Illustrators of the pre-1919 period put slightly more emphasis on the Western approach, while those between the world wars were more orientalist. Since 1946, there have been more authentically Persian illustrations, as well as a greater emphasis on modern Western styles.
- Just under half of all the artists working on FitzGerald's *Rubaiyat* have presented their work in full colour, others using part colour or black-and-white drawings, engravings etc. as the basis for their illustrations. The proportion is similar in the period since 1946, but full colour was more commonly used in the inter-war period.

Illustrators of *ROK* analysed

	Number	Per cent
All illustrators	127	100
Of which		
Western style		27
Orientalist		64
Persian		9
Full-colour format		46
Other form		54
Illustrators, pre-1919 versions	44	100
Of which		
Western style		30
Orientalist		70
Persian		0
Full-colour format		43
Other form		57
Illustrators, 1919–1945 versions	37	100
Of which		
Western style		14
Orientalist		78
Persian		8
Full-colour format		51
Other form		49
Illustrators, 1946 plus versions	46	100
Of which		
Western style		35
Orientalist		46
Persian		19
Full-colour format		46
Other form		54

Analysis of number of illustrations per quatrain

- The table shows, for the 127 illustrators seen, the number of different illustrations we have found for each of the quatrains in FitzGerald's first edition of *The Rubaiyat*.
- Quatrain 11 is the verse most often illustrated, with 56 identified illustrations. Quatrain 1 has nearly as many, 48, while six other quatrains have 30 or more illustrations (numbers 27, 36, 42, 48, 74 and 75).
- At the other end of the scale, quatrain 71 has the fewest identified illustrations, only 4, but as many as 19 other quatrains have fewer than 10 illustrations.

Quatrain in FitzGerald's first edition (First line)	Illus. no
1 AWAKE! for Morning in the Bowl of Night	48
2 Dreaming when Dawn's Left Hand was in the Sky	13
3 And, as the Cock crew, those who stood before	19
4 Now the New Year reviving old Desires,	14
5 Iram indeed is gone with all its Rose,	13
6 And David's Lips are lockt; but in divine	11
7 Come, fill the Cup, and in the Fire of Spring	28
8 And look – a thousand Blossoms with the Day	14
9 But come with old Khayyam, and leave the Lot	8
10 With me along some Strip of Herbage strown	11
11 Here with a Loaf of Bread beneath the Bough,	56
12 'How sweet is mortal Sovranty!' – think some:	8
13 Look to the Rose that blows about us – 'Lo,	23
14 The Worldly Hope men set their Hearts upon	12
15 And those who husbanded the Golden Grain,	13
16 Think, in this batter'd Caravanserai	23
17 They say the Lion and the Lizard keep	26
18 I sometimes think that never blows so red	12
19 And this delightful Herb whose tender Green	18
20 Oh, my Beloved, fill the Cup that clears	22
21 Lo! some we loved, the loveliest and best	26
22 And we, that now make merry in the Room	9
23 Ah, make the most of what we yet may spend,	16
24 Alike for those who for TO-DAY prepare,	19
25 Why, all the Saints and Sages who discuss'd	7
26 Oh, come with old Khayyam, and leave the Wise	9
27 Myself when young did eagerly frequent	38
28 With them the Seed of Wisdom did I sow,	11
29 Into this Universe, and *why* not knowing,	15
30 What, without asking, hither hurried whence?	10
31 Up from Earth's Centre through the Seventh Gate	17
32 There was a Door to which I found no Key:	17
33 Then to the rolling Heav'n itself I cried,	17
34 Then to this earthen Bowl did I adjourn	10
35 I think the Vessel, that with fugitive	14
36 For in the Market-place, one Dusk of Day,	30
37 Ah, fill the Cup: – what boots it to repeat	6
38 One Moment in Annihilation's Waste,	18
39 How long, how long, in infinite Pursuit	9
40 You know, my Friends, how long since in my House	26
41 For 'IS' and 'IS-NOT' though with Rule and Line,	6
42 And lately, by the Tavern Door agape,	38
43 The Grape that can with Logic absolute	5
44 The mighty Mahmud, the victorious Lord,	12
45 But leave the Wise to wrangle, and with me	10
46 For in and out, above, about, below,	20
47 And if the Wine you drink, the Lip you press,	11
48 While the Rose blows along the River Brink,	34
49 'Tis all a Chequer-board of Nights and Days	17
50 The Ball no Question makes of Ayes and Noes,	16
51 The Moving Finger writes; and, having writ,	22
52 And that inverted Bowl we call The Sky,	23
53 With Earth's first Clay They did the Last Man's knead,	10
54 I tell Thee this – When, starting from the Goal,	10
55 The Vine had struck a Fibre; which about	11
56 And this I know: whether the one True Light,	9
57 Oh, Thou, who didst with Pitfall and with Gin	11
58 Oh, Thou, who Man of baser Earth didst make,	15
KUZA-NAMA	
59 Listen again. One Evening at the Close	27
60 And, strange to tell, among that Earthen Lot	13
61 Then said another – 'Surely not in vain	8
62 Another said – 'Why ne'er a peevish Boy,	8
63 None answer'd this; but after Silence spake	5
64 Said one – 'Folks of a surly Tapster tell,	5
65 Then said another with a long-drawn Sigh,	7
66 So while the Vessels one by one were speaking,	13
* * * * * * * (end of Kuza-Nama)	
67 Ah, with the Grape my fading Life provide,	12
68 That ev'n my buried Ashes such a Snare	9
69 Indeed the Idols I have loved so long	9
70 Indeed, indeed, Repentance oft before	21
71 And much as Wine has play'd the Infidel,	4
72 Alas, that Spring should vanish with the Rose!	22
73 Ah Love! could thou and I with Fate conspire	8
74 Ah, Moon of my Delight who know'st no wane,	37
75 And when Thyself with shining Foot shall pass	30
TAMAM SHUD	

APPENDIX 4
OMAR KHAYYAM AND HIS *RUBAIYAT*

Chronology and key dates

c.1048 Born near Naishpur in Khorasan (now North East Iran).
Full name: Abdul Fath Omar ibn Ibrahim Khayyam.

c.1068 At Samarkand and Bukhara. Wrote treatise on algebra.

c.1074+ In service with Sultan Malik-Shah. Involved with the reformation of the Persian calendar and the building of the observatory at Isfahan. Published mathematical and philosophical treatises.

1092+ Death of Malik-Shah and accession of Sultan Sanjar. Fall from grace of Khayyam, pilgrimage to Mecca and extensive travels, including to Baghdad. Retirement to Naishpur.

1095 Published a further philosophical treatise.

c.1126 Death of Khayyam.

There is very little known about Omar Khayyam and his life, other than the knowledge of his treatises on mathematics and philosophy, some of which have been lost, and his involvement with the reorganisation of the Persian calendar at the behest of Sultan Malik-Shah. There are a few anecdotal stories of his adult life, written down by his contemporaries, and referring to his wisdom, memory and forecasting ability; but none relate to the composition of *rubaiyat* or other poetry. For more information, see detailed works by Dashti and Aminrazavi.[6] The story of the friendship linking Khayyam with fellow students Hasan Tusi (later given the title 'Nizam al-Mulk' and made Chamberlain of the Seljuq court), and Hasan Sabbah (the founder of the order of assassins) and their pact to help each other, included by FitzGerald in the introductions to his editions of *The Rubaiyat* and widely propagated thereafter, has been convincingly refuted.[7]

Omar Khayyam and *The Rubaiyat*

There are many manuscripts of *rubaiyat*, as well as other collections of verse, that contain one or more quatrains attributed to Omar Khayyam. These have been extensively documented by Khayyam scholars. In our brief comments, we draw particularly on the work of Dashti and Aminrazavi.[8]

No manuscript of *rubaiyat* has, so far, been discovered that was contemporaneous with Khayyam's life. The first reference to any verse by Khayyam came in 1174, some fifty years after his death, in an anthology of Khorasan poets who were writing in Arabic. This anthology (*Kharidat al-Qasr*) quotes four two-line verses by Khayyam in Arabic. The earliest verses in Persian attributed to Khayyam are contained in a number of manuscripts from the early thirteenth century.[9] There are a variety of other manuscripts, dated in the next two hundred years, with different numbers of verses attributed to Khayyam. The widely known Ouseley manuscript from the Bodleian Library in Oxford, which was used by FitzGerald, is dated 1460/61. It claims to be by Khayyam and contains 158 quatrains. The Calcutta manuscript, also used by FitzGerald, was not dated. It contained 516 quatrains attributed to Khayyam.

Research over the last two centuries or so has lead to many more manuscripts of *rubaiyat* being discovered. Swami Govinda Tirtha, in his book on Omar Khayyam, *The Nectar of Grace*, published in 1941, listed 111 manuscripts and editions of relevance.[10] One of these has over a thousand quatrains attributed to Khayyam. Since then, further manuscripts have been discovered, notably in Iran. However, from the late nineteenth century, scholars have queried the attribution to Khayyam of many of the quatrains in these manuscripts. As discussed in Part 1, work by many experts has narrowed the properly attributable total down to under two hundred quatrains.[11]

In more recent times, the analysis of the true heritage of Khayyam's verse has been complicated by the appearance of new manuscripts that have eventually been assessed as forgeries. Notable among these are several which appeared in the late 1940s, including one in the Chester Beatty Library in Dublin and one in the University Library in Cambridge. These purported to be dated 1260 and 1208 respectively, but subsequent analysis shows that they were probably based on Rosen's edition of 1925, itself a copy of a fifteenth-century manuscript.[12]

Libraries with manuscripts of *rubaiyat* attributed to Omar Khayyam

Many libraries, both in the West and the East, hold manuscripts and copies (lithographs) of collections of Khayyam's *rubaiyat*, and anthologies of Persian poets that include Khayyam's work. In the UK, notable collections are in the Bodleian Library in Oxford, the University Library in Cambridge and the British Library in London. Further important depositaries include the Bibliothèque Nationale in Paris, the Königliche Bibliothek in Berlin, other libraries in Europe and the United States, and others in Istanbul, India and various Eastern countries. For more details see Tirtha, Dashti, Saidi and Aminrazavi.[13]

APPENDIX 5
EDWARD FITZGERALD AND HIS *RUBAIYAT*

Chronology and key dates

1809	Born near Woodbridge, Suffolk.
1826–30	Attended Cambridge University.
1837	Return to Woodbridge, living at Boulge.
1844	Meets Edward Cowell. Introduced to Persian studies by him.
1851	Publication of FitzGerald's *Euphranor*.
1853	Publication of FitzGerald's *Six Dramas of Calderon*. Cowell enrols at Oxford University.
1856	Graduation of Cowell. Discovery by him of the Ouseley manuscript of *The Rubaiyat of Omar Khayyam* in the Bodleian Library. Cowell copies and sends this to FitzGerald. Departure of Cowell to India. Cowell finds another manuscript of *The Rubaiyat* in the library of the Asiatic Society of Bengal. Has a copy made and sends it to FitzGerald. FitzGerald marries Lucy Barton in November. They separate in August 1857.
1857	FitzGerald receives copy of Calcutta manuscript from Cowell.
1859	Publication of first version of *The Rubaiyat*, anonymously by FitzGerald.
1862	First pirated edition, Madras, India.
1868	Publication of second version of *The Rubaiyat* by Quaritch, again anonymously.
1870	First American edition. Second version in a limited private print.
1872	Publication of third version of *The Rubaiyat*.
1878	First published American edition, based on FitzGerald's third version.
1879	Publication of fourth version of *The Rubaiyat*, together with his reduced translation of the *Salaman and Absal* story by Jami.
1883	Death of FitzGerald.
1884	First illustrated edition of *The Rubaiyat* published by Houghton Mifflin in Boston.
1889	Publication of fifth version of *The Rubaiyat* in collection of *Letters and Literary Remains*.[14]
1899	Publication of FitzGerald's version of Attar's *Conference of the Birds*, together with a version of *Salaman and Absal*.
1902–3	Publication of definitive edition of FitzGerald's *Letters and Literary Remains*, with details of all editions of *The Rubaiyat*, edited by W. Aldis Wright.[15]

FitzGerald's editions of *The Rubaiyat* and his sources

The different editions of *The Rubaiyat* produced by FitzGerald and the revisions to the text that he made in them were mentioned in Part 1 and Part 2, especially pp. 6–7 and 159. The table below indicates the way in which the numbers of the equivalent verses changed through the editions. A comparative presentation of the text of the first four editions is to be found in Frederick Evans's Variorum Edition published in 1914 and in Decker's more recent publication.[16] The fifth edition had only minor differences, mainly in punctuation, from the fourth.

The table also summarises some information about the manuscript and other sources on which each of the quatrains is based. In preparing this we have drawn once again on the work of Heron-Allen and Arberry.[17] The references provide detailed analyses of the specific numbers of the source quatrains, on which these experts are not always agreed. Heron-Allen revised some of his analyses in his work on FitzGerald's second edition in 1908,[18] and Arberry specifically disputes Heron-Allen's conclusions for some quatrains.

Explanatory notes to the table (overleaf)
- *Equivalent editions*. These are shown in the order of the second and longest edition. There were no changes in numbering after the third edition.
- *Manuscript sources*. Summary information on the main Ouseley and Calcutta manuscripts is given in Appendix 4.
- *Other sources*. NIC refers to the work of the French translator Nicolas,[19] ATT to the Mantiq at-Tair of Attar,[20] EF to an original creation of Edward FitzGerald.

Table showing the relationship between FitzGerald editions of *The Rubaiyat* and MS sources

Editions: equivalent quatrain numbers			Manuscripts: sources		
1st	2nd	3rd–5th	Ouseley	Calcutta	Other
1	1	1		X	
2	2	2		X	
3	3	3		X	
4	4	4	X		
5	5	5			EF
6	6	6	X		
7	7	7		X	
	8	8	X	X	
8	9	9	X	X	
9	10	10	X	X	
10	11	11	X		
11	12	12	X		
12	13	13	X	X	
	14		X		
13	15	14		X	
15	16	15	X		
14	17	16		X	
16	18	17		X	
17	19	18		X	
	20			X	
20	21	21		X	
21	22	22		X	
22	23	23		X	
18	24	19	X		
19	25	20		X	
23	26	24	X		
24	27	25		X	
	28		X		
25	29	26	X	X	
27	30	27	X	X	
28	31	28	X	X	
29	32	29	X	X	
30	33	30	X		
31	34	31		X	
32	35	32	X	X	
	36	33			ATT
33	37	34			ATT
34	38	35	X	X	
35	39	36	X		
36	40	37	X		
	41	38		X	
	42	39	X		
	43	40		X	
	44			X	
47	45	42	X	X	
48	46	43		X	
	47	46			NIC

Editions: equivalent quatrain numbers			Manuscripts: sources		
1st	2nd	3rd–5th	Ouseley	Calcutta	Other
	48	47	X		NIC
38	49	48	X	X	
	50	49	X	X	
	51	50	X	X	
	52	51		X	
	53	52		X	
	54	53		X	
	55	41	X		
39	56	54	X		
40	57	55		X	
41	58	56	X		
	59	57	X	X	
42	60	58		X	
43	61	59	X	X	
44	62	60	X		ATT
	63	61	X	X	
	64	62	X	X	
	65		X	X	
26	66	63	X		
	67	64		X	
	68	65		X	
	69	44	X	X	
	70	45		X	
	71	66	X		
	72	67	X		
46	73	68	X		
49	74	69	X		
50	75	70		X	
51	76	71	X		
	77				EF
52	78	72	X		
53	79	73	X		
	80	74	X		
54	81	75		X	
55	82	76		X	
56	83	77	X		
	84	78		X	
	85	79		X	
	86			X	
57	87	80	X		
58	88	81		X	
59	89	82	X	X	
	90	83	X		
61	91	84		X	
62	92	85	X		
63	93	86			EF
60	94	87	X		

Editions: equivalent quatrain numbers			Manuscripts: sources		
1st	2nd	3rd–5th	Ouseley	Calcutta	Other
64	95	88		X	
65	96	89	X	X	
66	97	90	X		
67	98	91	X	X	
	99				EF
68	100	92		X	
69	101	93		X	
70	102	94		X	
71	103	95	X		
72	104	96		X	
	105	97		X	
	106	98			NIC
	107				NIC
73	108	99	X		
74	109	100	X		
75	110	101	X		
37				X	
45					EF

See explanatory notes on previous page.

NOTES

Notes to Part 1

1. FitzGerald, E., *The Rubaiyat Of Omar Khayyam, the Astronomer-Poet of Persia*, (London, B. Quaritch, 1st ed., 1859).
2. See Appendix 3 for more information on sources of these and other figures on *Rubaiyat* publishing and illustration.
3. Elihu Vedder's illustrations were first published in FitzGerald, E., *The Rubaiyat Of Omar Khayyam, the Astronomer-Poet of Persia* (Boston, Houghton Mifflin & Co., 1884).
4. See Appendix 5 and bibliography for more information on Edward FitzGerald and *The Rubaiyat*.
5. See Appendix 4 and bibliography for more information on Omar Khayyam and his *Rubaiyat*.
6. The event is well documented in Arberry, A.J., *The Romance of the Rubaiyat* (London, Allen & Unwin, 1959), pp. 41–2.
7. Included in FitzGerald's letter to E.B. Cowell, 8 December 1857, quoted in Heron-Allen, E., *The Rubaiyat of Omar Khayyam* (London, H.S. Nichols, 1898), p. xxiii. The original comment probably applied to Attar's Mantiq at-Tair, but Heron-Allen suggests that it is also applicable to *The Rubaiyat*.
8. Scaliger, J., *De Emendatione Temporum* (Basle, 1583).
9. Hyde, T., *Historia Religionis Veterum Persarum* (Oxford, 1700).
10. Hammer, J. von, *Geschichte Der Schoenen Redekunste Persiens* (Vienna, Heubner und Wolke, 1818). Schack, A.F. von, *Strophen des Omar Chijam* (Stuttgart, I.G. Cotta'Schen, 1878). Bodenstedt, F. von, *Die Lieder und Spruche des Omar Chajjam* (Breslau, Schletter'sche, 1881).
11. Tassy, G. de, 'Note sur les Rubaiyat de 'Omar Khaiyam', in *Journal Asiatique*, no IX, Paris, 1857. Nicolas, J.B., *Les Quatrains de Kheyam* (Paris, Imprimerie Imperiale, 1867).
12. Zhukovsky, V.A., 'Umar Khayyam and the Wandering Quatrains', translated from Russian by E.W.D. Ross, in *Journal of the Royal Asiatic Society*, no XXX, 1898, pp. 349–66.
13. Garner, J.L., *The Strophes of Omar Khayyam* (Milwaukee, Corbitt & Skidmore, 1888).
14. Whinfield, E.H., *The Quatrains Of Omar Khayyam* (London, Trubner, 2nd ed., 1901) (reprinted in 1980 by Octagon Press, London, for the Sufi Trust). McCarthy, J.H., *Rubaiyat of Omar Khayyam* (London, David Nutt, 1889).
15. Christensen, A., *Critical Studies in the Rubaiyat of Umar-i-Khayyam* (Copenhagen, Host & Son, 1927).
16. Rosen, F., *Die Sinnspruche Omars des Zeltmachers* (Stuttgart and Leipzig, Deutsche Verlagsanstalt, 1909).
17. Arberry, A.J., *Omar Khayyam: A new version based upon recent discoveries* (London, John Murray, 1952). Arberry, *The Romance*. Avery, P. and Heath-Stubbs, J., *The Rubaiyat of Omar Khayyam* (London, Allen Lane, 1979).
18. Zhukovsky, 'Umar Khayyam'.
19. The work in this area, by the British Orientalist Sir Denison Ross and the Danish scholar Arthur Christensen, is referred to in Dashti, A. and Elwell-Sutton, L.P., *In Search of Omar Khayyam* (London, George Allen & Unwin, 1971), p. 179.
20. Aminrazavi, M., *The Wine of Wisdom* (Oxford, Oneworld Publications, 2005), pp. 90–8.
21. Dashti and Elwell-Sutton, *In Search of Omar Khayyam*, p. 185.
22. Nicolas, *Les Quatrains de Kheyam*.
23. FitzGerald, E., *The Rubaiyat Of Omar Khayyam, the Astronomer-Poet of Persia* (London, B. Quaritch, 2nd ed., 1868). FitzGerald, E., *The Rubaiyat Of Omar Khayyam, the Astronomer-Poet of Persia* (London, B. Quaritch, 3rd ed., 1872). FitzGerald, E., *The Rubaiyat Of Omar Khayyam* (4th ed.) and *The Salaman and Absal of Jami* (London, B. Quaritch, 1879).
24. The fifth edition was first published in vol. iii of Wright, W. Aldis, ed., *Letters and Literary Remains of Edward FitzGerald* (London, Macmillan, 1889). It was republished, together with the first edition as FitzGerald, E., *The Rubaiyat Of Omar Khayyam, the Astronomer-Poet of Persia* (London, Macmillan & Co., 1890).
25. Heron-Allen, E., *Edward FitzGerald's Rubaiyat Of Omar Khayyam* (London, B. Quaritch, 1899). Batson, H.M. and Ross, E.D., *The Rubaiyat of Omar Khayyam* (London, Methuen, 1900). Rodwell, E.H., *Omar Khayyam* (London, Kegan Paul Trench Trubner, 1931). Arberry, *The Romance*. Dashti and Elwell-Sutton, *In Search of Omar Khayyam*. Saidi, A., *Ruba'iyat of Omar Khayyam* (Berkeley, CA, Asian Humanities Press, 1991).
26. Potter, A.G., *A Bibliography of the Rubaiyat of Omar Khayyam* (London, Ingpen and Grant, 1929) (reissued in 1994 by Georg Olms Verlag, Hildesheim).
27. FitzGerald, E., *The Rubaiyat Of Omar Khayyam, the Astronomer-Poet of Persia* (Columbus, OH, Richard Nevis, 1870).
28. Claim is made on p. 84 of an edition of *The Rubaiyat*, illustrated by Eugene Karlin and published by Thomas Y. Crowell, New York, 1964.
29. Potter, *A Bibliography*, pp. 269 et seq.
30. Darwin, C., *The Origin of Species* (London, John Murray, 1859).
31. Mill, J.S., *On Liberty* (London, 1859).
32. Bland, D., *The Illustration of Books* (London, Faber & Faber, 1951).
33. Felmingham, M., *The Illustrated Gift Book 1880–1930* (Aldershot, Wildwood, 1989).
34. Bland, *The Illustration of Books*, pp. 12–13.
35. Bland, *The Illustration of Books*, pp. 21–2.
36. Watson, R., *Illuminated Manuscripts and their Makers* (London, V&A Publications, 2003).
37. Canby, S.R., *Persian Painting* (London, British Museum Press, 1993).
38. These techniques and their impact on book illustration are discussed in Bland, *The Illustration of Books*; Houfe, S., *The Dictionary of 19th Century British Book Illustrators and Caricaturists* (Woodbridge, Antique Collectors' Club, 1978); Horne, A., *The Dictionary of 20th Century British Book Illustrators* (Woodbridge, Antique Collectors' Club, 1994); Slythe, R.M., *The Art of Illustration 1750–1900* (London, The Library Association, 1970).
39. Mahfuz-ul-Haq, M., *The Rubaiyat of Umar-i-Khayyam* (Calcutta, Royal Asiatic Society Bengal, 1939).
40. See note 23.
41. See note 3.
42. MacKenzie, J.M., *Orientalism: History, theory and the arts* (Manchester, Manchester University Press, 1995).
43. See e.g. Said, E., *Orientalism: Western conceptions of the Orient* (London, Penguin, rev. ed., 1995).
44. Bruijn, J.T.P. de, *Persian Sufi Poetry* (Richmond, Curzon Press, 1997), pp. 6–9.
45. FitzGerald set out his scheme in a letter to his publisher Bernard Quaritch, quoted in Arberry, *The Romance*, pp. 22–3.
46. More information about Pogany's work is given in Greer, R., 'The Published Illustrations of Willy Pogany', in *The IBIS Journal*, no. 1, Imaginative Book Illustration Society, London, 1999. We have been unable to trace much information on Gilbert James, beyond

the entry in Houfe, S., *The Dictionary of 19th Century British Book Illustrators*.
47. See e.g. Macer-Wright, P., *Brangwyn: A study of genius at close quarters* (London, Hutchinson & Co, 1940).
48. *Grove Art Online* (www.groveart.com), which provides access to *The Dictionary of Art* (Oxford, Oxford University Press, 1996).
49. Le Gallienne, R., *Rubaiyat of Omar Khayyam: A paraphrase from several literal translations* (London, John Lane Bodley, 1897). Rosen, F., *The Quatrains of Omar Khayyam* (London, Methuen, 1930).
50. The English edition is Golestan, S., *The Wine of Nishapur: A photgrapher's promenade in the Rubaiyat of Omar Khayyam* (Paris, Souffles, 1988).
51. These issues are discussed by FitzGerald himself in his prefaces to the second and third editions of his *Rubaiyat* (see note 23) and also *inter alia* in Arberry, *The Romance*, p.18, and in Martin, R.B., *With Friends Possessed: A life of Edward FitzGerald* (London, Faber & Faber, 1985), pp. 205–8.
52. Leacock-Seghatolislami, T., 'The Tale of the Inimitable Rubaiyat', in Bloom, H., ed., *Edward FitzGerald's The Rubaiyat of Omar Khayyam* (Philadelphia, Chelsea House Publishers, 2004), pp. 201–2.
53. See e.g. Aminrazavi, *The Wine of Wisdom*. Bloom, *Edward FitzGerald's The Rubaiyat*. Decker, C., Edward FitzGerald, *Rubaiyat of Omar Khayyam: A critical edition* (Charlottesville, University Press of Virginia, 1997).

Notes to Part 2

1. Heron-Allen, E., *Edward FitzGerald's Rubaiyat Of Omar Khayyam* (London, B. Quaritch, 1899). Batson, H.M. and Ross, E.D., *The Rubaiyat of Omar Khayyam* (London, Methuen, 1900). Arberry, A.J., *The Romance of the Rubaiyat* (London, Allen & Unwin, 1959).
2. This includes our assessment of the artist's work as Western, orientalist and Persian. The distinction is discussed further in Part 1, pp. 14–15.
3. See Part 1, p. 16.
4. See e.g. Yoganda, P., *Wine of the Mystics: The Rubaiyat of Omar Khayyam, a spiritual interpretation* (Los Angeles, Self Realisation Fellowship, 1994).
5. See Batson and Ross, *The Rubaiyat*, p. 137.
6. See e.g. Yoganda, *Wine of the Mystics*. Pattinson, J.S., *The Symbolism of the Rubaiyat of Omar Khayyam* (Edinburgh, Orpheus Publishing House, 1921), p. 38.
7. See Part 1, pp. 23–24.
8. See Part 1, p. 21.
9. Batson and Ross, *The Rubaiyat*, pp. 141–2.
10. Schimmel, A., *A Two-Coloured Brocade: The imagery of Persian poetry* (Chapel Hill and London, The University of North Carolina Press, 1992), p. 73.
11. See discussion of eroticism in *Rubaiyat* illustration in Part 1, p. 28.
12. Pattinson, *The Symbolism of the Rubaiyat*, p. 38.
13. See comparison of Pogany editions in Part 1, pp. 19–20.
14. Heron-Allen, *Edward FitzGerald's Rubaiyat*, p. 33.
15. Shakespeare, W., *As You Like It*, Act II, scene vii.
16. See Batson and Ross, *The Rubaiyat*, p. 172.
17. Heron-Allen, *Edward FitzGerald's Rubaiyat*, p. 57.
18. Heron-Allen, *Edward FitzGerald's Rubaiyat*, p. 77.
19. Arberry, *The Romance*, pp. 21–2.
20. Heron-Allen, *Edward FitzGerald's Rubaiyat*, p. 93.
21. Heron-Allen, E., *The Second Edition of Edward FitzGerald's Rubaiyat of Omar Khayyam* (London, Duckworth and Co., 1908), p. 147.
22. Heron-Allen, *Edward FitzGerald's Rubaiyat*, pp. 119–23.
23. See e.g. Batson and Ross, *The Rubaiyat*, pp. 257–8.
24. Heron-Allen, *Edward FitzGerald's Rubaiyat*, p. 125. Arberry, *The Romance*, pp. 228–9.
25. Heron-Allen, *Edward FitzGerald's Rubaiyat*, p. 129. Arberry, *The Romance*, p. 231.
26. See Arberry, *The Romance*, pp. 101–2.
27. Quoted as quatrain 208 in Whinfield, E.H., *The Quatrains Of Omar Khayyam* (London, Trubner, 2nd ed., 1901). This edition of Whinfield's work was reissued by The Octagon Press (London) for The Sufi Trust in 1980.
28. Schimmel, *A Two-Coloured Brocade*, pp. 178–81.
29. For details of FitzGerald's different editions, see Part 1, p. 6 and bibliography.
30. Nicolas, J.B., *Les Quatrains de Kheyam* (Paris, Imprimerie Imperiale, 1867).
31. Heron-Allen, *Edward FitzGerald's Rubaiyat*.
32. Decker, C., Edward FitzGerald, *Rubaiyat of Omar Khayyam: A critical edition* (Charlottesville, University Press of Virginia, 1997).
33. For details of these and other illustrated editions mentioned, see Appendix 1.
34. Heron-Allen, E., *The Rubaiyat Of Omar Khayyam* (London, H.S. Nichols, 1898).
35. The editions with old Persian illustrations are listed in a table in Appendix 1.
36. For details of this and other illustrated editions mentioned, see Appendix 1.
37. See Part 1, p. 12.

Notes to Appendices

1. Potter, A.G., *A Bibliography of the Rubaiyat of Omar Khayyam* (London, Ingpen and Grant, 1929) (reissued in 1994 by Georg Olms Verlag, Hildesheim).
2. Potter, *A Bibliography*.
3. Houfe, S., *The Dictionary of 19th Century British Book Illustrators and Caricaturists* (Woodbridge, Antique Collectors' Club, 1978). Horne, A., *The Dictionary of 20th Century British Book Illustrators* (Woodbridge, Antique Collectors' Club, 1994).
4. Whinfield, E.H., *The Quatrains of Omar Khayyam* (London, Trubner, 1883). Heron-Allen, E., *The Rubaiyat of Omar Khayyam* (London, H.S. Nichols, 1898). Avery, P. and Heath-Stubbs, J., *The Rubaiyat of Omar Khayyam* (London, Allen Lane, 1979). Saidi, A., *Ruba'iyat of Omar Khayyam* (Berkeley, CA, Asian Humanities Press, 1991).
5. For the basis of this classification, see Part 1, p. 14–15.
6. Dashti, A. and Elwell-Sutton, L.P., *In Search of Omar Khayyam* (London, George Allen & Unwin, 1971). Aminrazavi, M., *The Wine of Wisdom* (Oxford, Oneworld Publications, 2005).
7. See e.g. Rosenfeld, B.A., ''Umar Khayyam', in *Encyclopaedia of Islam*, vol. X (Leiden, Brill, new ed., 2000).
8. Dashti and Elwell-Sutton, *In Search of Omar Khayyam*. Aminrazavi, *The Wine of Wisdom*.
9. Dashti and Elwell-Sutton, *In Search of Omar Khayyam*, pp. 35–7.
10. Tirtha, Swami Govinda, *The Nectar of Grace: Omar Khayyam's life and works* (Allahabad, Kitabistan, 1941).
11. See Part 1 pp. 5–6, and notes.
12. The discovery of these forgeries is discussed *inter alia* by Elwell-Sutton in his introduction to Dashti and Elwell-Sutton, *In Search of Omar Khayyam*, p. 15.
13. Tirtha, *The Nectar of Grace*. Dashti and Elwell-Sutton, *In Search of Omar Khayyam*. Saidi, *Ruba'iyat*. Aminrazavi, *The Wine of Wisdom*.
14. Wright, W. Aldis, ed., *Letters and Literary Remains of Edward FitzGerald*, 3 vols (London, Macmillan, 1889).
15. Wright, W. Aldis, ed., *Letters and Literary Remains of Edward FitzGerald*, 7 vols (London, Macmillan, 1902–3).
16. Evans, F.H., *Rubaiyat of Omar Khayyam: A variorum edition* (London, privately printed, 1914). Decker, C., Edward FitzGerald, *Rubiayat of Omar Khayyam: A critical edition* (Charlottesville, University Press of Virginia, 1997).
17. Heron-Allen, E., *Edward FitzGerald's Rubaiyat Of Omar Khayyam* (London, B. Quaritch, 1899). Arberry, A.J., *The Romance of the Rubaiyat* (London, Allen & Unwin, 1959).
18. Heron-Allen, E., *The Second Edition of Edward FitzGerald's Rubaiyat of Omar Khayyam* (London, Duckworth and Co., 1908).
19. Nicolas, J.B., *Les Quatrains de Kheyam* (Paris, Imprimerie Imperiale, 1867).
20. Information on Attar and editions of his work is contained in Bruijn, J.T.P. de, *Persian Sufi Poetry* (Richmond, Curzon Press, 1997).

SELECT BIBLIOGRAPHY

This classified bibliography provides a guide to some important publications relating to the following topics:

- the different editions of FitzGerald's *Rubaiyat*;
- commentaries and other works relating to FitzGerald's *Rubaiyat* and his life;
- some other historic translations of the *Rubaiyat of Omar Khayyam*;
- other works on Omar Khayyam and his *Rubaiyat*;
- book publishing and illustration.

Those seeking more comprehensive bibliographies should look at the works by Aminrazavi, Dashti, R.B. Martin and others in the listings below.

Editions of FitzGerald's *Rubaiyat*

FitzGerald, E., *The Rubaiyat Of Omar Khayyam, the Astronomer-Poet of Persia* (London, B. Quaritch, 1st ed., 1859).

FitzGerald, E., *The Rubaiyat Of Omar Khayyam, the Astronomer-Poet of Persia* (London, B. Quaritch, 2nd ed., 1868).

FitzGerald, E., *The Rubaiyat Of Omar Khayyam, the Astronomer-Poet of Persia* (London, B. Quaritch, 3rd ed., 1872).

FitzGerald, E., *The Rubaiyat Of Omar Khayyam, the Astronomer-Poet of Persia* (4th ed.), and *The Salaman and Absal of Jami* (London, B. Quaritch, 1879).

FitzGerald, E., 'The Rubaiyat Of Omar Khayyam, 5th ed.', in Wright, W. Aldis, ed., *Letters and Literary Remains of Edward FitzGerald*, vol iii (London, Macmillan, 1889).

Commentaries and other works relating to FitzGerald's *Rubaiyat* and his life

Adams, M., *Omar's Interpreter: A new life of Edward FitzGerald* (Hampstead, The Priory Press, 1911).

Arberry, A.J., *The Romance of the Rubaiyat* (London, Allen & Unwin, 1959).

Batson, H.M. and Ross, E.D., *The Rubaiyat of Omar Khayyam* (London, Methuen, 1900).

Bloom, H., ed., *Edward FitzGerald's The Rubaiyat of Omar Khayyam* (Philadelphia, Chelsea House Publishers, 2004).

Cowell, G., *Life and Letters of Edward Byles Cowell* (London, Macmillan, 1904).

D'Ambrosio, V.M., *Eliot Possessed: T.S. Eliot and FitzGerald's Rubaiyat* (New York, New York University Press, 1989).

Decker, C., *Edward FitzGerald, Rubaiyat of Omar Khayyam: A critical edition* (Charlottesville, University Press of Virginia, 1997).

Evans, F., ed., *Rubaiyat of Omar Khayyam: A variorum edition of Edward FitzGerald's renderings into English verse* (London, privately printed, 1914).

Heron-Allen, E., *Edward FitzGerald's Rubaiyat Of Omar Khayyam* (London, B. Quaritch, 1899).

Heron-Allen, E., *The Second Edition of Edward FitzGerald's Rubaiyat of Omar Khayyam* (London, Duckworth and Co., 1908).

Martin, R.B., *With Friends Possessed: A life of Edward FitzGerald* (London, Faber & Faber, 1985).

Prideaux, W.F., *Notes for a Bibliography* (London, Frank Hollings, 1901).

Rodwell, E.H., *Omar Khayyam* (London, Kegan Paul Trench Trubner, 1931).

Terhune A.M., *The Life of Edward FitzGerald* (New Haven, Yale University Press, 1947).

Tutin, J.F., *Concordance of Rubaiyat of Omar Khayyam* (London, Macmillan, 1900).

Wright, W. Aldis, ed., *Letters and Literary Remains of Edward FitzGerald*, 7 vols (London, Macmillan, 1902).

Some other historic translations of *The Rubaiyat of Omar Khayyam*

Avery, P. and Heath-Stubbs, J., *The Rubaiyat of Omar Khayyam* (London, Allen Lane, 1979).

Bodenstedt, F., *Die Lieder und Spruche des Omar Chajjam* (Breslau, Schletter'sche, 1881).

Christensen, A., *Critical Studies in the Rubaiyat of Umar-i-Khayyam* (Copenhagen, Host & Son, 1927).

Costello, L.S., *The Rose Garden of Persia* (London, Longmans Brown et al., 1845).

Garner, J.L., *The Strophes of Omar Khayyam* (Milwaukee, Corbitt & Skidmore, 1888).

Hammer-Purgstall, J. von, *Geschichte Der Schoenen Redekunste Persiens* (Vienna, Heubner und Wolke, 1818).

Heron-Allen, E., *The Rubaiyat of Omar Khayyam* (London, H.S. Nichols, 1898).

Johnson Pasha, *The Rubaiyat of Omar Khayyam*, translated from the Lucknow Edition (London, Kegan Paul Trench Trubner, 1913).

Le Gallienne, R., *Rubaiyat of Omar Khayyam: A paraphrase from several literal translations* (London, John Lane Bodley, 1897).

McCarthy, J.H., *Rubaiyat of Omar Khayyam* (London, David Nutt, 1889).

Nicolas, J.B., *Les Quatrains de Kheyam* (Paris, Imprimerie Imperiale, 1867).

Payne, J., *The Quatrains of Omar Khayyam of Nishapour* (London, Villon Society, 1898).

Rosen, F., *The Quatrains of Omar Khayyam* (London, Methuen, 1930).

Schack, A.F. von, *Strophen des Omar Chijam* (Stuttgart, I.G. Cotta'Schen, 1878).

Schenk, M.R., *Spruche des Omar Chajjam* (Halle, Otto Hendel, 1897).

Tassy, G. de, 'Note sur les Rubaiyat de 'Omar Khaiyam', in *Journal Asiatique*, no IX, Paris, 1857.

Thompson, E.F., *The Quatrains of Omar Khayyam of Nishapur* (Worcester, MA, privately printed, 1906), reprinted as *The Complete Rubaiyat of Omar Khayyam* (Victoria, Australia, New Humanity Books, 1990).

Whinfield, E.H., *The Quatrains of Omar Khayyam* (London, Trubner, 1883).

Whinfield, E.H., *The Quatrains Of Omar Khayyam* (London, Trubner, 2nd ed., 1901) (reprinted in 1980 by Octagon Press, London, for the Sufi Trust).

Other works on Omar Khayyam and his *Rubaiyat*

Aminrazavi, M., *The Wine of Wisdom* (Oxford, Oneworld Publications, 2005).

Dashti, A. and Elwell-Sutton, L.P., *In Search of Omar Khayyam* (London, George Allen & Unwin, 1971).

Forughi, M.A. and Ghani, Q., *Roba'iyat-e Hakim Khayyam-e Nishaburi* (Tehran, Chap-I Rangin, 1942).

Halbach, H., *Romance of the Rubaiyat: A comprehensive directory to the myriad editions* (Santa Barbara, CA, Halbach, 1975).

Hedayat, S., *Roba'iyat Hakim Omar-e Khayyam* (Tehran, Kitabkhana Barukhim, 1923).

Hedayat, S., *Roba'iyat Hakim Omar-e Khayyam* (Tehran, Roschenai, 1934).

Mahfuz-ul-Haq, M., *The Rubaiyat of Umar-i-Khayyam* (Calcutta, Royal Asiatic Society Bengal, 1939).

Potter, A.G., *A Bibliography of the Rubaiyat of Omar Khayyam* (London, Ingpen and Grant, 1929) (reissued in 1994 by Georg Olms Verlag, Hildesheim).

Saidi, A., *Ruba'iyat of Omar Khayyam* (Berkeley CA, Asian Humanities Press, 1991).

Saklatwalla, J.E., *The Voice of Omar Khayyam: A variorum study of his Rubaiyat* (Bombay, Qayyimah Press, 1936).

Tirtha, Swami Govinda, *The Nectar of Grace: Omar Khayyam's life and works* (Allahabad, Kitabistan, 1941).

Book publishing and illustration

Bland, D., *The Illustration of Books* (London, Faber & Faber, 1951).

Canby, S.R., *Persian Painting* (London, British Museum Press, 1993).

Elfick, I. and Harris, P., *T.N. Foulis: The history and bibliography of an Edinburgh publishing house* (London, Werner Shaw, 1998).

Feather, J., *A History of British Publishing* (London, Routledge, 1988).

Felmingham, M., *The Illustrated Gift Book 1880–1930* (Aldershot, Wildwood, 1989).

Greer, R., 'The Published Illustrations of Willy Pogany', in the *IBIS Journal*, no 1, Imaginative Book Illustration Society, London, 1999.

Horne, A., *The Dictionary of 20th Century British Book Illustrators* (Woodbridge, Antique Collectors' Club, 1994).

Houfe, S., *The Dictionary of 19th Century British Book Illustrators and Caricaturists* (Woodbridge, Antique Collectors' Club, 1978).

Houfe, S., *Fin de Siècle: The illustrators of the nineties* (London, Barrie & Jenkins, 1992).

Lewis, J., *The 20th Century Book: Its illustration and design* (London, Herbert, 2nd ed., 1984).

MacKenzie, J.M., *Orientalism: History, theory and the arts* (Manchester, Manchester University Press, 1995).

Muir, P., *Victorian Illustrated Books* (London, Portman Books, 3rd ed., 1989).

Peppin, B. and Micklethwait, L., *Dictionary of British Book Illustrators: The twentieth century* (London, John Murray, 1983).

Slythe, R.M., *The Art of Illustration 1750–1900* (London, The Library Association, 1970).

Taylor, J.R., *The Art Nouveau Book in Britain* (Edinburgh, Paul Harris Publishing, 2nd ed, 1979).

Tebbel, J.W., *A History of Book Publishing in the United States*, vol. 2 (New York, Bowker, 1972).

Watson, R., *Illuminated Manuscripts and their Makers* (London, V&A Publications, 2003).

Winkler, P.A., *History of Books and Printing: A guide to information sources* (Detroit, Gale Research, 1979).

Wood, G., *Essential Art Deco* (London, V&A Publications, 2003).

INDEX

The names of individual publishers and authors are only included where they have been mentioned in the main text. Further details of publishers of FitzGerald's *Rubaiyat* are given in Appendix 1, pp. 167–169, and author references are in the Bibliography, pp. 179–180.

References to illustrations by specific artists are shown as bold. Page number here refers to the caption for the illustration reproduced.

Allix, Susan 27, 168, 170
Aminrazavi, Mehdi 174
Anderson, (Florence M.) 168, 170
Anderson, Marjorie **68**, **89**, **120**, 168, 170, 171
Angelo, Valenti **165**, 168, 170
Arberry, Arthur J. 5, 6, 33, 138, 175
art deco *see* illustration: styles of
art nouveau *see* illustration: styles of
Ashbee, Charles R. 167, 170
Attar, Farid ud-Din 4, 90, 108, 122, 130, 159, 175
Ault, Norman **60**, 86, **127**, **143**, 167, 170, 171
Avery, Peter 5, 172
Bakst, Leon 46
Balfour, Ronald **3**, 24, **46**, 50, **66**, **87**, **92**, 108, 122, **132**, **138**, 144, **152**, 163, 168, 170
Bantock, Granville 8
Bateman, John Y. **28**, **102**, **150**, 168, 170, 171
Batson, Henrietta M. 6, 33
Beardsley, Aubrey 21, 23–24, 40, 92
Beck, Hope **85**, **151**, 168, 170
Behzad Miniatur, Hossein 27, **45**, **48**, **55**, 58, 76, **79**, **125**, **130**, **134**, **137**, **159**, 168, 170
Bell, Robert A. **40**, **71**, 167, 170
Belsey, Karen 27, 168, 170
Bible, The 3, 11
 see also FitzGerald, Edward: *Rubaiyat*: Biblical imagery in

Bihzad, Kamal al-Din **12**
Bjerregaard, Carl H.A. 167, 170
Black Knight Press 27, 168, 170
Blake, William 9
Bock, Vera 27, 166, 168, 170
Bodenstedt, Adolf F. 5
Bodleian Library, Oxford 4, 5, 163, 174, 175
Bomford, Jean 168, 170
'Book of the Pots' *see* 'Kuza-Nama'
books: market for 10, 12
Bowers, Georgina 171
Brangwyn, Sir Frank 20–21, 22, 40, 46, **52**, 66, 80, 109, 167, 170
Buckland-Wright, John 24, **25**, 163, **164**, 168, 170
Buday, George 168, 170
Bull, Rene 22, 23, **45**, 46, 66, 73, **74**, 76, **79**, 86, **88**, **109**, 124, **142**, **153**, 168, 170
Burnett, Virgil **164**, 168, 170
Buttera, F.J. 168, 170
Caird, Margaret R. **62**, **94**, 134, 168, 170
Carroll, Lewis 9, 117
Caxton Editions 29, 166, 168, 170
Christensen, Arthur 5, 6
Chugtai, Muraqqa 29, **166**, 168, 170
Coates, Henry T. & Co. 15, 169
Cole, Herbert 36, 60, **105**, 110, **114**, 167, 170
Coles, W.F. **65**, **132**, 168, 170
Cowell, Edward B. 4, 6, 175
Cox, Elijah A. **68**, **102**, **134**, **147**, 168, 170
Cranston N.A.S. 168, 170
Crowell, Thomas Y. 8, 166, 168, 170
Cumming, Blanche 23, 60
Darwin, Charles 8, 9

Dashti, Ali 6, 174
Davies, Ivor? 143, 168, 170
de Santa Anna, M. 168, 170
de Tassy, Garcin 5
Decker, Christopher 159, 175
Dickens, Charles 9
Dixon, Arthur A. 167, 170
Doughty 168, 170
Doxey's 23, 167, 170
Dulac, Edmund **vii**, **18**, 20, 22, 25, **57**, 76, **102**, **114**, **131**, **151**, **157**, 159, **161**, 167, 170
Eardley-Wilmot, Mabel 23, 167, 170
Easton, William G. **49**, 167, 170
engravings *see* illustration: techniques of
Erte (Romain de Tirtoff) 46
Evans, Frederick 175
Ferdowsi: *Shah-Nama* 50
Fish, Anne H. **24**, 56, **60**, **71**, **81**, **85**, 108, **111**, **147**, **155**, 168, 170
FitzGerald, Edward
 life of 3, 175
 Rubaiyat
 anniversaries 8, 13, 20, 22, 30
 Biblical imagery in 42–43, 59, 73, 95, 128, 131
 calendar editions 10, 21, 53
 change in different editions 4, 6–7, 12, 17–18, 34, 96, 109, 159–162, 175–176
 creation of 4
 decoration and calligraphy 7, 14, 27, 171
 eroticism in illustration of 27–28, 150
 FitzGerald's problems in interpretation 62, 105, 141
 gift and collectable editions 10, 22, 27, 29, 165

FitzGerald, Edward: *Rubaiyat*, (cont.)
 illustration
 approach and styles *see* illustration:
 approach to; illustration: styles of
 history and statistics 3, 7–9, 12–14,
 21–22, 33–34, 167–173
 problems in relating to quatrains
 16–19, 34, 163–164
 illustrators *see* individual artists
 and Appendix 2
 modern Iranian editions 25–29, 165
 musical interpretations 8
 not a precise translation 5
 parodies 8
 Persian culture and mythology in
 42, 44, 45, 48, 50, 62, 68, 86,
 107, 116, 118, 125, 132, 141, 150
 philosophy 8–9, 30, 96
 private press editions 7, 27, 29, 30
 publishers *see* individual firms
 and Appendix 1
 publishing
 history and statistics 7–8, 12–14,
 21–22, 29, 167–173
 undated editions 19
 quatrains most illustrated 36, 52,
 80, 94, 105, 154, 156, 173
 quatrains not from Khayyam 44,
 90, 108, 109, 138, 159
 reasons for success 8–10
 spiritual interpretation of 27,
 36, 38, 40, 46, 53, 140
 structure as poet's day 17, 36, 132, 143
 uses of alliteration 66, 83, 85, 91
Folio Society, The 27, 164, 168, 169, 170
Foulis, T.F. 20, 167, 170
Francis J. 168, 170
Galambos, Margrit 171
Gaman, H. 168, 170
Garner, John L. 5
Garrett, Edmund H. 21, 28, **154**, 167, 170

Gaugin, Paul 69
Gebhard, Catherine 168, 170
Geddes, Ewan? 16, **36**, 43, 70, **82**,
 90, **107**, **146**, 167, 170
Gibbings 20, 167, 170
Golden Cockerel Press 163, 164, 168, 170
Golestan, Shahrokh 27
Gooden, Stephen **71**, 168, 170
Gorter, Hans 41, 90, 168, 170
Greiffenhagen, Maurice 23, **50**, **114**, 167, 170
Hafiz, Khwaja 4
Halder, Asit K. 73, 88, 114, 168, 170
Hall, Isabel H. 23, 167, 170
Hallward, Ella **163**, 167, 170, 171
Hammer-Purgstall, Joseph von 5
Hanscom, Adelaide **15**, 22–23, **60**, 69, 86,
 87, **121**, 146, 160, 163, 167, 170, 171
Hardy, E. Stuart **40**, **157**, 167, 170
Harrap, George G. 8, 19, 167, 168, 170, 171
Hemmant, Lynette 26, **45**, 62, **67**,
 114, **117**, **160**, 168, 170
Henkel, August **123**, **132**, 168, 170
Heron-Allen, Edward 5, 6, 33, 40, 108, 110,
 130, 132, 138, 159, 163, 171, 172, 175
Hesketh, R.C. 168, 170
Hill, Jeff **18**, 26, 56, **57**, **104**, **121**, 166, 168, 170
Hobson, A.E. 167, 170
Hodder & Stoughton 20, 167, 168, 170
Houghton Mifflin 3, 13, 21, 167, 171, 175
Hunter, D. 171
Hyde, Rev. Thomas 5
illustration
 approach to 9, 11, 16–18, 33–34
 history of 11–12, 19–20
 in FitzGerald's *Rubaiyat see* FitzGerald, Edward:
 Rubaiyat: illustration: history and statistics
 styles of 13–16, 19–28
 art deco 14, 19, 24–25, 108, 163
 art nouveau 14, 19, 21–24, 166
 Biblical imagery *see* FitzGerald, Edward:
 Rubaiyat: Biblical imagery in

Chinese imagery 59, 74, 109, 114
classification as Western, orientalist,
 Persian 14–15, 23–24, 26, 36 et seq., 173
modern 19, 25–27
Persian miniatures **12**, **13**, **15**, 16,
 21, 53, 58, 63, 113, 119, 131, 149,
 163, **165**, 167, 169, 171
pre-Raphaelite 23
techniques of 11–12, 173
 engraving 12, 14
 photography 12, 14, 22–23, 60, 87, 121, 163
 photogravure 12, 22
 woodcuts 12, 14
illustrators
 general information *see* individual
 artists and Appendix 2
 Persian old *see* illustration: styles
 of: Persian miniatures
 selecting for reproduction 33–34, 169–171
 unknown artists **74**, **109**, **145**, 168, 171
 with more than one portfolio 19–20
 with unrelated illustrations 163–166
 work often reissued 19–20, 21–25
Iranian revolution: pre and post 25, 27
Isom, Joseph 37, **116**, **141**, 164, 168, 170
Jackson, Albert E. **53**, 167, 170
Jamalipur, A. **34**, **125**, 168, 170
James, Gilbert **15**, 19–20, 21, **22**–23, 25,
 45, 46, **54**, **67**, **73**, 80, 90, **91**, **151**,
 155, **160**, 167, 169, 170, 171
Jameson, Margaret 168, 170
Jami: *Salaman and Absal* 6, 12, 175
Johnson, Maurice? 168, 170
Jones, G. 168, 171
Jones, Wilfrid J. **69**, **77**, **123**, 168, 170
K.S. (name not known) 167, 170
Kalthoum, Oum 8
Karlin, E. 28, **166**, 168, 170
Karpuzas, M. **166** 168, 170
Karr, Hamzeh A.-U. 53, **84**, **99**,
 113, **124**, 168, 170

Katchadourian, Sarkis 27, **95**, **104**, **149**, **161**, 168, 170
Kegan Paul Trench Trubner 23, 167, 168, 170, 171
Khayyam, Omar, life of 4, 78, 174
 Rubaiyat
 authenticity of 5–6, 174
 commentaries 6, 33
 forgeries 6, 174
 manuscripts 5–6, 33, 174
 Calcutta 5, 174, 175–176
 Ouseley 4, 5, 12, 174, 175–176
 publishing history *see* FitzGerald, Edward: *Rubaiyat*: publishing: history and statistics
 in other countries 3, 5, 8, 25–29, 165, 166
 Sufi thinking in *see* FitzGerald, Edward: *Rubaiyat*: spiritual interpretation of
 translation 3, 7, 8, 11, 20, 25, 27, 29, 33, 172–173
 tomb of, at Nishapur 4, 25, 26
King, Jessie M. 24, **156**, 167, 170
Klimt, Gustav 37
'Kuza-Nama' ('Book of the Pots') 17, 91, 113, 132, 138, 141
Laudermilk, Jerome **58**, **98**, 168, 170
Le Gallienne, Richard 25
Lear, Edward **9**
Lefeaux, S.W. 171
Limited Editions Club 165, 168, 170
Lipincott 20–21
Low, Joseph 26, **59**, **88**, **92**, **114**, **136**, 168, 170
Lowinsky, Thomas E. 171
Lundborg, Florence **23**, **49**, 56, **92**, 120, **137**, 167, 170
MacDougall, William B. 171
Macmillan 8, 171
Mahamad, Racim et al. 168, 170
Mahmud of Ghazna 51, 108
Marcel, A.D. 163, 167, 170

Marie, Helen et al. 16, 28, 58, **59**, **72**, 76, **78**, 82, 90, 127, 138, **140**, 146, 156, 168, 170
McCannell, Otway **6**, **41**, **100**, **117**, 168, 170
McCarthy, Justin H. 5
McManus, Blanche **9**, 21, **42**, **43**, **47**, 167, 170, 171
McPharlin, Paul 163, **166**, 168, 170
Meacham, Charles 171
Methuen 22, 168, 171
Michaelangelo 21
Micklewright, G. 168, 170
Mill, John Stuart 9
Morley, T.W. 167, 170
Morris, Steven 27, **65**, 76, **127**, 168, 170, 171
Morris, William 171
Murray, Webster **81**, **121**, **143**, 168, 170
N... (name not known) **42**, 167, 170
Nedelman, S. 168, 170
Nicolas, J.B. 5, 6, 148, 159, 175
Nister, Ernest 10, 167, 170, 171
Noller, N.H. 168, 170
O'Brien **82**, **109**, 168, 171
Orient: interest in 10, 14
Orientalism *see* illustration: styles of
Otsuko Shinichi 8
Ouseley, Sir William *see* Khayyam, Omar: *Rubaiyat*: manuscripts
Page, L.C. 21, 167, 170
Palmer, Doris M. 24, **33**, **49**, **80**, **91**, **101**, **132**, **155**, 168, 171
Parry, Nicholas 27, **30**, **47**, **89**, **117**, **128**, **134**, 168, 171
Patterson, Laurence A. 168, 171
Paul Jones, C.W. 168, 171
Peno, Andrew 29, **41**, **49**, **69**, **108**, **126**, **128**, 168, 171
Persian miniatures *see* illustration: styles of
Peter Pauper Press, The 27, 166, 168, 170, 171
photography *see* illustration: techniques of
photogravure *see* illustration: techniques of

Pogany, Willy 19–20, 22, 24–25, 28, **38**, **57**, 60, 70, 76, 80, **90**, **99**, 105, 109, 122, 128, 132, **142**, **144**, **145**, **147**, **161**, 167, 168, 171
Popoff, Georges 41, **81**, **97**, 168, 171
Potter, Ambrose G. 7, 8, 167
Pownall, Gilbert A. **16**, 168, 171
printing technology: history of 10, 11–12, 14
private presses *see* FitzGerald, Edward: *Rubaiyat*: private press editions
Pym, Roland 168, 171
Quaritch, Bernard 4, 167, 169, 170
quatrain: definition of *see* rubai
R.G.T. (name not known) 51, **76**, **128**, 168, 171
Rackham, Arthur 21
Rado, Anthony **37**, **63**, 76, **89**, **108**, **144**, 168, 171
Random House 165, 168, 171
Ricketts, Charles 167, 171
Robinson, Charles **17**, **95**, 167, 171
Robinson, Thomas H. **60**, **137**, 138, 167, 171
Rodwell, E.H. 6
Rose, R.T. 70, **123**, 167, 171
Rosen, Friedrich 5, 25, 171, 174
Ross, Alice **63**, 167, 171
Ross, E. Denison 6
Ross, Gordon 11, 24, **39**, 41, **50**, **55**, 56, 59, 65, **78**, 91, 96, 107, 124, **126**, 127, **134**, **139**, 144, 148, 156, 168, 171
rubai, rubaiyat: definition 4, 17
Ruzicka, Rudolf 171
Ryder, T.R.R. 171
Saidi, Ahmad 6, 172, 174
Sayah, Mahmoud 27, **165**, 168, 171
Scaliger, Joseph 5
Schack, Adolf F. von 5
Scharr, G. 171
Seal, E.D. 168, 171
Self Realisation Fellowship 27–28, 168, 170
Sett, Mera K. 23–24, **40**, **110**, **118**, 168, 171
Shakespeare, William S. 3, 11, 73
Shakiba, Hojat **26**, 27, 29, **165**, 168, 171
Sheehan, G.A. **47**, **106**, 168, 171

Sherriffs, Robert S. 26, **37**, 53, 62, **102**, **111**, **119**, 168, 171
Simpson, Joseph W. 171
Sketch, The 21
Smith, Austin 171
Souffles 27
Sprouse, W.C. 168, 171
Stack, A. 168, 171
Stella, Guido M. 167, 171
Stewart, Charles **53**, 58, **63**, **136**, 168, 171
Stirling, William G. **50**, **77**, **96**, **157**, 168, 171
Sullivan, Edmund J. 20, 22, **23**, 24, 25, 28, **43**, 44, **51**, 58, 59, 65, 66, 70, **72**, 90, 91, 92, 96, **107**, 114, 118, 127, **128**, 134, 137, **139**, 148, **153**, 168, 171
Szyk, Arthur **25**, **77**, **106**, 168, 171

Tagore, Abanindro N. 23, **24**, **39**, 56, 65, 167, 171
Tajvidi, Akhbar 27, 48, **55**, 66, **70**, 76, **87**, 88, 91, **92**, 109, **111**, **119**, 137, **138**, 139, 140, **148**, **152**, 164, 168, 171
Tajvidi, Mohammad **58**, **74**, **84**, 91, **113**, 139, **143**, 168, 171
Tern Press 27, 168, 171
Tirtha, Swami Govinda 174
Tobin, George T. 28, 43, **53**, 110, **131**, **160**, 167, 171
Turner, Ross 171
Vedder, Elihu 3, **13**, **16**, 21, **35**, 36, **43**, 49, 53, 62, 66, **84**, 86, 91, **95**, 110, **124**, **131**, **142**, 145, 159, **161**, 167, 171
Viegland, Gustav 82

Vincent Jarvis, S.C. 23, 167, 171
Watson Davis, John **87**, **106**, **162**, 168, 171
Webb, Marie P. 23, 167, 171
Weston, Hope 86, 168, 171
Wethered, Ned 168, 171
Whinfield, Edward H. 5, 172
White, Enrique U. 168, 171
Wilson, Edgar W. 171
Wong, Jeanyee 26, **69**, **119**, **132**, 166, 168, 171
woodcuts *see* illustration: techniques of
World War
 First 13, 19, 24
 Second 13, 19, 25, 164
Wright, William Aldis 175
Zadkine, Ossip 123
Zhukovsky, Valentin 5, 6